The Surreal Calder

The Surreal Calder

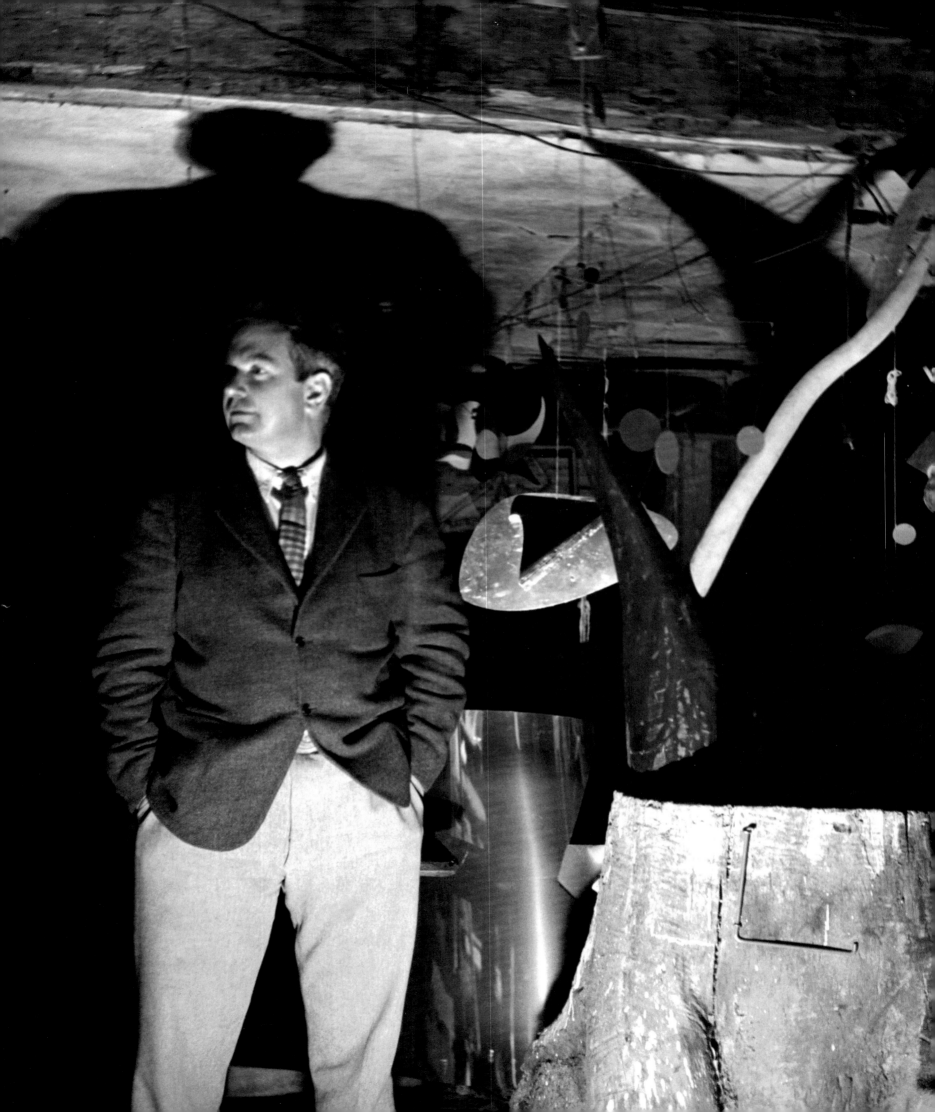

The Surreal Calder

Mark Rosenthal

With a chronology by Alexander S. C. Rower

THE MENIL COLLECTION

Distributed by Yale University Press, New Haven and London

Published on the occasion of the exhibition
The Surreal Calder
Organized by The Menil Collection
Curated by Mark Rosenthal

The Menil Collection, Houston
September 30, 2005–January 8, 2006

San Francisco Museum of Modern Art
March 3–May 21, 2006

The Minneapolis Institute of Arts
June 11–September 10, 2006

At The Menil Collection, *The Surreal Calder* is generously supported in part by The Eleanor
and Frank Freed Foundation, Anita and Mike Stude, and Mrs. Nancy C. Allen, with additional
support from The Cullen Foundation, Fayez Sarofim & Co., George and Josephine Hamman
Foundation, Houston Endowment, Inc., The Wortham Foundation, and the City of Houston.

The Calder Foundation wishes to thank the Glenstone Foundation for its support.

Book Designer: Eileen Boxer
Production Assistants: Angela Taormina, Hoa Luu, Lucy Kaminsky
Printed in America by The Studley Press, Inc.
Editor: Lucy Flint

Published by Menil Foundation, Inc.
© 2005 by Menil Foundation, Inc.
1511 Branard, Houston, Texas 77006
"The Surrealist Years: 1926-1947" © 2005 Alexander S. C. Rower

Unless otherwise noted, all works reproduced are by Alexander Calder.
Full caption information for illustrations in "The Surreal Calder: A Natural" and "Calder by
Matter" is provided in the Catalogue Checklist.

Front cover:
The Spider, 1940

Frontispiece:
Calder in his icehouse studio in Roxbury, 1936. Photograph by James Thrall Soby

Back cover:
Eucalyptus, 1940

ISBN 0-939594-60-9 (The Menil Collection)
ISBN 0-300-11436-2 (Yale University Press)
Library of Congress Control Number: 2005931146

Available through Yale University Press
P.O. Box 209040
New Haven, Connecticut 06520-9040
www.yalebooks.com

Contents

Preface

The Menil Collection is proud to present the first exhibition to focus on the Surrealist dimension of one of the most innovative American sculptors of the twentieth century: Alexander Calder. When Calder became "Calder," well known for his signature mobiles and stabiles, it was due to a unique conjunction of presiding influences in Paris in the 1920s and 1930s—among them Jean Arp, Marcel Duchamp, Joan Miró, and Piet Mondrian. Expertly curated by Adjunct Curator of Twentieth-Century Art Mark Rosenthal, "The Surreal Calder" is a historic event that returns the artist to the midst of Surrealism so that his achievement can be more profoundly understood.

The Menil has enjoyed a long association with the artist, beginning in 1951 when Calder traveled to Houston on the occasion of the installation of "Calder-Miró" at the Contemporary Arts Museum. At this time, Dominique de Menil acquired her first Calder, a silver brooch given to her by the artist. Later, in 1962, John and Dominique de Menil gave Calder's *International Mobile* (1949) to the Museum of Fine Arts, Houston, in memory of Marcel Schlumberger, brother of Dominique's father, Conrad. The director of the museum at the time was James Johnson Sweeney, a close friend of Calder and the de Menils. Sweeney's final exhibition at the MFAH, in 1964, was "Alexander Calder: Circus Drawings, Wire Sculpture and Toys," the last major Calder show in Houston. Thus the presentation of "The Surreal Calder" at the Menil is a welcome and timely event in all respects.

The de Menils' enthusiasm for Calder's work is represented within the permanent collection of the museum as well. Between 1951 and 1994, the Menil Foundation acquired approximately twenty works, including several monumental mobiles and a number of stabiles, wire sculptures, prints, and documentary photographs of the artist taken by Henri Cartier-Bresson and Gordon Parks. There are several Calder drawings in the Menil Archives—including two portraits of Dominique and John—as well as handwritten letters from the artist.

An exhibition of Calder's work depends on many partners for its success. First and foremost, we are deeply grateful for the support of Alexander S. C. Rower, director

of the Calder Foundation, without whose steadfast, generous support neither the exhibition nor catalogue would have been possible. His chronology is an important addition to this publication, revealing new information on the artist's Surrealist orientation between the years 1926 and 1947.

We extend our sincerest appreciation to those individuals and institutions who have supported our endeavor through loans: Mr. and Mrs. Graham Gund; Director Glenn Lowry, Chief Curator John Elderfield, and Curator of Painting and Sculpture Ann Temkin at the Museum of Modern Art, New York; Raymond Nasher and Steven Nash of The Nasher Sculpture Center, Dallas; Jonathan O'Hara of the O'Hara Gallery, New York, and his assistant, Caroline Cohen; Director Alfred Pacquement, Centre Pompidou, Musée national d'art moderne, Paris; Director Earl A. Powell III and Curator Jeffrey Weiss of the National Gallery of Art, Washington; Ivan and Genevieve Reitman; Jon and Mary Shirley; Saul Steinberg estate; Director Adam Weinberg of the Whitney Museum of American Art, New York; and the generous private collectors who wish to remain anonymous.

We are pleased to have the San Francisco Museum of Modern Art and the Minneapolis Institute of Arts as venues for the exhibition. We appreciate their support and patience during the complex organization of this tour. At SFMOMA, we give special thanks to Director Neal Benezra, Elise S. Haas Senior Curator of Painting and Sculpture Madeleine Grynsztejn, Deputy Director of Exhibitions and Collections Ruth Berson, and Curator Janet Bishop. At MIA, we express our sincere appreciation to Acting Director Robert D. Jacobsen, Patrick and Aimee Butler Curator of Paintings and Modern Sculpture Patrick Noon, and Administrator of Exhibitions Laura DeBiaso.

Finally, we wish to acknowledge the financial support of the following individuals and organizations: The Eleanor and Frank Freed Foundation; Anita and Mike Stude; Mrs. Nancy C. Allen; The Cullen Foundation; Fayez Sarofim & Co.; George and Josephine Hamman Foundation; Houston Endowment, Inc.; The Wortham Foundation; and the City of Houston.

JOSEF HELFENSTEIN, Director
The Menil Collection and Foundation

Lenders to the Exhibition

Calder Foundation, New York

Centre Pompidou, Musée national d'art moderne, Paris

Collection of Mr. and Mrs. Graham Gund

The Menil Collection, Houston

The Museum of Modern Art, New York

Nasher Sculpture Center, Dallas

National Gallery of Art, Washington, D.C.

O'Hara Gallery, New York

Private collection

Private collection, San Francisco

Collection of Ivan and Genevieve Reitman

Collection of Jon and Mary Shirley

The Saul Steinberg estate

Whitney Museum of American Art, New York

Acknowledgments

Well known as a repository of Surrealist art, the Menil Collection is eager to examine through its programming the many sides of this historic movement. Certain artists who have not necessarily been identified with Surrealism have long been seen as quietly sympathetic to or instrumental in the formation of its outlook, Paul Klee and Pablo Picasso among them. This exhibition and catalogue considers the role of another such figure, Alexander Calder, who likewise contributed to the breadth of Surrealism as well as to its artistic interchange, while remaining aloof from its polemics.

Along with Menil director Josef Helfenstein, I extend my thanks to the lenders, most prominently to the Calder Foundation. When I first approached Alexander S. C. Rower, grandson of the artist and director of the Calder Foundation, he immediately embraced the theme of the exhibition. Like me, he thought an investigation of the subject was long overdue, and soon offered the full support of the Foundation. I am profoundly indebted to him for his advice and friendship, and for the many contributions he has made to this enterprise. I also wish to recognize the essential assistance provided by his staff—Registrar Jessica Holmes; Archivist Alexis Marotta; and Research Assistants Terry Roth and Claire Vancik—during various stages of the exhibition planning and catalogue preparation.

At the Menil Collection, I am grateful to the Board of Trustees and Josef Helfenstein for their encouragement. The logistical skills of Chief Curator Matthew Drutt are inestimable. Project Curatorial Assistant Susan Braeuer worked tirelessly to oversee the myriad details of the exhibition and catalogue, and made important contributions to the bibliography, "Calder by Matter," and the chronology.

In addition, I am indebted to the entire Menil staff, whose expertise made the project a success: Registrar Anne Adams skillfully managed the details of this demanding installation, with support from Assistant Registrar Judy Kwon; former Head of Exhibitions and Public Programs Deborah Velders; the past and present exhibitions staff—Mark Flood, Anthony Martinez, and Brooke Stroud; and Head of Art Services Gary "Bear" Parham and his staff—Gary "Buster" Graybill and

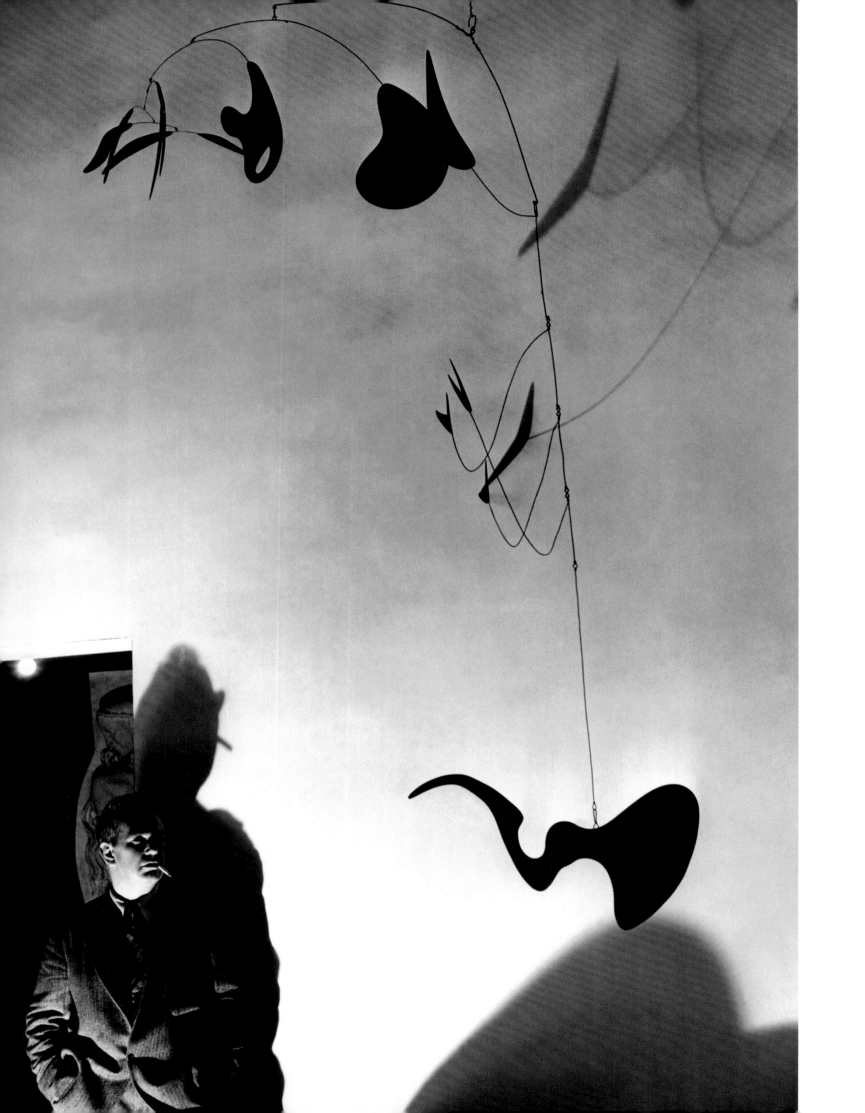

Calder with
Eucalyptus, in 1943.
Photograph
André Kertész

Tom Walsh. I would also like to thank Building, Grounds, and Security Manager Steve McConathy and Facilities Manager Tim Ware. To the entire conservation department I am most grateful, and extend a special thanks to Chief Conservator Elizabeth Lunning and Assistant Objects Conservator Laramie Hickey-Friedman for their dedication and perseverance.

Other colleagues at the Menil who supported catalogue research in invaluable ways are Archivist Geri Aramanda; Assistant Librarian Stephanie Capps; Manager of Rights and Reproductions Joanna Cook; Administrative Curatorial Assistant Clare Elliott; Librarian Phil Heagy; and Collections Registrar Mary Kadish. I express sincere appreciation of the hard work of Director of Planning and Advancement Will Taylor and his staff: Director of Development Tripp Carter; Special Events Coordinator Elsian Cozens; Membership Coordinator Marta Galicki; Director of Communications Vance Muse; and Director of Principal Gifts Mary Anne Pack. Finally, thanks go to Assistant to the Director Kristin Schwartz-Lauster, as well as Chief Financial Officer E. C. Moore and Manager–Finance/HR Tom Madonna, for administrative management.

I applaud Eileen Boxer for designing and producing a very exciting catalogue. A number of works in the exhibition have never before been published, and we were fortunate to benefit from the expert photography of Gordon Christmas and Paul Hester. Special thanks are due to Lucy Flint for her careful editing of the texts. Finally, we are delighted to work again with Yale University Press, and I would like to extend the keenest gratitude to Publisher Patricia Fidler and Associate Editor Michelle Komie for their enthusiastic support.

The following people were also helpful in the realization of this complex undertaking: President Marc Glimcher and Director Douglas Baxter, PaceWildenstein, New York; John Silberman, Esq., John Silberman Associates PC; Sculpture Conservator Eleonora Nagy, Solomon R. Guggenheim Museum, New York; and Senior Curator for Exhibitions Constance Lewallen and Principal Photographer Ben Blackwell, University of California, Berkeley Art Museum/Pacific Film Archive.

MARK ROSENTHAL

The Surreal Calder: A Natural

Mark Rosenthal

Fig. 1
Cello on a Spindle, 1936

Writing to the curator James Johnson Sweeney in 1943, sculptor Alexander Calder described his *Cello on a Spindle* (fig. 1) as "rather Sewer-realist."[1] This droll comment pithily summarizes the artist's longtime outlook. On the one hand, being descended from noted sculptors—his father and grandfather both practiced academic realism of a grandiose sort—and a mother who had been a painter, Calder would have been eager to distinguish his own approach to art. While he suggests with the punning phrase that his origins were in the proverbial gutter, he also pointedly refers to his connection with the art phenomenon that reigned in Paris during the 1920s and 1930s when he resided there.

Like Surrealism—*sur-réalisme*—Calder's work plays off and departs from reality, offering a meta-version of concrete phenomena. Despite his identification with Surrealism the art form, however, the caustic tone of his comment hints at a certain disdain for Surrealism the movement. Although Calder had many personal ties to artists associated with Surrealism, with whom he showed frequently, curators and art historians in the last quarter-century or so have rarely, or only superficially, considered him in that context. The current catalogue and exhibition seek to reestablish Calder's lineage, examining areas in which his work and interests converge with those of Surrealism.

The Surrealist movement/organization was founded in 1924 by the writer-critic André Breton, who autocratically presided over it until 1947, when its manifestations came to an end. Although Surrealist art was clearly an outgrowth of the Dada movement of the teens, and some of the key figures of Dada—including Jean Arp, Marcel Duchamp, Francis Picabia, and Man Ray—continued to play pivotal roles in the subsequent movement, it was Breton who personified Surrealism and defined its premises most extensively. One more-or-less enlisted in Breton's faction by signing his manifestos, but there were endless disputes, outbursts, and crises among the adherents. Calder never signed a manifesto and was able to stay above the fray.

Calder started to make extended visits to Paris in 1926, essentially living there until 1933. Being a very social creature, he made an immediate splash. His initial fame rested on performances he presented between the fall of 1926 and 1931 of his sculpture *Cirque Calder* (*Calder's Circus*, fig. 2). These were viewed by personalities as diverse as the writer Jean Cocteau, the musician Edgard Varèse, and virtually every important visual artist and architect in Paris, including Le Corbusier, Theo van Doesburg, Fernand Léger, Piet Mondrian, Jules Pascin, and, from the Surrealist camp, Arp, Duchamp, Frederick Kiesler, and Joan Miró. With friends and admirers in all districts of the balkanized Parisian art world, it is noteworthy in relation to Surrealism that Calder identified "Man Ray, Kiki, Desnos" as members of his 1929 "gang."[2] As Man Ray was a key member of Surrealism, the Parisian model Kiki de Montparnasse a companion to many in the group, and poet Robert Desnos a crucial force at the movement's beginnings, Calder must have been well aware of the ideas surrounding Surrealism from its formulators at a very early stage in his own artistic development.

In Calder's evolution from the *Cirque Calder* and his wire and wood sculptures (figs. 2 and 3; pages 19, 22–23) up to 1930, he fused the competing visions of Surrealism and abstraction. Mondrian, one of the three pioneers of abstract art, was a major catalyst, his work propelling Calder to the next step in his development after the

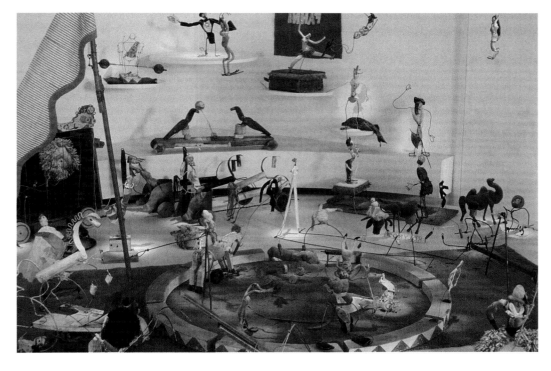

Fig. 2
Cirque Calder, 1926–31

caricatures; moreover, from 1931 to 1933, Calder contributed to the exhibitions and publications of the group called Abstraction-Création. At the same time, he added to his "gang" the Dadaists Duchamp and Arp, whose work had given birth to Surrealism; they were responsible for classifying Calder's work as "mobile" and "stabile," respectively. His good friend Léger, the great Cubist painter, astutely observed in 1933 the multi-pronged relationship of Calder's work with that of "Satie, Mondrian, Marcel Duchamp, Brancusi, Arp"[3] (this, incidentally, was significant praise at so early a date).

Although the Surrealists launched their publications in 1924 and exhibitions the following year, Calder did not show with them until 1936. From then on, he was a frequent participant in presentations in Europe and the United States, even preparing a lithograph for the catalogue of what was to be the last Surrealist exhibition organized by Breton and Duchamp, held in 1947 at the Galerie Maeght in Paris. Though Calder was a willing contributor to many of the announced Surrealist exhibitions—indeed, his sculptures clearly fit the context—he did not sign the group's documents. In addition, it was reported that he disliked having the appellation "Surrealist" applied to his work in 1937 on the occasion of his first joint show with Miró.[4] Though Breton, known as the Pope, often practiced a form of excommunication, he rarely did so with major artists, including Miró and Pablo Picasso, and this exemption extended to Calder, whom he praised in 1941.[5] In fact, he and Calder became so close during and after World War II that he arranged to have the artist make a monument for his tomb.[6]

With friends on all sides of the art world from the late 1920s on, Calder sensibly assumed an ecumenical stance in relation to opposing camps. In taking this position, he followed the example of his friend Miró, who started out as an avowed Surrealist, later withdrew from an official commitment to the group, yet continued to show with its members. Interestingly, Calder began his lifelong friendship with Miró in 1928, about the time the latter pulled away from the group. It was as if the older, more experienced Miró were alerting the young Calder to the problem of artists' movements that adopt dogmatic theories and extreme positions. For Miró, nevertheless, it was important to maintain good relations; he explained in a 1934 letter to Henri Matisse that he had given a new work to Breton because "the Surrealists have become *official personalities* in Paris."[7] Calder likewise tried to play

all sides, though not always with success. He, like Miró, had shown with Julien Levy, a major New York art dealer of Surrealist art, in 1932. But in Levy's 1936 book on Surrealism, the first in English, the author described Calder as "sometimes surrealist and sometimes abstractionist," and expressed the hope that Calder "may soon choose in which direction he will throw his weight."[8] Years later, in 1965, Calder reported that Levy "often reproaches me for having seceded from his league;"[9] of course, Calder never formally joined any "league." Levy, while having a genuine reciprocal sympathy with Calder, raised the political dimensions of engaging with Surrealism and adding one's "weight." Though he kept his distance, Calder remained unassailable, having Arp and Duchamp as godparents, as it were, Miró as a friend and artistic colleague, and many other influential associations.

The contradictory position of the Surreal Calder is epitomized by the jewelry he designed. At the 1942 opening of her New York gallery Art of This Century, Peggy Guggenheim wore two earrings, one by Yves Tanguy and one by Calder, to indicate her "impartiality" toward Surrealism and abstraction respectively.[10] Yet it was also said during the same period that any woman associated with Surrealism wore Calder jewelry.[11] Here again, then, Calder's positioning was open to argument.

Calder might best be described as an independent, as he was in the catalogue for the 1936 exhibition "Fantastic Art, Dada and Surrealism" organized by the Museum of Modern Art. Nevertheless, like Miró, his rejection of reason and embrace of

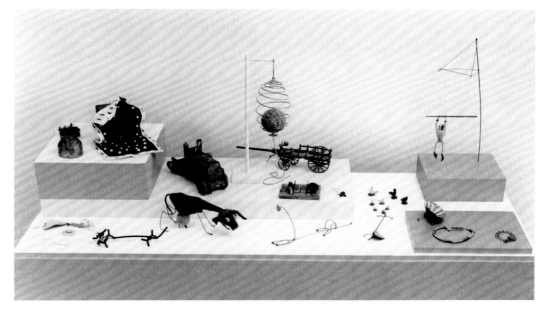

Fig. 3
Toys, 1902–45

the Surrealists' themes placed him squarely in their camp, if only as a "natural." If he did not accept Surrealism's manifestos, Calder's artistic character was, nonetheless, consonant with much of its outlook and work, hence the ongoing invitations to participate in exhibitions. Starting with the performances of *Cirque Calder*, one can see that he was a kindred spirit. The vision of this ebullient bear of an individual, a virtual American *sauvage*, performing an art version of the beloved French tradition of the circus must have recalled Charlie Chaplin, another American natural who was revered by Breton for his freewheeling, antiestablishment actions.[12] Like Calder's artistic heroes Francisco de Goya and Hieronymus Bosch,[13] he himself was drawn to the fantastic, as were the Surrealists. His love of machinery and toys (fig. 3), a childhood passion developed long before his exposure to Surrealism, also happened to coincide with the mechanistic enthusiasms of Dada and Surrealism as practiced by Duchamp, Max Ernst, and Picabia.

Although Breton outlined various aesthetic principles in his writings, the Surrealist artists did not strictly abide by them. While there are the two obvious categories within Surrealism of the abstract and the representational, it might be more instructive

to say that there were as many approaches as there were artists. In effect, one knows Surrealist art when one sees it, recognizing in it certain consistent characteristics. The work of Arp (fig. 4), André Masson (fig. 5), and Miró (fig. 6) from the initial phase of Surrealism in the mid-1920s was improvisational and abstract. According to the art historian William Rubin, the artists, in theory, painted without deliberation or forethought and "worked *toward* an interior image."[14] This process, which

was essentially playful, relies on the fundamental Surrealist concept of psychic automatism, an approach in which the artist works in a kind of trance, spontaneously producing images that arise directly from the subconscious. Thus the dream was ubiquitous in Surrealist art, whether it appeared in abstract or representational form. Even if psychic automatism was only an occasional pastime—artists being too concerned with the final appearance of their compositions—it provided a *look* for much Surrealist work.

Surrealism offers a wealth of metamorphic imagery, in which more-or-less non-representational images are imbued with suggestiveness, conjoining the dream life with the waking world. Paul Klee, also tangentially connected to the Surrealist movement, famously remarked that "art does not reproduce the visible but makes visible,"[15] an act of prestidigitation that was at the heart of almost all Surrealism. Surrealistic imagery often conjures up a state of becoming and transformation, with all things in flux. It creates a place for discovery; fantasy and fantastic sights are ubiquitous. In more representational Surrealist works, identity is a multiple affair. Unlikely juxtapositions such as those described by Surrealist poet Comte de Lautréamont (Isidore-Lucien Ducasse)—for example, the beautiful and accidental meeting of a sewing machine and an umbrella on a dissecting table—were celebrated with gusto (fig. 7).

Fig. 4
Jean Arp
Configuration with Two Dangerous Points, ca. 1930
(opposite page, top)

Fig. 5
André Masson
Automatic Drawing, 1925–26
(opposite page, bottom)

Fig. 6
Joan Miró
The Hermitage, 1924

Fig. 7
René Magritte
The Invisible World, 1954

The Surrealists searched the unconscious or hallucinations, or whatever else was at hand, for imagery that they developed in as free a way as possible. On encountering a particularly successful Surrealist artwork, it was customary to respond with Breton's word of praise—*merveilleux* (marvelous)—expressing the wonderment generated by a sense of beholding a dream. Critic Maurice Nadeau, as if describing Calder, explains that the *merveilleux* was, for Breton, "endowed with an eternal youth ... the very law of life," from which emerges a "poetic grace."[16] In that spirit, Breton, in lauding Calder, wrote that the sculptor's work "conveys to us with equal felicity the evolutions of the celestial bodies, the trembling of leaves on the branches, the memory of caresses."[17] As suggested by this quotation, the poet detected in Calder's art an erotic dimension, which, for Breton, offered the highest levels of revelation.[18]

Separate from the political dramas that permeated the activities of the group, Surrealism offered a fresh group of options for the artists—themes, techniques, outlooks, and points of departure for art practice. As will become apparent, Calder and the others were effectively engaged in a kind of dialogue, a series of calls and responses among themselves. At times, Calder was in the forefront, and at others, he was contributing to what was already ongoing.

24 *Calderoulette*, ca. 1940

23 *Two Acrobats,* 1929

One propensity Calder shared with the Surrealists was the cultivation of wit. The Cubists opened the door for this, especially in their *papiers collés* and objects (fig. 23), in which pasted word fragments or titles spark wordplay in relation to the imagery and overall composition. In their impulse to topple convention, the Dadaists in the 1920s introduced irony and even parody, Duchamp titling a urinal *Fountain* (fig. 8), and Man Ray calling an eggbeater *La Femme* (*Woman*, 1920, Centre Pompidou, Musée national d'art moderne, Paris). The Dadaists would assign an everyday identity to a mechanistic image to comic effect, much in the spirit of Chaplin contemplating contemporary life in *Modern Times* (1936). One infers from the Dadaist gags an attempt to come to terms with a changing cultural environment. The Surrealists went even further in their fun, though Breton at times seemed a bit strait-laced or limited in this respect, in 1928 chastising Miró for being "ill-protected against . . . playfulness."[19] On the other hand, in 1936 he

eloquently described the humor of Salvador Dalí as "the denial of reality and the splendid affirmation of the pleasure principle."20 Wit and Surrealism both offer a way to comment on one's milieu from a distance, or to offer an alternative reality. They propose a removed relationship—whether pleasurable or alienated—to the world (figs. 9 and 10). With its position of superiority vis-à-vis its subject matter, wit may be said to represent an elevated point of view, even wisdom.

Calder had always infused his work with humor, starting with his toys and wire sculptures of the mid-1920s (figs. 2 and 3; pages 19, 22–23). Long before he knew about Surrealism he found the human physiognomy funny, ripe for caricature. In his mechanical and machine-inspired images, he anthropomorphized with abandon, often provoking belly laughs. Like Duchamp (who had invested a chocolate grinder with sexual connotations) and Picabia during the Dada years of the teens, and Ernst and Klee in the early 1920s, Calder turned humans and their activities into images at once burlesque and mechanistic.

Calder on occasion parodied mythic sources, for example, with *Hercules and Lion* (page 19), *Romulus and Remus*, and *Spring* (the latter two 1928, Solomon R. Guggenheim Museum, New York). Here we see Calder using words, as the Dadaists and Surrealists had done, to advance an absurdist sensibility. Through language he assigned unexpected identities and endowed well-known figures with unimagined characteristics. (By contrast, abstractionists generally would title their work "compositions," if anything at all.) Calder shared the Surrealists' pleasure in the interplay of language and image, freely combining the two modes. Such play is a hallmark of the Surrealist cast of mind—hence, when James Johnson Sweeney's brother, John Lincoln Sweeney, convivially referred to a sculpture as a "Calderberry-bush" in 1935, the moniker stuck.

Like many Surrealists, Calder conjoined words in a fanciful way in his titles, providing a surprising entry point for a work, as for instance, *Calderoulette* (page 24). In this suggestive world, in which metamorphosis was easily evoked, all things are possible and free association is the norm. Calder's antics resulted in improbable, irrational situations, in the

Fig. 8
Marcel Duchamp
Fountain, 1917/1964
(opposite page, top)

Fig. 9
René Magritte
Golconda, 1953
(opposite page, bottom)

Fig. 10
René Magritte
This Is a Piece of Cheese,
1936 or 1937

manner of all of Surrealist art. The whimsy of these works relates most strongly to Arp, Miró, and Ernst, though it also resonates with Klee and, in the realm of film, Chaplin. Calder's *Tightrope* (page 26) can aptly be compared with Klee's *Seiltänzer* (*Tightrope Walker*, fig. 11), which also depicts a figure engaged in a light-hearted act of daring. Calder, Klee, and Chaplin shared the qualities of profound gentleness, vulnerability, and magnanimity. Like Chaplin effecting his improbable escapes, Calder's tightrope figure appears to be divinely blessed. Calder's sense of humor was not derisive but genteel. It is not surprising that he was too mild for the sexual edge of some Surrealism. Even when he engaged in parody, it was of a generous, good-natured type.

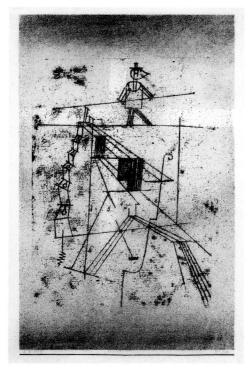

Fig. 11
Paul Klee
Tightrope Walker, 1923

Wit often is expressed in a graphic medium, and Calder was a fluid draftsman who contributed illustrations to magazines in his early years. His facility with line imbued his wire figures as well, and would come to characterize his sculptures, where the "line" of the wire seems so free as to have been improvised. Indeed, his report in *Calder: An Autobiography with Pictures* (New York, 1966) that he was rarely seen without a set of pliers in his hands suggests a spontaneous spirit. This quality has parallels in the technique called "automatic drawing" that was practiced by the Surrealists in the late 1920s, wherein the artist, ostensibly working in a trance, literally draws forth intimations of the unconscious. The line acts as if independent of the hand and mind of the artist; at the same time, it spontaneously defines space and whatever animate or inanimate elements that emerge within it, much as occurs in Calder's work.

26 *Tightrope,* 1936

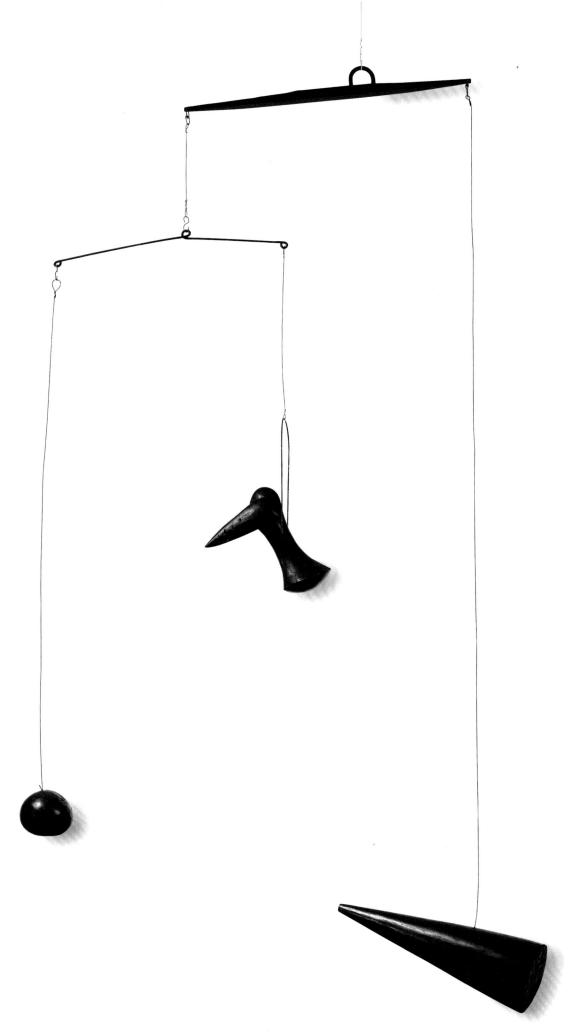

27 *Cône d'ébène,* 1933

The contrary Dada and Surrealist artists, having absorbed from Cubist collage the idea that everyday detritus could be made into beautiful art, were eager to return it to the category of trash. The Surrealist Object, as it came to be known after the 1936 "Exposition surréaliste d'objets" ("Exhibition of Surrealist Objects") at the Galerie Charles Ratton in Paris,[21] was assembled from diverse and unlikely materials according to new poetic values to form an unexpected entity (figs. 12 and 14). The handling of discarded materials in these three-dimensional objects approximated the effects of the automatic or dream-inspired work that was flat in format; in both, a subconscious play of choices resulted in art. Bronze and oil paint had lost their significance, for a new form of beauty was at hand.

Although Calder had often made use of found materials, starting with his earliest toys, in December 1928 he was shocked by the presence of a feather and a corkscrew in a work by Miró. Visiting his new friend's studio and seeing a recent Surrealist collage from his series Spanish Dancer, Calder "was nonplussed; it did not look like art to me."[22] But Surrealist practice liberated him, just as his meeting with Mondrian had; indeed, it seemed to mesh with his innate or natural tendencies (pages 27, 30–37). When Calder said later that "disparity is the spice of life,"[23] he had moved from the skepticism he had experienced in Miró's studio to a full appreciation of one of the essential aspects of Surrealism, its use of found materials.

When Calder began making his own Surrealist objects, he often used wood, perhaps inspired by the example of Miró and Arp. He would later speak of "making two or more objects find actual relations in space,"[24] a variation on the Lautréamont/Surrealist notion of the unexpected conjunction. Calder's Surrealist objects are not beings, but some other kind of entity, and *merveilleux* is the suitably vague praise that should be bestowed on them. (Indeed, the imprecision of the word reflects the inadequacy of language in response to something previously unimagined.) Sometimes assuming the spiky, prickly, or unpleasant forms the Surrealists favored, these

sculptures have a disturbing beauty. In this instance, Calder came as close as he ever would to making a "disagreeable object," to borrow a phrase from the title of Alberto Giacometti's *Objet désagréable, à jeter* (*Disagreeable Object* [*To Be Disposed of*], 1931, private collection).

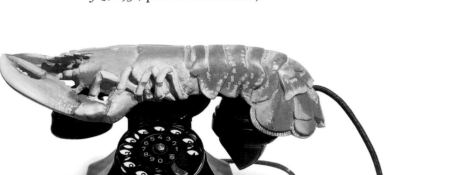

30 *Money Bags,* 1934

31 *Wooden Bottle with Hairs,* 1943

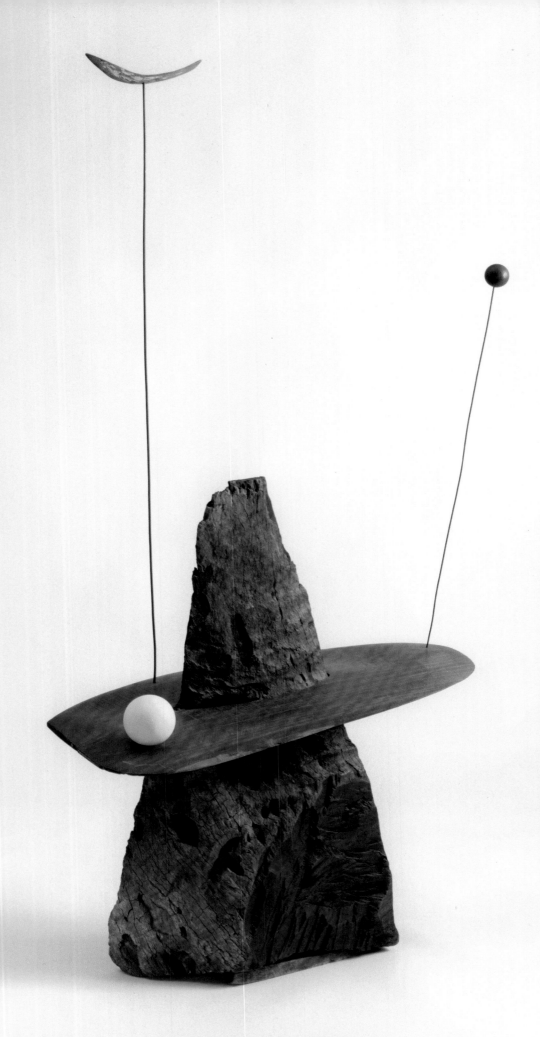

32 *Gibraltar*, 1936

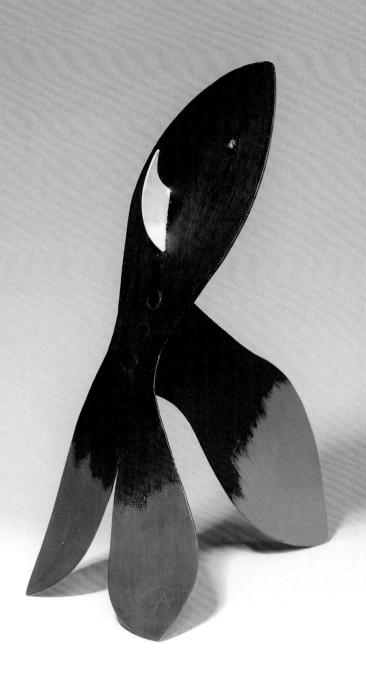

33 *Ruby-Eyed,* 1936

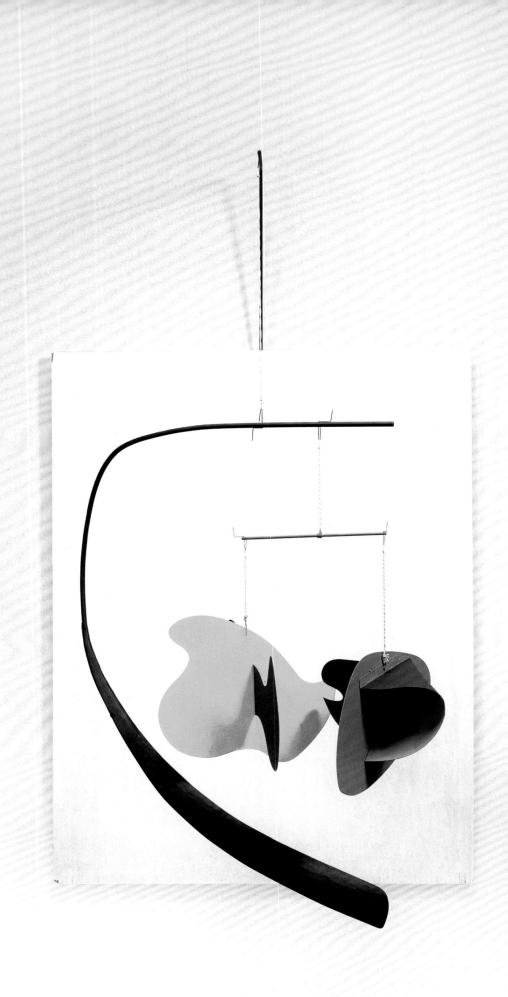

34 *White Panel,* 1936

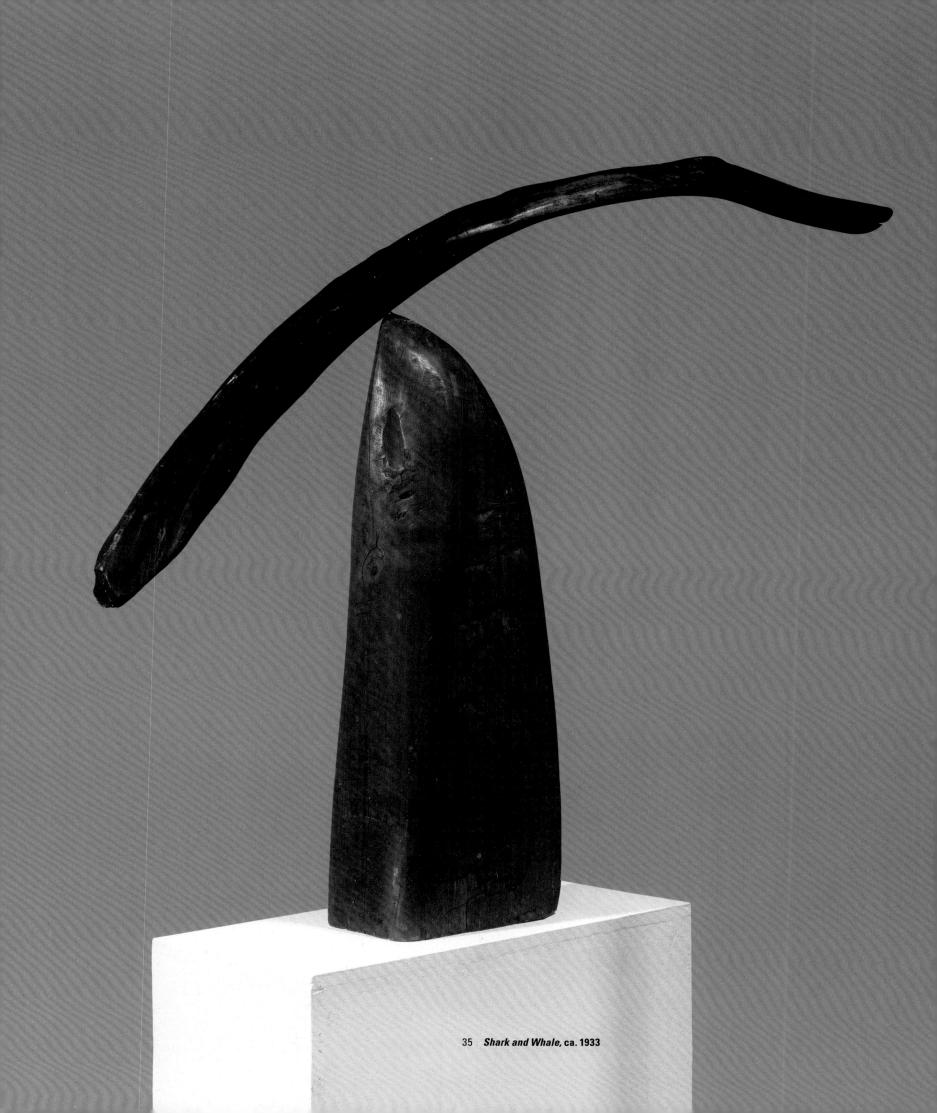

35 *Shark and Whale,* ca. 1933

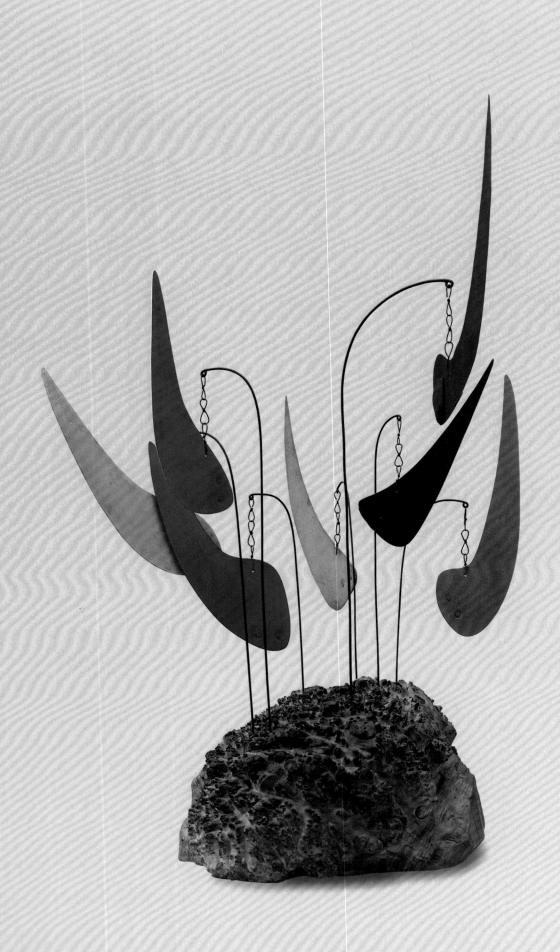

36 Untitled, 1941

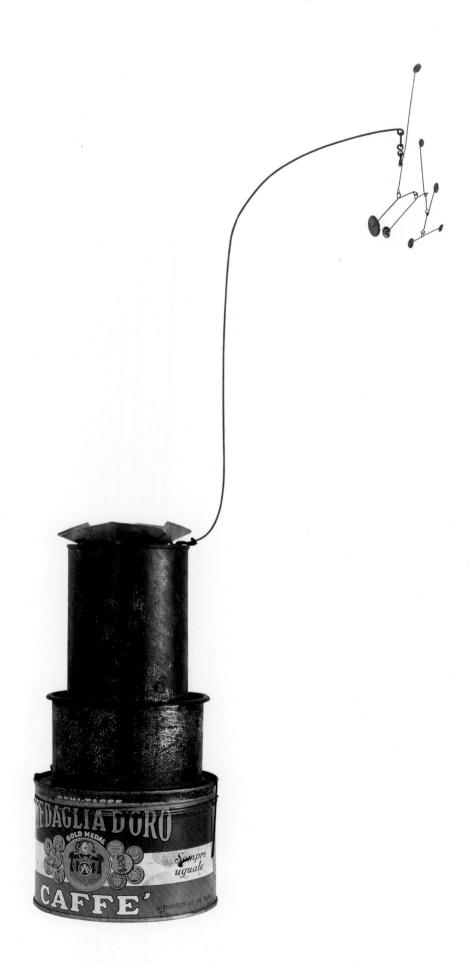

37 *Ashtray Mobile,* ca. 1951

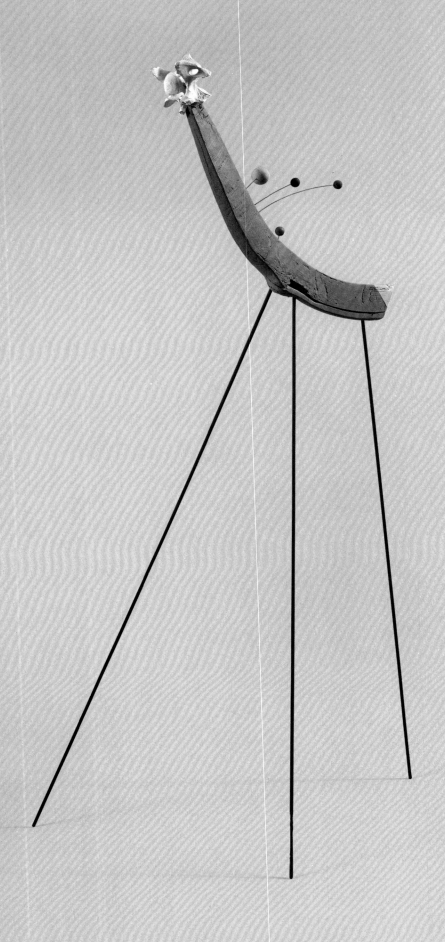

38 Untitled, 1938

n the aforementioned exhibition "Surrealist Objects," natural objects such as quartz, minerals, and vegetal fragments were shown alongside the sculptures, enjoying full parity. Beyond that appreciation, Calder, like Breton and virtually every Surrealist artist, collected and derived inspiration from non-Western material (pages 40–43). What Breton saw in it was a quality he termed "convulsive beauty,"[25] a phrase undoubtedly inspired by the work of Picasso (fig. 15). To

be aggressive, shocking, and unpredictable in the eyes of bourgeois culture could result in a new kind of sensuality. While convulsive beauty was often associated with themes of sexuality and aggression in the hands of Picasso, it also led to images with a monstrous—sometimes comically monstrous—aspect, which characterized some of Calder's work (pages 38, 44–57). In effect, the Surrealist Object had morphed into a being. Calder already had the example of Miró's creatures when he undertook his own savage and unimagined personages in the early 1930s. For Calder, as well as for Ernst (figs. 16–17), Dalí, and Picasso, metamorphic and hybrid personages occupy states that straddle the human, animal, and mythical, or may even exist in conditions of becoming. At times terrifying, at other times amusing, such characters may frighten or delight; Calder's inventions, even when called "monsters," possess a playful quality.

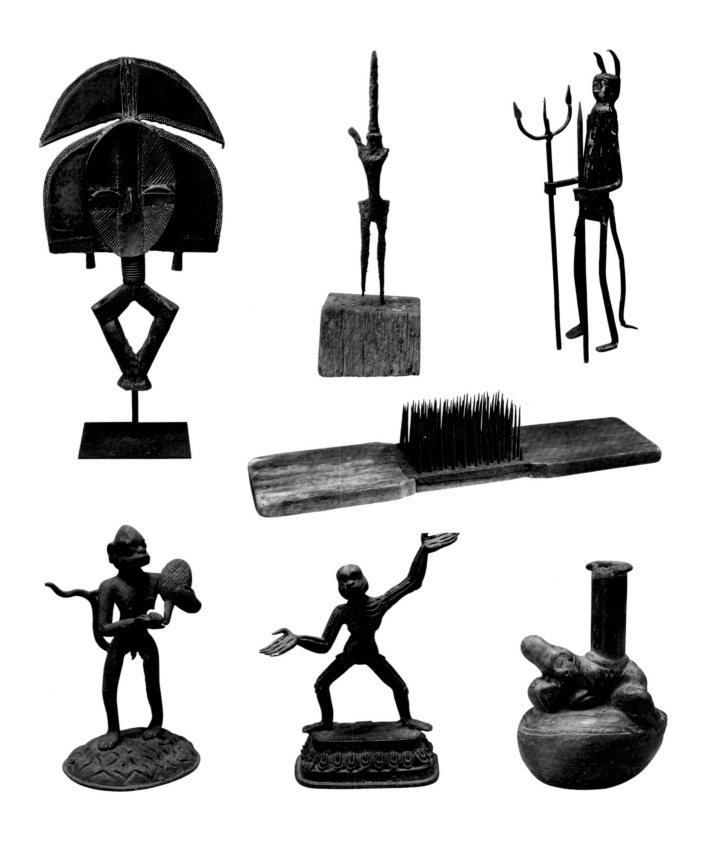

"Cabinet of Curiosities," (pages 40–43)　　Gathered by the artist's grandson, Alexander S. C. Rower, from Calder's Roxbury studio, these 30 objects recall the Surrealists' fascination with mysterious objects, as well as provide an intimate experience of Calder's surroundings and interests.

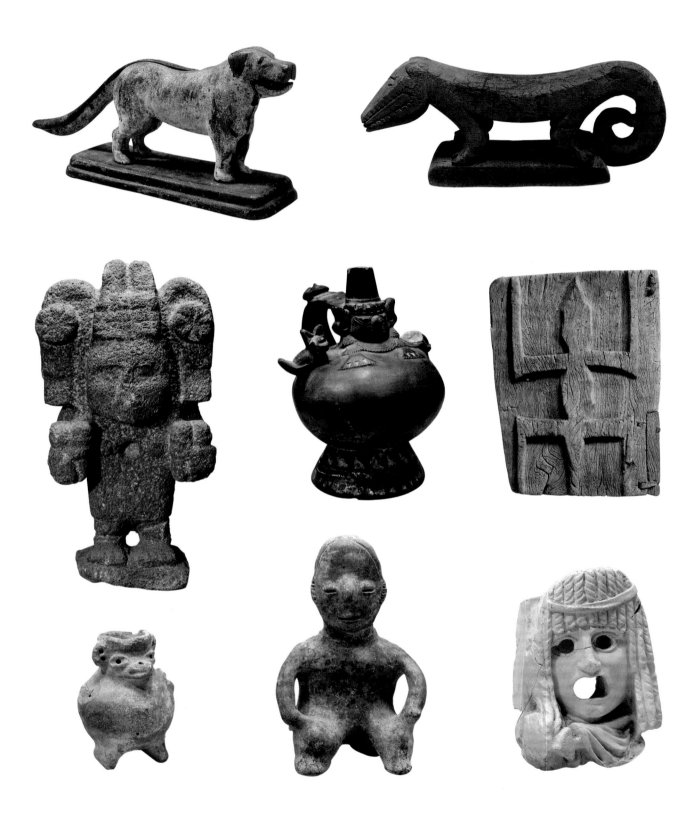

44 **Untitled, 1933**

45　**Untitled, 1932**

46　**Untitled, 1932**

47 Untitled, 1933

48 *Apple Monster,* 1938

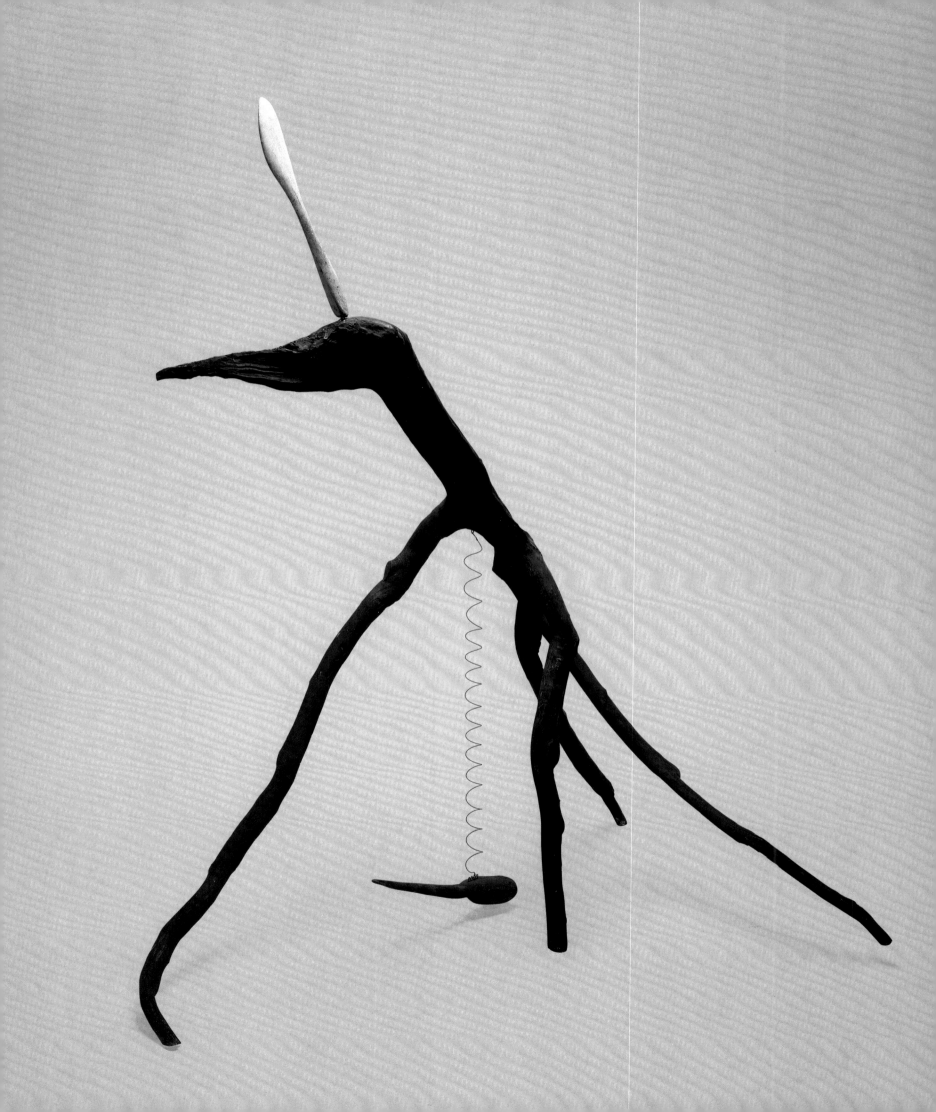

50 *Devil Fish,* 1937

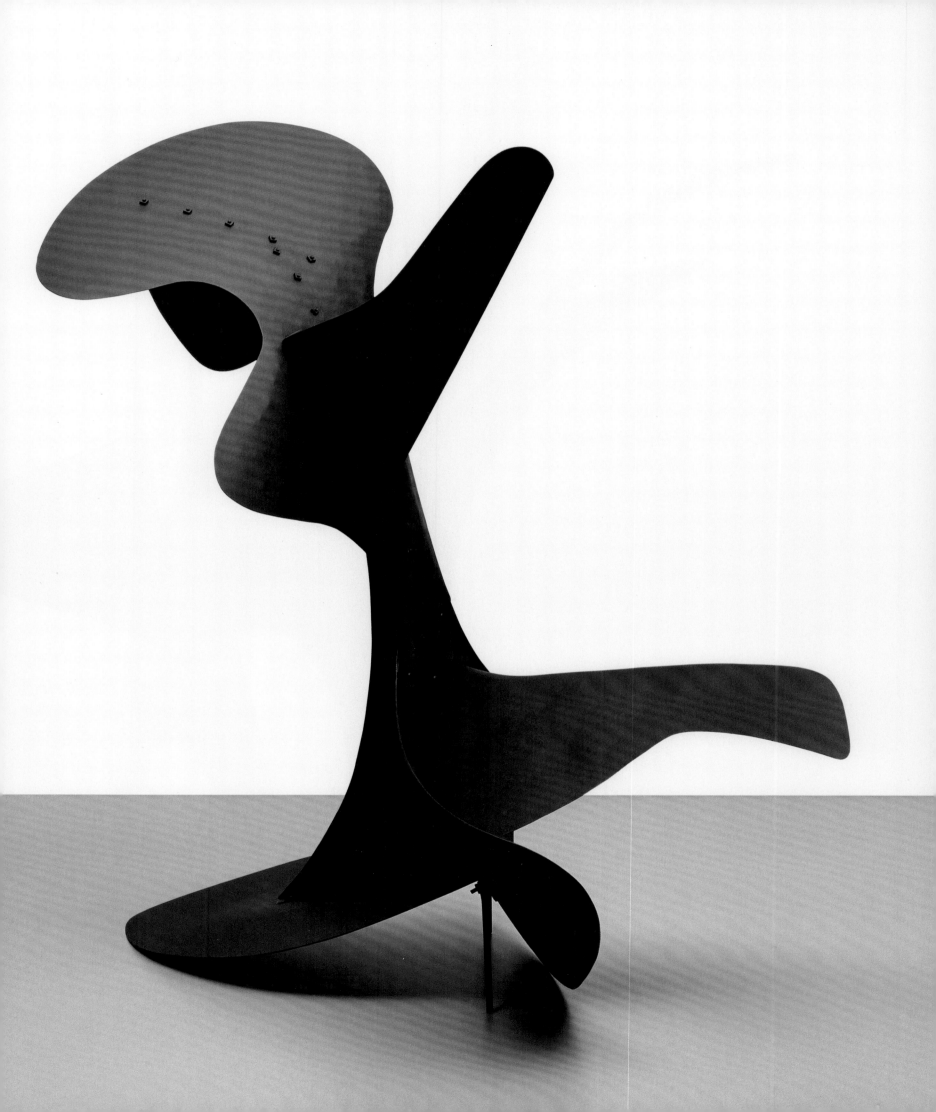

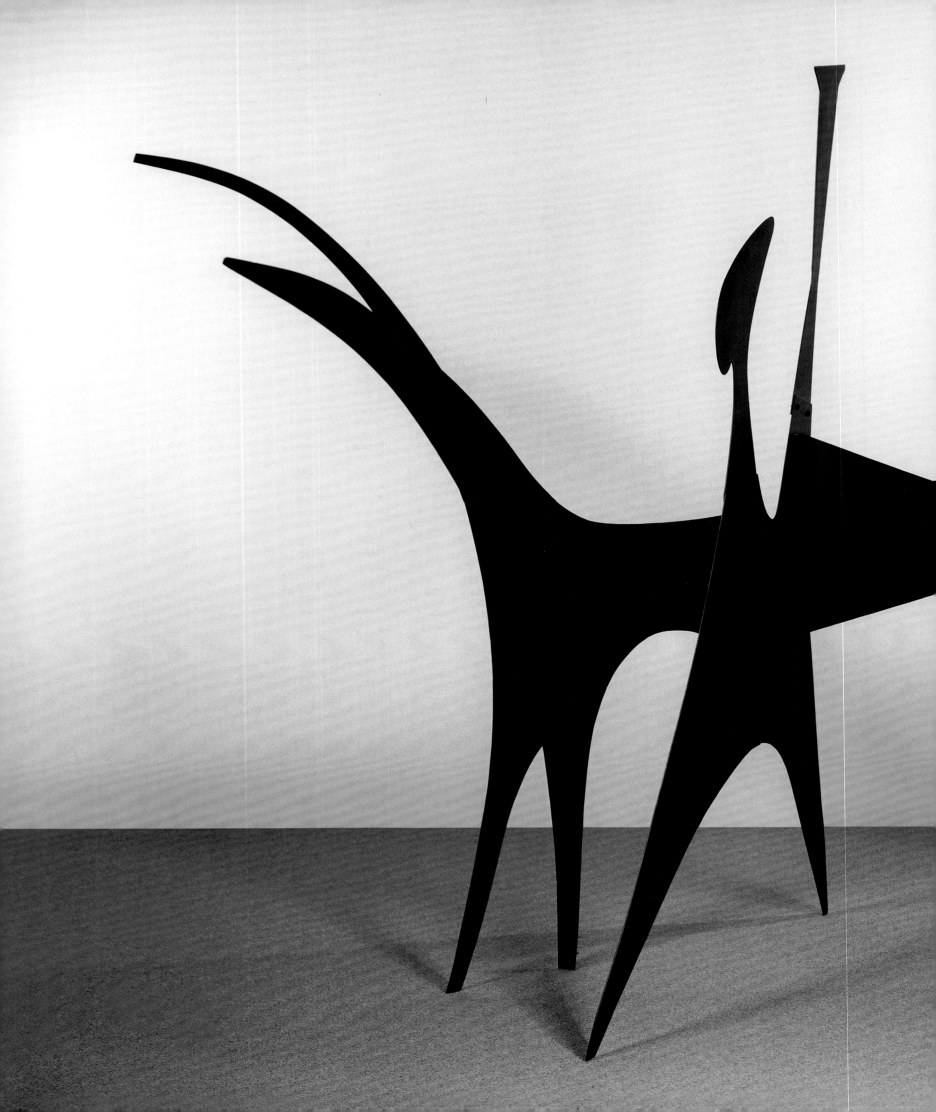

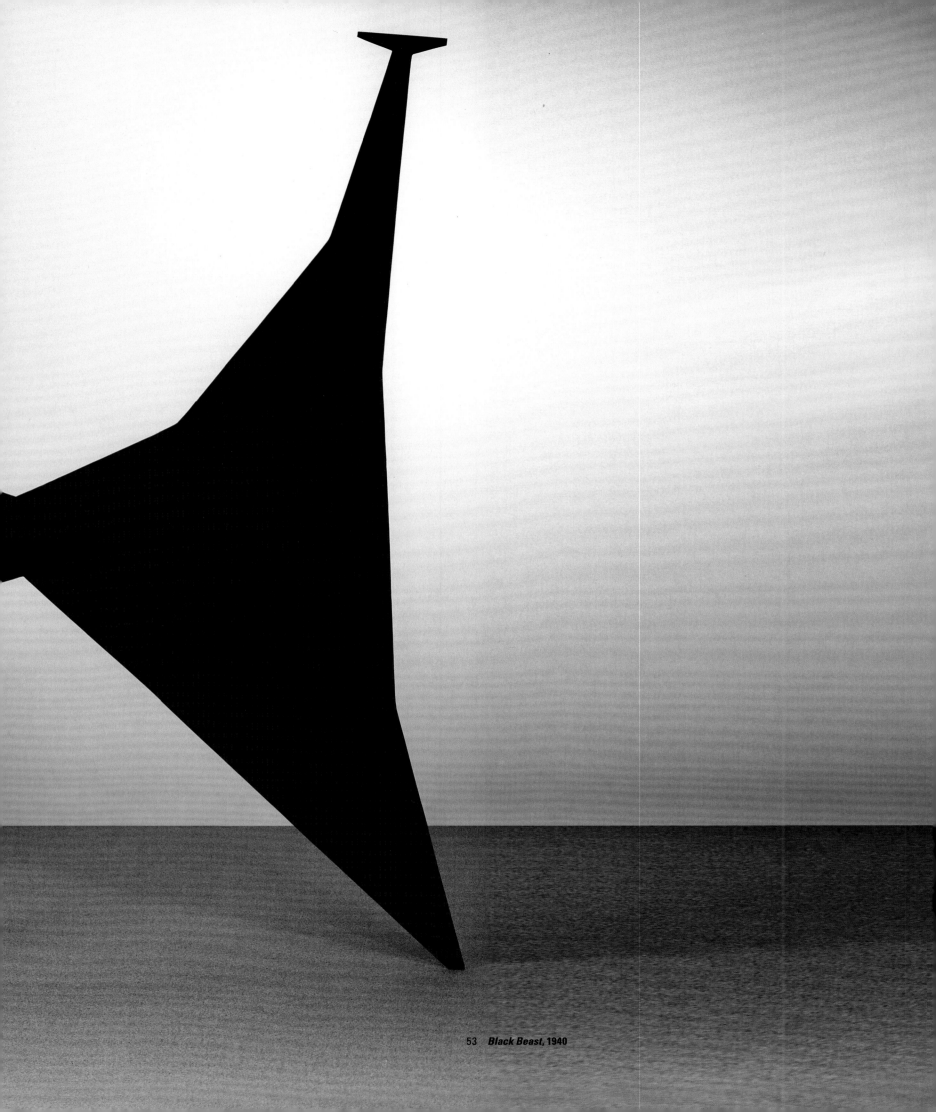

53 *Black Beast*, 1940

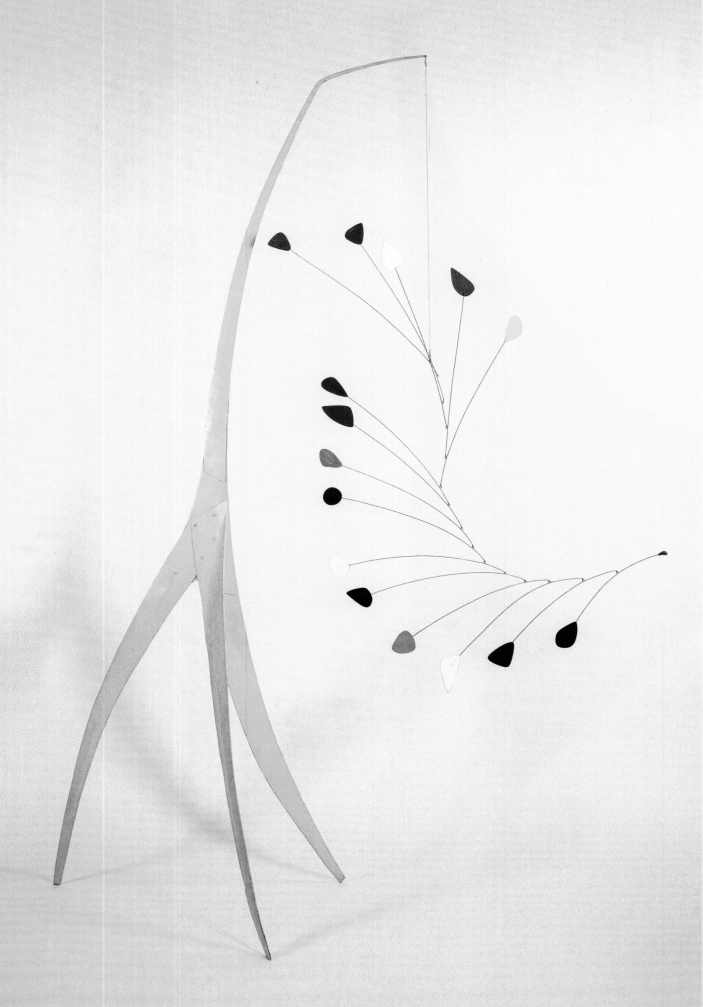

54 *Giraffe,* ca. 1941

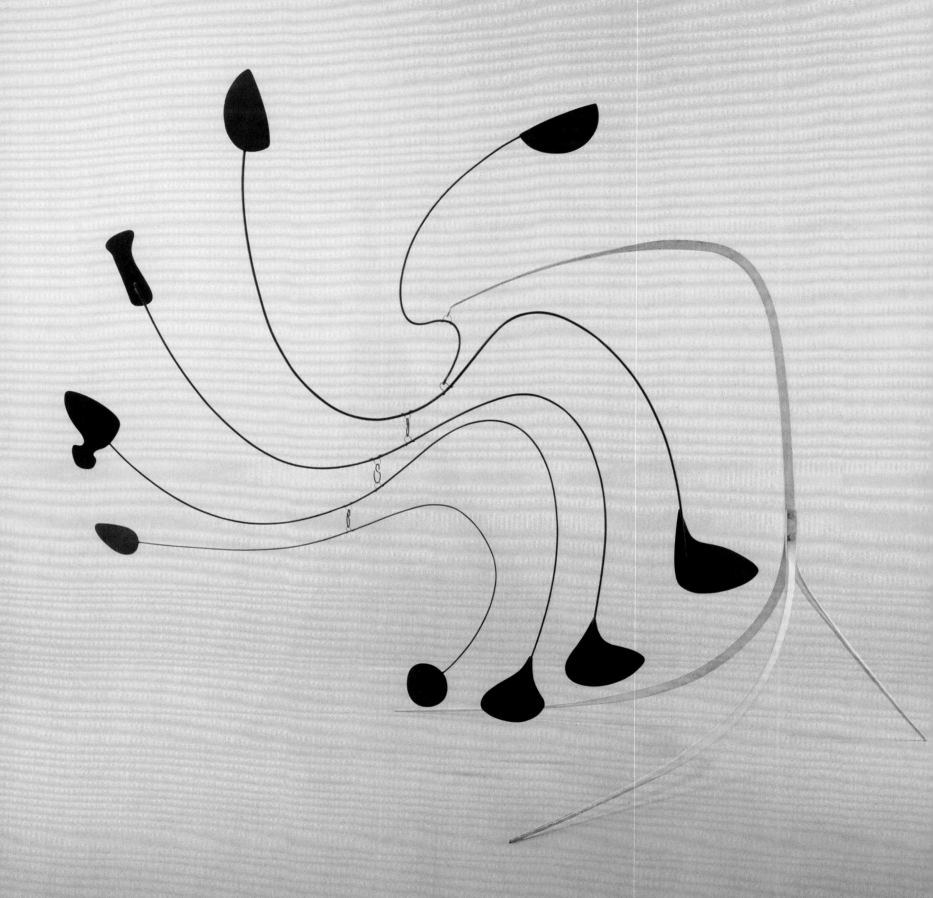

The Spider, 1940

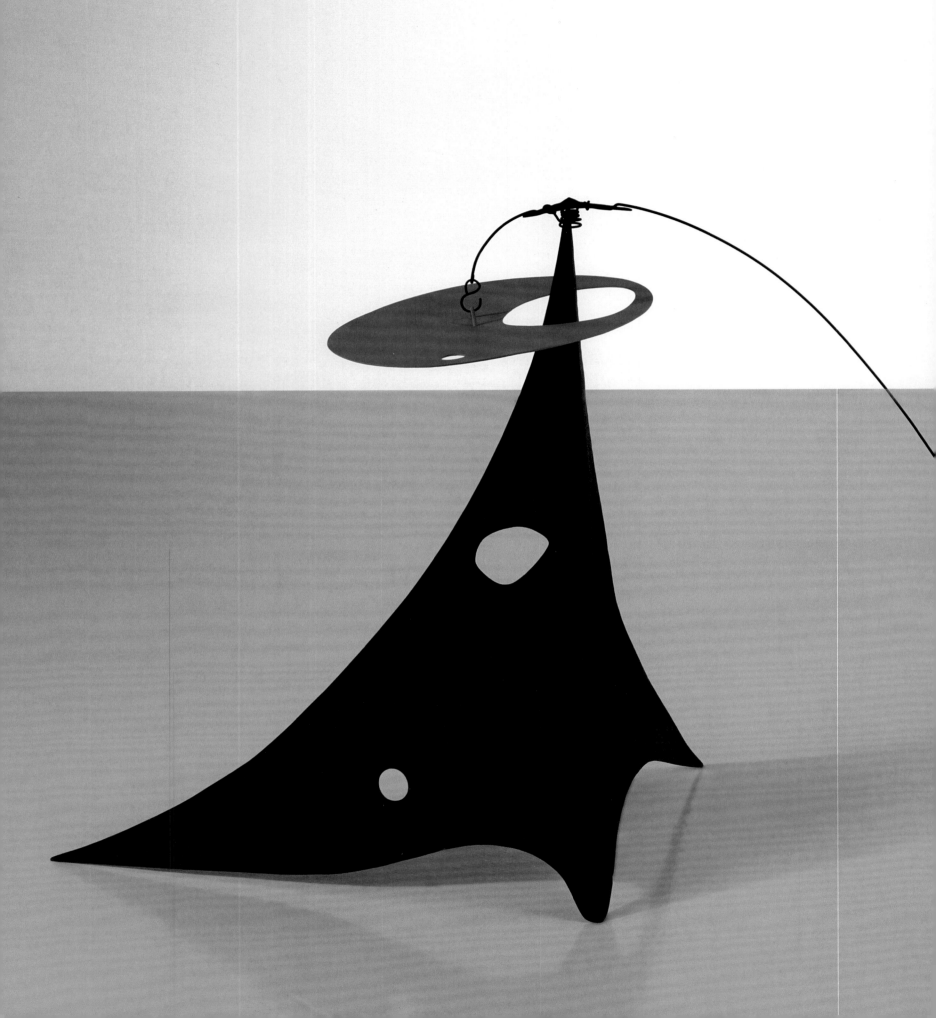

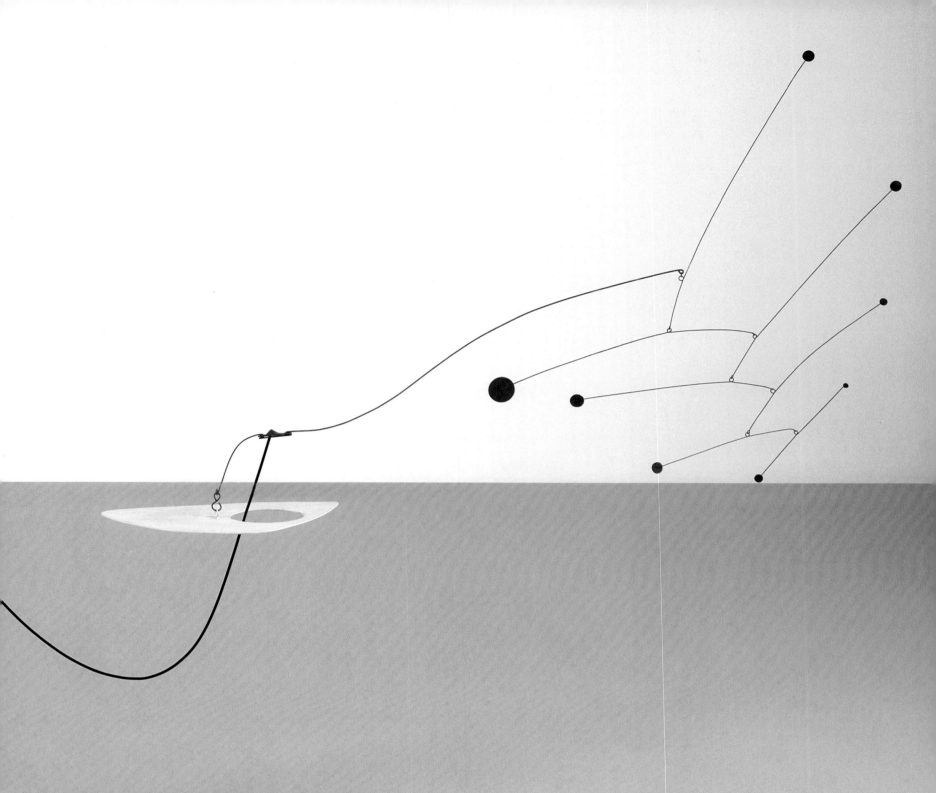

57 *Parasite*, 1947

A chaotic profusion of organic-cum-biomorphic forms was the province of many Surrealists, especially Ernst (figs. 18–19). Regarding forests, Ernst wrote: "They are . . . savage and impenetrable, black and russet, extravagant, secular, swarming, diametrical, negligent, ferocious, fervent and lovable. Neither yesterday nor tomorrow exists for them. Naked, they stake only their majesty and their mystery."[26] Whereas Matisse could title a work *Luxe, calme, et volupté* (1904, Centre Pompidou, Musée national d'art moderne, Paris), the Surrealists never pursued so placid and idyllic a vision. Their images show nature anthropomorphized into a devouring personage. In nature they were drawn to particularly extravagant displays, in which growth could become a metaphor for accretion without boundaries. As in their *cadavres exquis* (exquisite corpses), one element is added randomly to another to release boundless and anarchic possibilities. Amorphous forms become amorous, with metamorphosis everywhere apparent. Natural profusion has a spontaneous, out-of-control aspect, much as the subconscious imagines things that the inhibitions of the *id* cannot suppress. Thus nature and the waking world give evidence of a dreamscape, an irrational sphere in which the artist is willingly, even joyfully, engulfed.

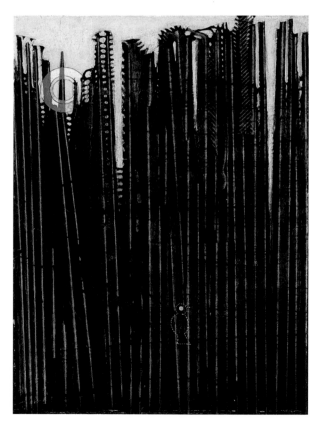

Fig. 18
Max Ernst
Forest, 1927

In Calder's nature-related work, too, there is at times an ecstatic plenitude presented on a large scale, and at other times an exquisite delicacy (pages 60–69). Interestingly, Calder rendered this theme through extraordinary linear displays, as if he were improvising. As he explained in relation to his mobiles, "I work upward, linking the parts together."[27] Likewise, Calder often created his organic works in an ascending fashion, the way growth occurs in nature.

By adding the dimension of movement, Calder literally animated his vision of the natural world. Jean-Paul Sartre, the existential philosopher-novelist, greatly enjoyed this quality in the mobiles, noting that the unexpected motion gives rise to "a little private celebration."[28] Sartre might as well have exclaimed "*merveilleux*," for the pure pleasure the unpredictable movement gives lies beyond reason. The Surreal Calder himself, in elaborating on the value of motion, says that it "avoids the connotation of ideas. . . . The aesthetic value of these [moving] objects cannot be arrived at by reasoning."[29] It is no doubt significant that on two of the occasions when Calder's work was represented in Surrealist publications, it was with a "mobile in motion" (fig. 26, page 88), photographed by Herbert Matter.[30]

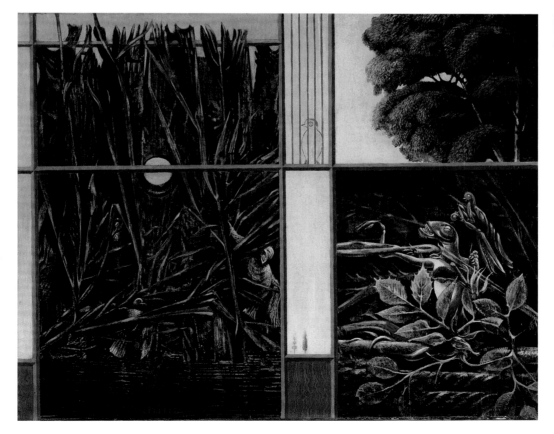

Fig. 19
Max Ernst
Painting for Young People, 1943

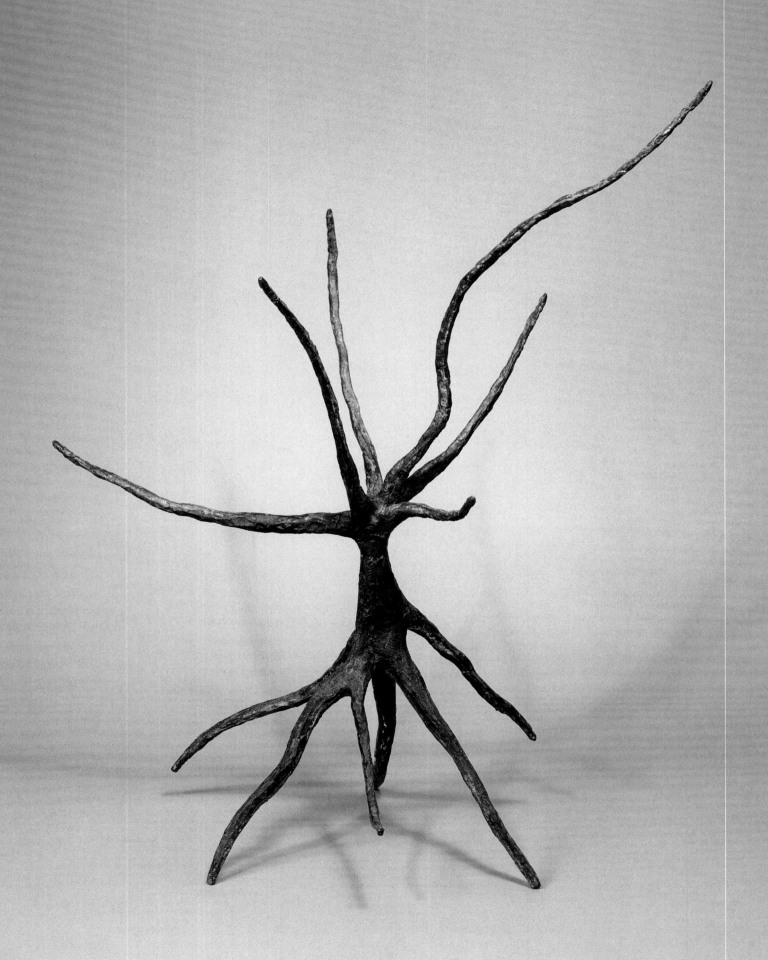

60 *The Snag,* 1944

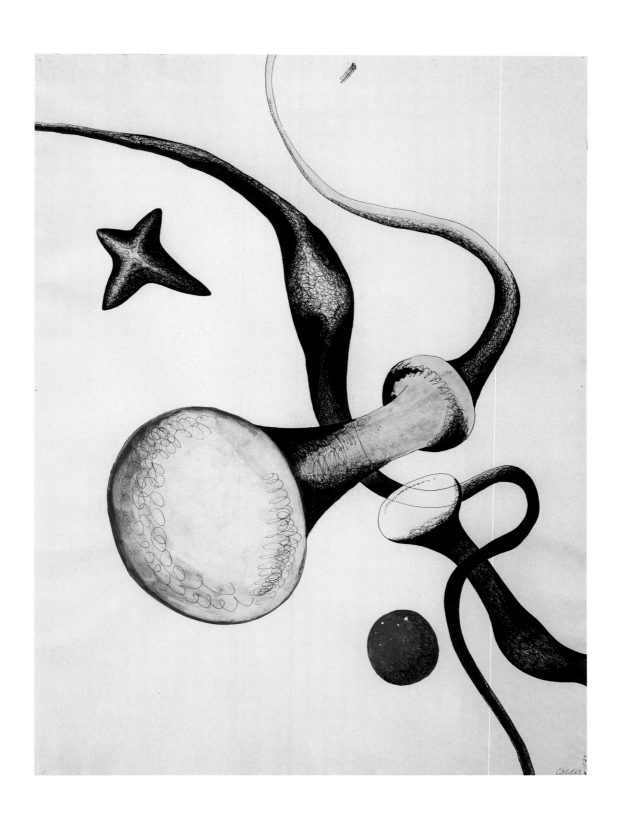

61 **Untitled, 1932**

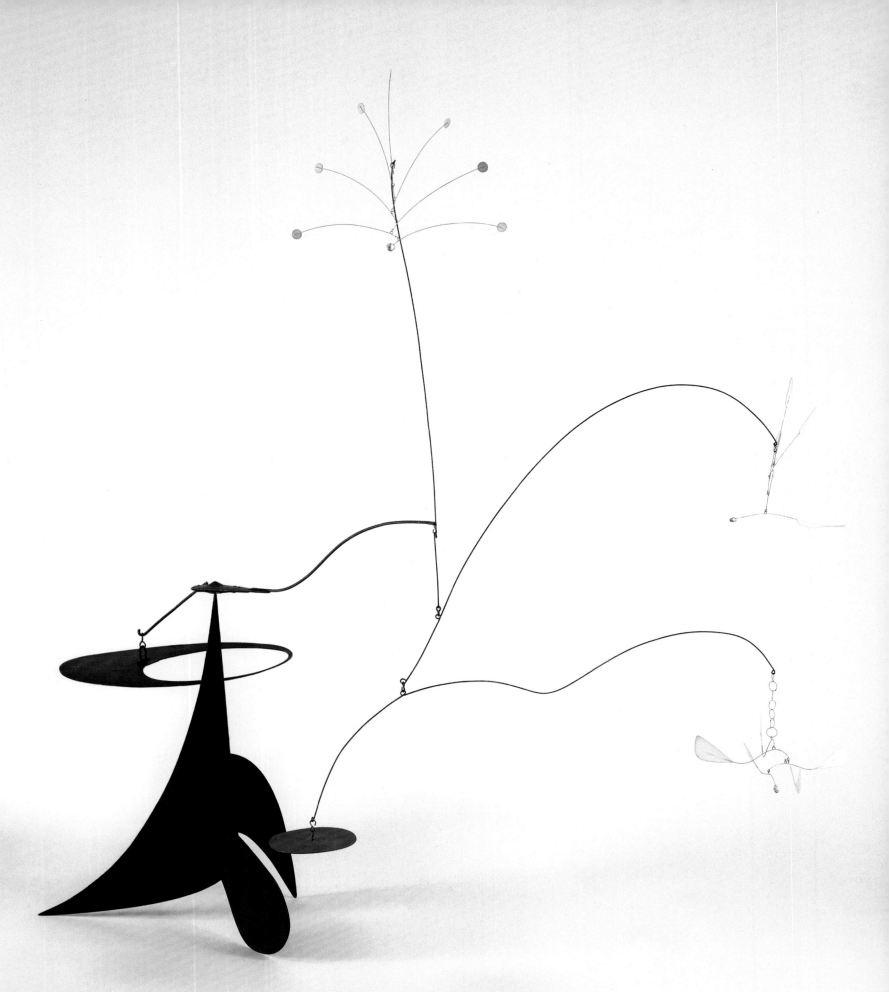

62 *Bougainvillier, 1947*

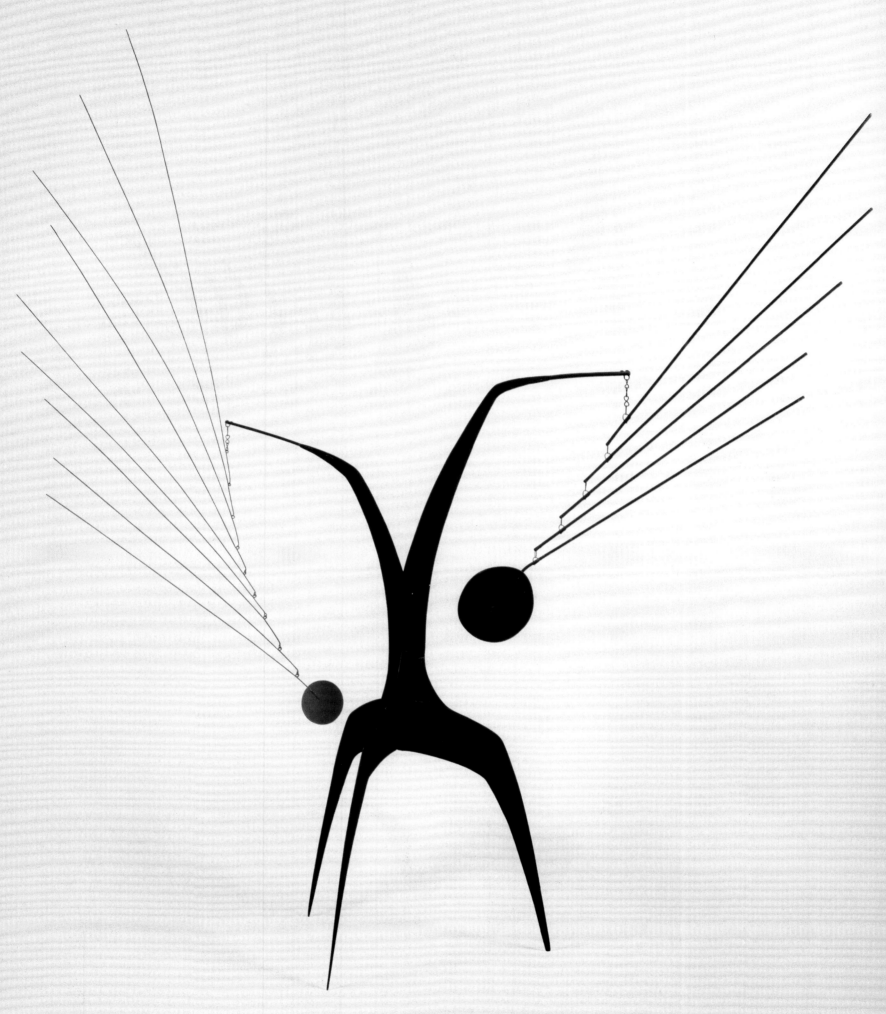

63 *Un effet du japonais*, 1941

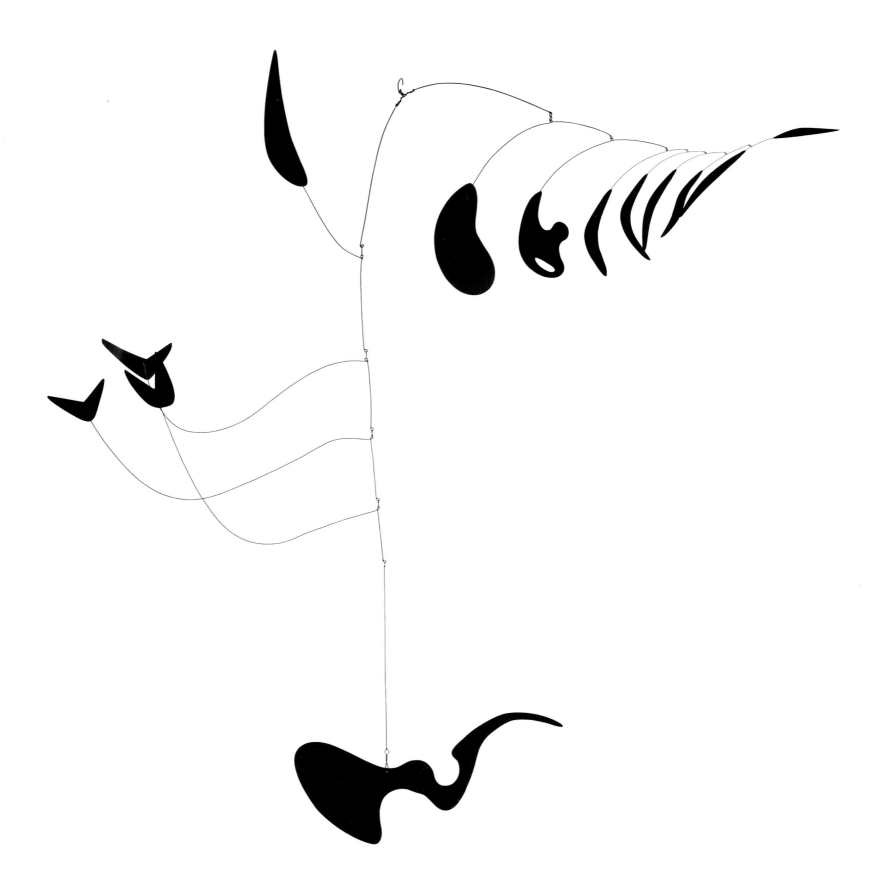

64 *Eucalyptus,* 1940

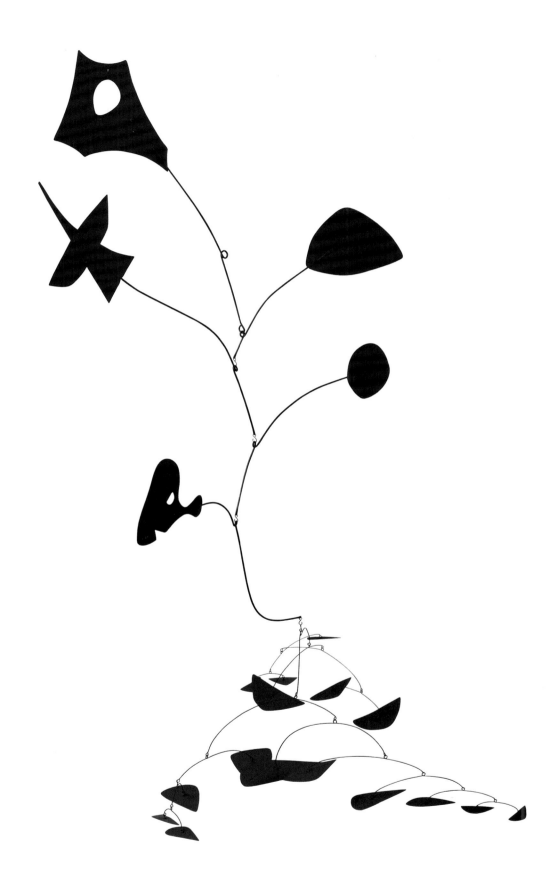

65 Untitled, 1945

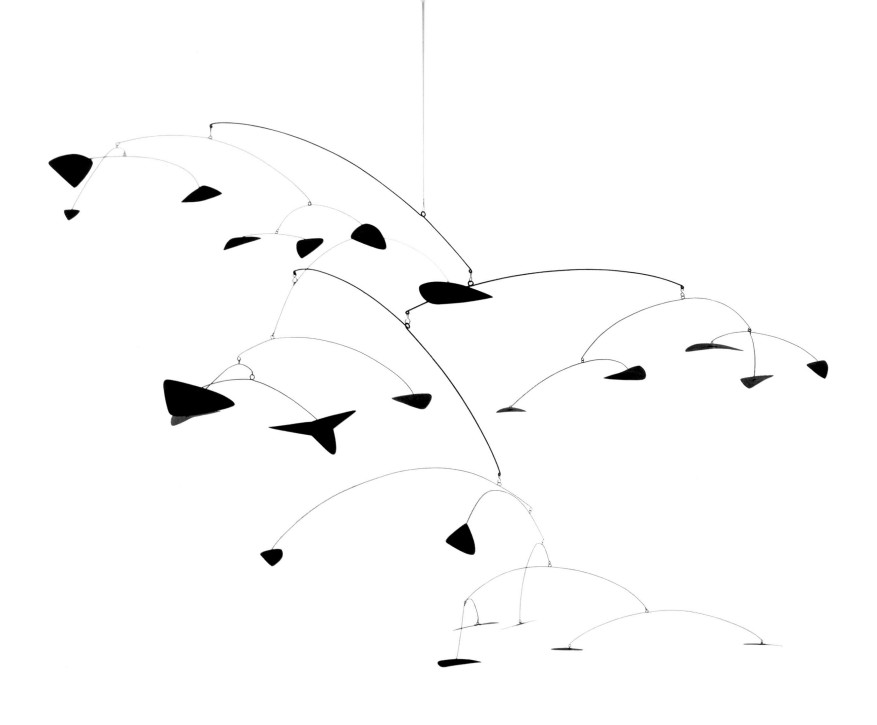

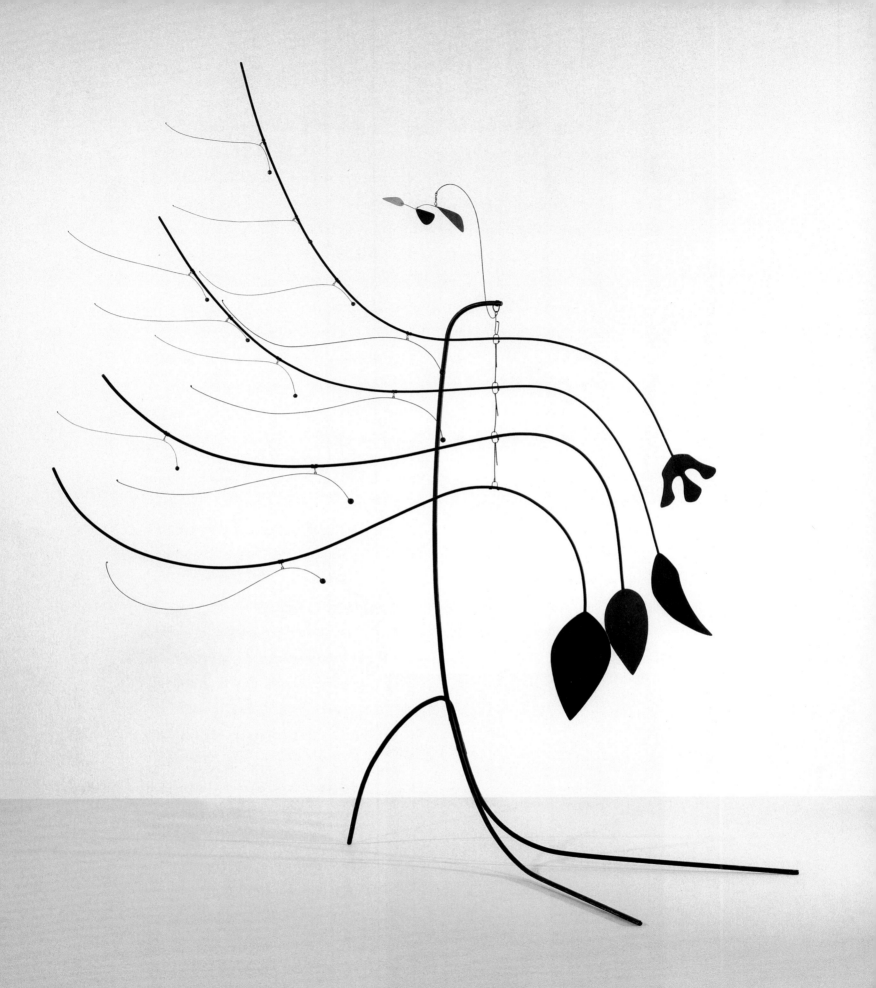

Finally, from the start of his mature career, Calder was deeply immersed in visions of the heavens or cosmos (pages 72–81). This idea goes back, according to him, to a point in his youth, in 1922, when he was on a steamship early in the morning off the coast of Guatemala: "I saw the beginning of a fiery red sunrise on one side and the moon looking like a silver coin on the other. Of the whole trip this impressed me most of all; it left me with a lasting sensation of the solar system."[31] Such an image had metaphoric and Surrealistic resonance—witness Desnos, who was part of Calder's "gang," mentioning in 1926 that he "sees" shooting stars and constellations.[32] The Surrealist poet Paul Éluard reported a kind of "double vision" with regard to reality, in which a slippage exists between conscious and unconscious states: "It should be possible to see day and night simultaneously, to capture in one glance the visual clarity of daylight and the visionary quality of night. . . . Such a moment in time represents Breton's idea of surreality."[33]

When Calder began making his mobiles, he was, in one sense, simply arranging the elements as "masses" moving in space. However, as if recalling his experience in Guatemala, he remarked that "the underlying sense of form in my work has been the system of the Universe."[34] Cosmos, constellations, and outer space all converge, as they did for Arp (fig. 4), Tanguy (fig. 20), and Miró (fig. 21). When Calder started a group of works related to this theme in 1943 (pages 82–86), the solar system was his primary concern, in contrast to Miró in his Constellation series of 1940–41

(fig. 22), where one discovers an intermingling of erotic profusion and intimations of war. While Calder's precarious constellations evoke the heavens in constant motion, Miró's concern human tenuousness. Calder again sought a title for this series from Duchamp, who, with Calder's friend Sweeney, recommended Constellations. Reflecting the convergence of ideas among artists, Pierre Matisse chose to complement Calder's Constellations with works by Tanguy in a 1943 exhibition in New York.

Fig. 20
Yves Tanguy
There! (The Evening Before), 1927
(opposite page)

Fig. 21
Joan Miró
Painting (The Magic of Color), 1930
(top)

Fig. 22
Joan Miró
Constellation: Awakening in the Early Morning, 1941
(bottom)

With the Constellations, Calder is perhaps at his closest to abstractionists such as Vasily Kandinsky, El Lissitzky, and Mondrian, for whom the pure order of the heavens was a model for the formal relationships that might be found on earth. This strain of work provides a fascinating point of intersection between the avowed abstractionists and the professed Surrealists. The theme that interested the abstractionists for its transcendental aspects appealed to the Surrealists for its evocation of metamorphosis, change, and infinite possibility.

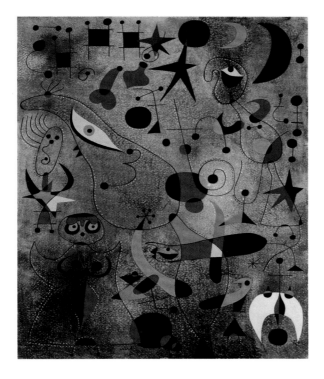

72 **Untitled, 1930**

73 *Croisière*, 1931

74 **Untitled, 1932**

76 **Untitled, 1932**

77 *The Planet,* 1933

78 *Black Frame,* 1934

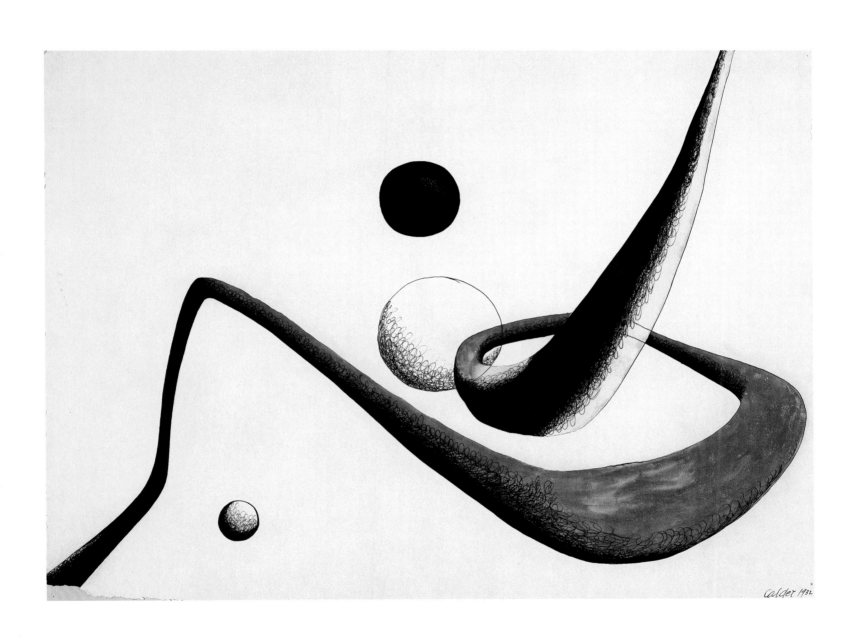

79 *Space Tunnel,* 1932

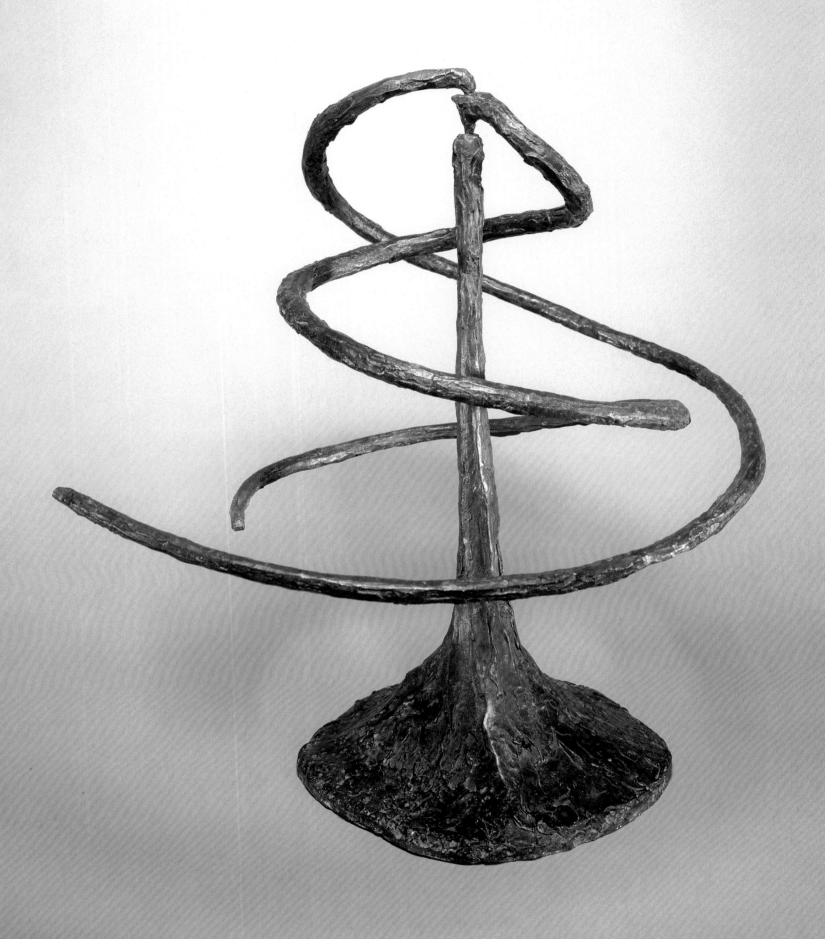

80 *Double Helix,* 1944

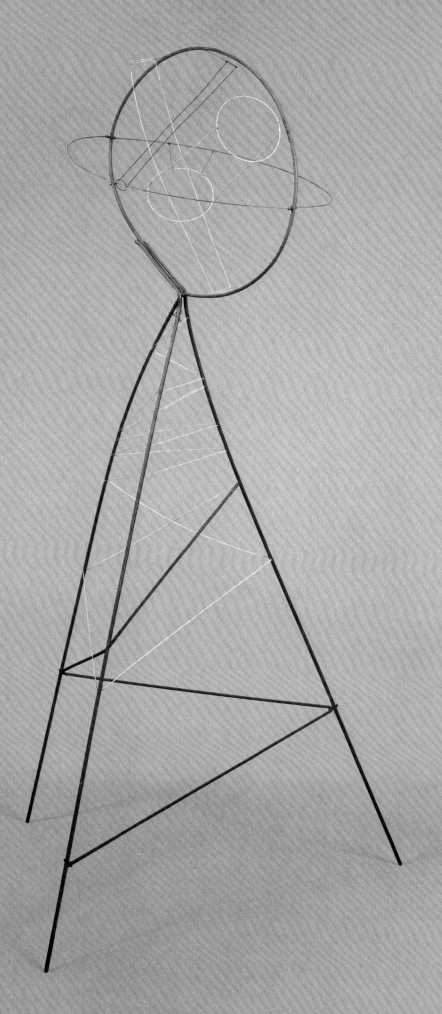

81 *Sphere Pierced by Cylinders,* 1939

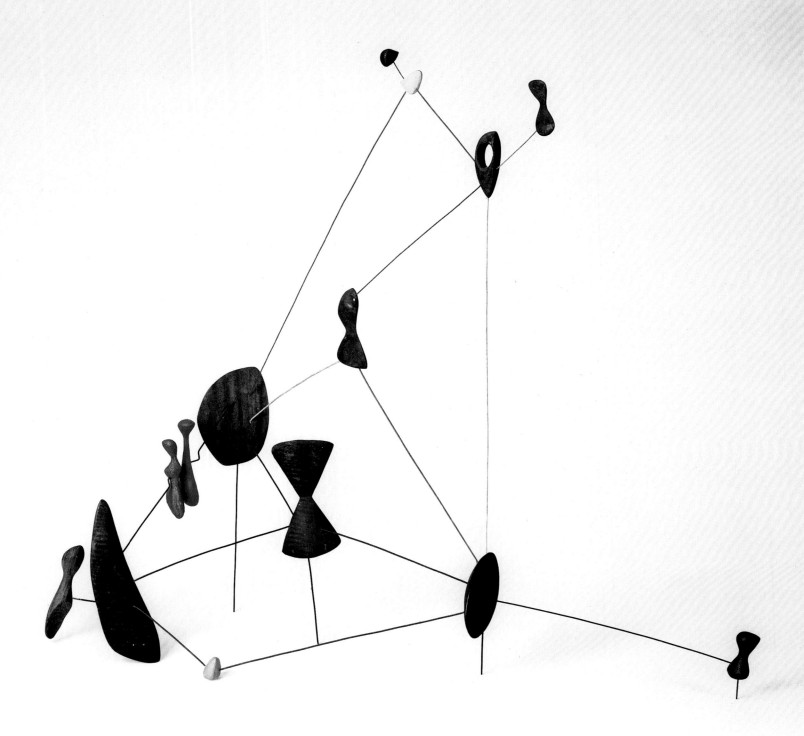

82 *Constellation,* 1943

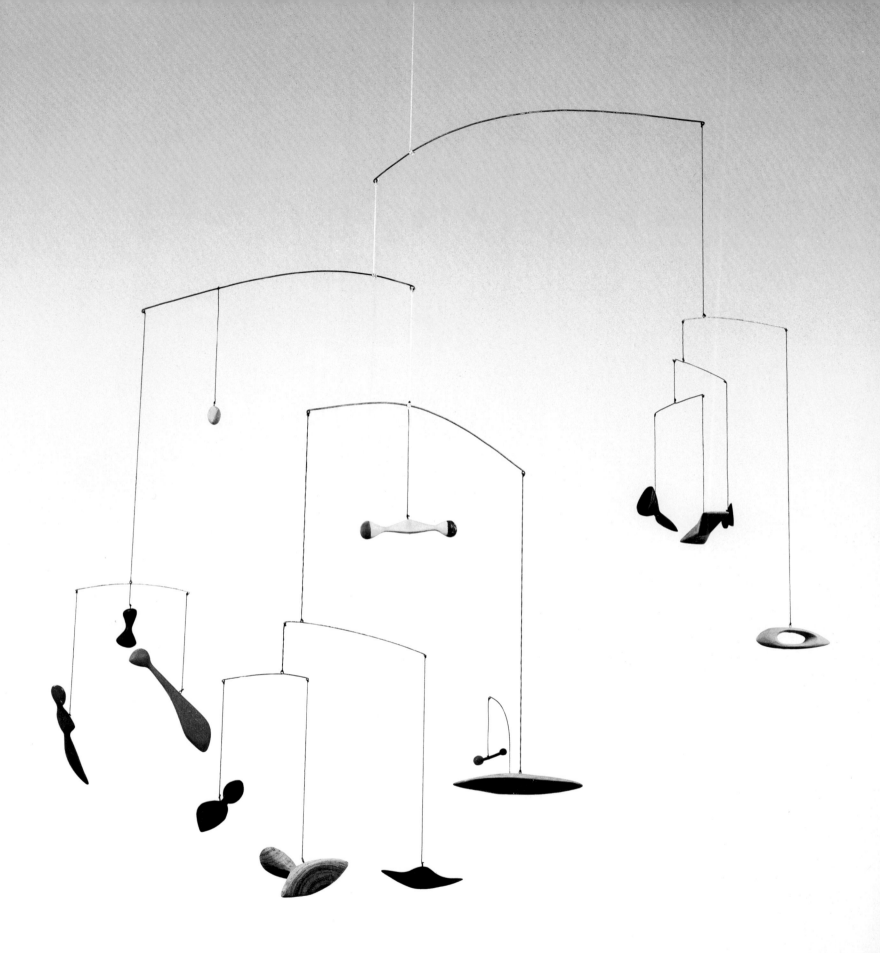

83 *Constellation Mobile,* 1943

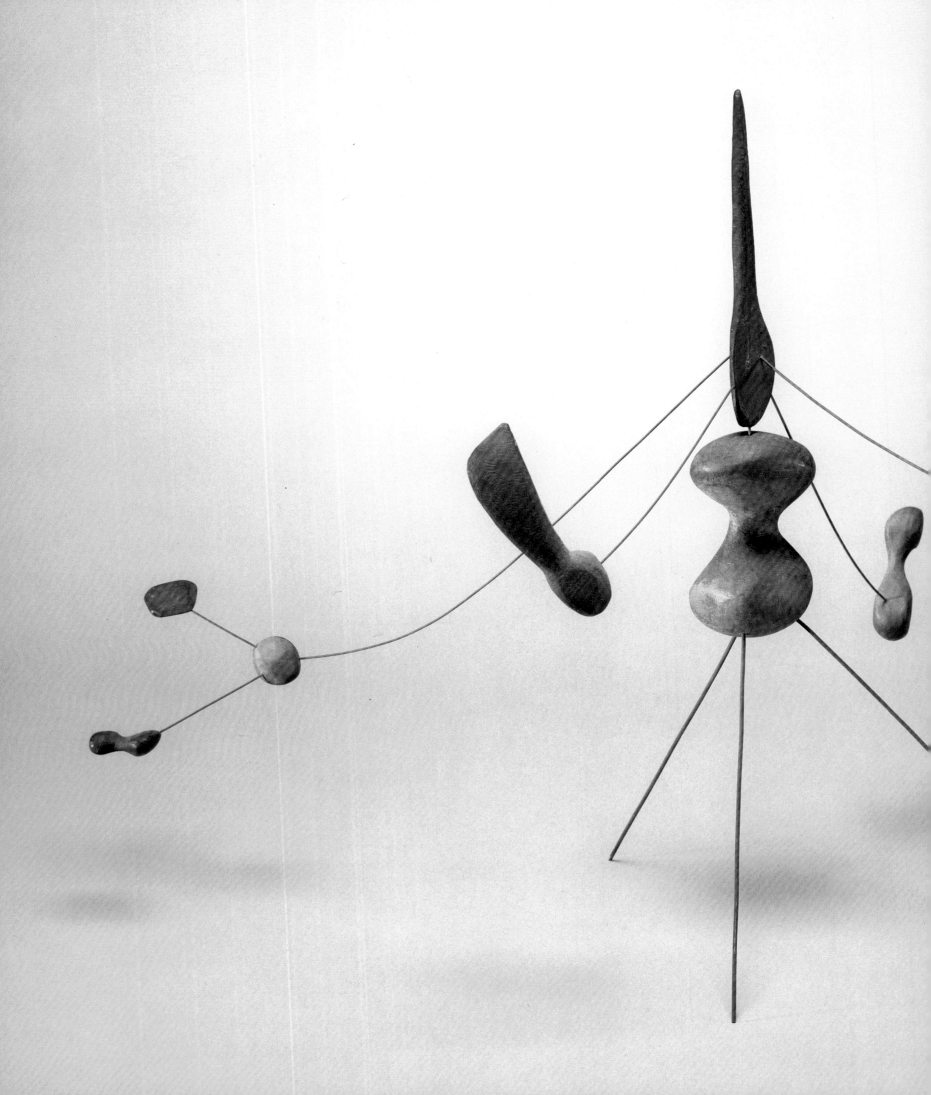

85 *Constellation,* ca. 1942

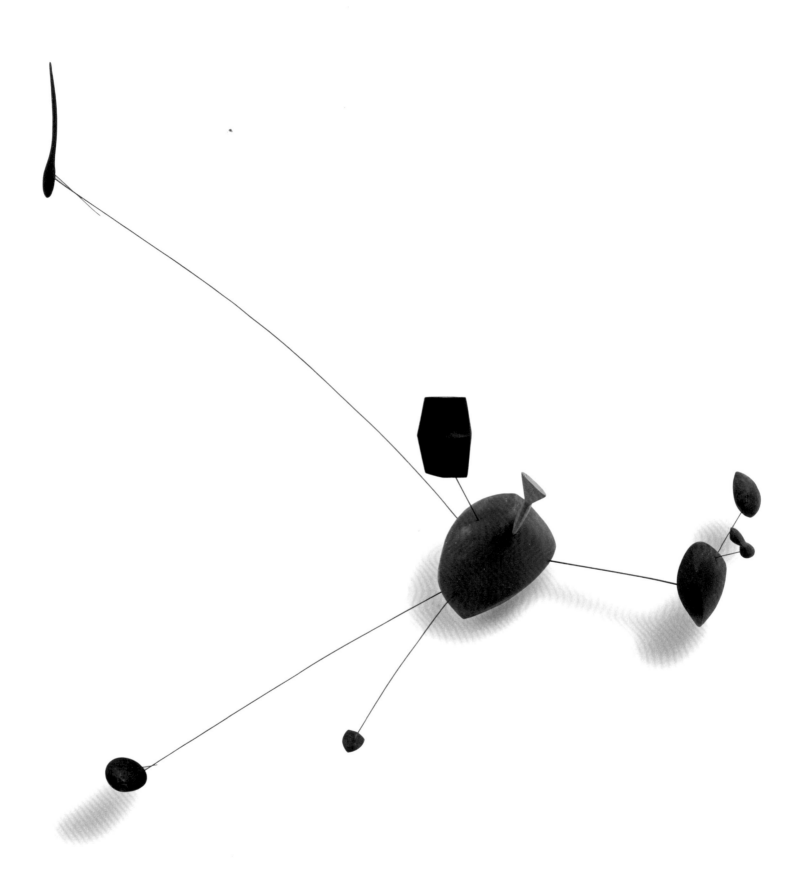

The "parentage" of Calder's art—Miró and Mondrian—not only joins him to the abstract branch of Surrealism but also signals his resolution of seemingly opposing aesthetic camps in the period between the two world wars. He was not alone in this regard: Arp, Jean Hélion, and Klee come to mind too. Calder sought an aesthetic "third way" that enabled him to gain from these major advances and, more importantly, contribute to their achievements. On the one hand, his interests converged with Surrealist themes of wit, exotic creatures, and extravagant displays of nature; moreover, he took the Surrealist Object and transformed it into a personage. On the other hand, his focus on heavenly constellations coincided with characteristic images of abstraction, to which he added his own interpretation.

Though seemingly linked equally to abstraction and Surrealism—the movements—it was to the latter camp that Calder seemed more naturally to belong. The "Surrealist Objects" exhibition of 1936 was the first time he actually showed with the group. Although it is not known what he presented there except that it was a mobile, a wide range of Surrealist and closely associated sculpture was on view, including Duchamp's readymade *Bottlerack* (1914, original lost) and assisted readymade *Why Not Sneeze Rrose Sélavy?* (1921, Philadelphia Museum of Art); Picasso's *Le Verre d'absinthe* (*Glass of Absinthe*, fig. 23); Ernst's *Habakuk* (1934, Max Ernst Museum, Brühl) and *Les Asperges de la lune* (*Lunar Asparagus*, fig. 24); Meret Oppenheim's *Déjeuner en fourrure* (*Fur Breakfast*, 1935, The Museum of Modern Art, New York); Magritte's *Ceci est un morceau de fromage* (*This Is a Piece of Cheese*, fig. 10); Dalí's *Téléphone–Homard* (*Lobster Telephone*, fig. 14); and Miró's *Object* (fig. 12). If one were to complete the survey of Surrealist sculpture, one might add an evocative abstraction by Arp (fig. 25) and Giacometti's *Table surréaliste* (*The Surrealist Table*, fig. 13). With this group of objects it is apparent that, as in painting, there are many Surrealisms to behold, from the nearly abstract to the representational, from the ephemeral

Fig. 23
Pablo Picasso
Glass of Absinthe, 1914

Fig. 24
Max Ernst
Lunar Asparagus, 1935

Fig. 25
Jean Arp
Case for a Da, 1920–21

to the permanent, from the disturbing to the witty, from the ready-made to the assembled, and from modified reality to sheer fantasy. Where does Calder fit?

The Surrealist vision of sculpture is flexible, and Calder, by embracing a number of Surrealist themes, participated in the artistic preoccupations of the movement and expanded its elastic approach. What he perhaps chiefly brought to Surrealist sculpture, his singular contribution to the *merveilleux*, was the surprise and pleasure of movement.[35] Leaving the final form of a work of art to the chance effects of air demonstrates a particularly Surrealist sensibility, while distinguishing Calder from the weighty gravity of other artists and giving evidence of his unique *élan vital*.

Fig. 26
Herbert Matter
Untitled [set in motion],
1936

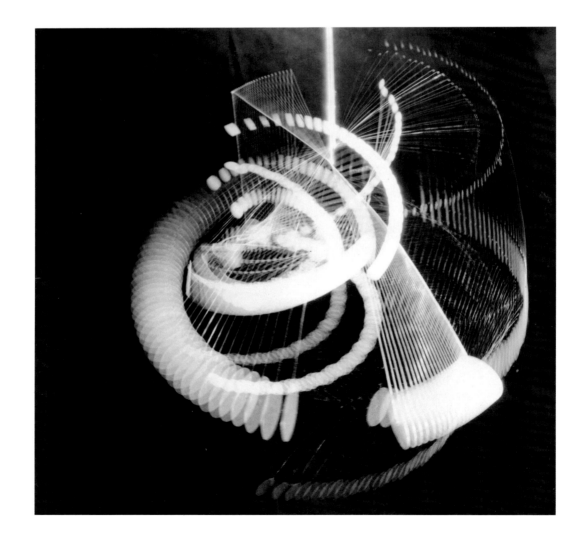

ENDNOTES

1 Calder to Sweeney, courtesy Calder Foundation archives.

2 Alexander Calder, *Calder: An Autobiography with Pictures* (New York: Pantheon Books, 1966), 112.

3 Quoted in Marla Prather, et al., *Alexander Calder: 1898–1976*, exh. cat. (Washington: National Gallery of Art, 1998), 70; from the introduction to *Alexander Calder. Volumes–Vecteurs–Densités. Dessins–Portraits*, trans. Mánus Sweeney, exh. cat. (Paris: Galerie Percier, 1932), unpag.

4 Elizabeth Hutton Turner and Oliver Wick, eds., *Calder, Miró*, exh. cat. (Riehen/Basel and Washington, D.C.: Fondation Beyeler and Phillips Collection, 2004), 284, 287.

5 André Breton, "Artistic Genesis and Perspective of Surrealism," in Breton, *Surrealism and Painting*, trans. Simon Watson Taylor (New York: Harper & Row, 1972), 71–72.

6 Anna Balakian, *André Breton: Magus of Surrealism* (New York: Oxford University Press, 1971), 256.

7 Turner and Wick, *Calder, Miró*, 284.

8 Julien Levy, *Surrealism* (New York: Black Sun Press, 1936), 28. Twelve years later, there was still a question of Calder's allegiances. See Gabrielle Buffet, "Sandy Calder, forgeron lunaire," *Cahiers d'art* 20–21 (1945–46), 324.

9 Calder, *Autobiography*, 99.

10 Gérard Durozoi, *History of the Surrealist Movement*, trans. Alison Anderson (Chicago: University of Chicago Press, 2002), 405.

11 Mark Stevens and Annalyn Swan, *De Kooning: An American Master* (New York: Alfred A. Knopf, 2004), 207. See also *Surrealism and Its Affinities: The Mary Reynolds Collection*, exh. cat. (Chicago: Art Institute of Chicago, 1956), bookplate.

12 See Maurice Nadeau, *The History of Surrealism*, trans. Richard Howard (New York: Macmillan, 1965), 139; see also *André Breton*, exh. cat. (Paris: Centre Georges Pompidou, 1991), 185, 188; Balakian, *Magus*, 26.

13 Quoted in Carmen Giménez and Alexander S. C. Rower, *Calder: Gravity and Grace*, exh. cat. (Bilbao: Museo Guggenheim, 2003), 90.

14 William Rubin, *Dada, Surrealism, and Their Heritage*, exh. cat. (New York: Museum of Modern Art, 1968), 64.

15 Paul Klee, "The Creative Credo" (1920), reproduced in Jürg Spiller, ed., *The Thinking Eye: The Notebooks of Paul Klee*, vol. 1, trans. Ralph Manheim (New York: George Wittenborn, 1961).

16 Nadeau, *History of Surrealism*, 201. See also André Breton, "Le Merveilleux contre le mystère, à propos du symbolisme," *Minotaure*, ser. 2, no. 9 (1936), 25–31. For just a few other uses of the *merveilleux* by Breton, see Werner Spies, *La Révolution surréaliste*, exh. cat. (Paris: Centre Georges Pompidou, 2002), 54, 63, 70, 88, 93.

17 Breton, "Artistic Genesis," 71–72.

18 Balakian, *Magus of Surrealism*, 116.

19 Breton, "Artistic Genesis," 70; one wonders whether this was a moment when Breton was inspired by a desire to excommunicate the nonconforming Miró.

20 Ibid., 130.

21 See Durozoi, *History*, 224–30.

22 Calder, *Autobiography*, 92.

23 Quoted in Eric M. Zafran, *Calder in Connecticut*, exh. cat. (Hartford: Wadsworth Atheneum, 2000), 86.

24 James Johnson Sweeney, *Alexander Calder: Sculptures and Constructions*, exh. cat. (New York: Museum of Modern Art, 1943), 33.

25 Breton, "André Masson: The Magical Eloquence of André Masson," in *Surrealism and Painting*, 164. See also *André Breton. La Beauté convulsive*, exh. cat. (Paris: Centre Georges Pompidou, 1991).

26 Quoted in John Russell, *Max Ernst: Life and Work* (New York: Harry N. Abrams, 1967), 112; trans. from the original text in *Minotaure*, no. 5 (May 1934).

27 Quoted in Richard D. Marshall, *Alexander Calder: Poetry in Motion*, exh. cat. (Seoul: Kukje Gallery, 2003), 34.

28 Jean-Paul Sartre, "The Mobiles of Calder," *Recent Work by Alexander Calder*, exh. cat. (New York: Buchholz Gallery/Curt Valentin, 1944), 47.

29 *Modern Painting and Sculpture*, exh. cat. (Pittsfield: Berkshire Museum, 1933), 25.

30 The Coordinating Council of French Relief, *First Papers of Surrealism*, exh. cat. (New York: Whitelaw Reid Mansion, 1942), unpag.; Breton and Duchamp, *Le Surréalisme en 1947*, exh. cat. (Paris: Galerie Maeght, 1947), 12.

31 Calder, *Autobiography*, 54–55. In 1944, referring to a flight over the Amazon River, Calder observed that "the moon shone in spots from overhead on the river and cut out great black islands of different shapes It was stunning." Ibid., 199.

32 Cited in Jennifer Mundy, ed., *Surrealism: Desire Unbound*, exh. cat. (London: Tate, 2001), 102.

33 Ibid., 101–2.

34 Giménez and Rower, *Gravity and Grace*, 51–52.

35 In a 1950 text on Calder's mobiles, Duchamp wrote: "A light breeze, an electric motor or both in the form of an electric fan start in motion weights, counterweights, levers which design in mid air their unpredictable arabesques and introduce an element of lasting surprise." Reproduced in Eleanor S. Apter et al., *The Société Anonyme and the Dreier Bequest at Yale University: A Catalogue Raisonné* (New Haven and London: Yale University Press, 1984), from "Thirty-three Critical Notes," in Katherine S. Dreier, Marcel Duchamp, and George Heard Hamilton, ed., *Collection of the Société Anonyme: Museum of Modern Art 1920*, exh. cat. (New Haven: Yale University Art Gallery, 1950).

Calder by Matter

Some of the most vivid photographs of Alexander Calder were those taken by Swiss graphic designer Herbert Matter (1907–1984), who for many years was one of Calder's closest friends. Matter pursued photography in the late twenties and early thirties in Paris, while studying painting at the Académie Moderne under Fernand Léger and Amédée Ozenfant. Inspired by Man Ray and El Lissitzky, he mastered the experimental photographic techniques of photogram, collage, and montage. In 1929 he was hired by the legendary type foundry Deberny et Peignot as a photographer and designer, and worked with the graphic designer A. M. Cassandre and architect Le Corbusier.

After moving to Zurich in 1932, Matter applied his extensive education in photomontage and typography to advertisements for the Swiss National Tourist Office, which established his international reputation as an expert graphic designer. In 1936 he emigrated to the United States, and over the course of five decades he worked as a head designer for Knoll, Inc., a professor at Yale University (where he taught photography and design for some thirty years), and a design consultant for the Solomon R. Guggenheim Museum and the Museum of Fine Arts, Houston.

After settling in New York, Matter photographed Calder frequently in intimate settings, namely his Roxbury and New York studios. By incorporating theatrical elements such as frames and spotlights, Matter captured a world at once eerie and playful. Many of the photographs taken in the New York studio depict a haunting world where shadows seemingly engulf Calder and create an ominous atmosphere of irrational origin. Using the camera as an imaginative and descriptive tool, Matter assumed the role of both spectator and participant. Interestingly, Matter's first cinematic attempt was for *Alexander Calder: Sculpture and Constructions*, a 1944 film based on the Museum of Modern Art retrospective; in 1951 he directed and filmed *Works of Calder*, which explores the imaginary vision of nature both seen and heard through Calder's mobiles.

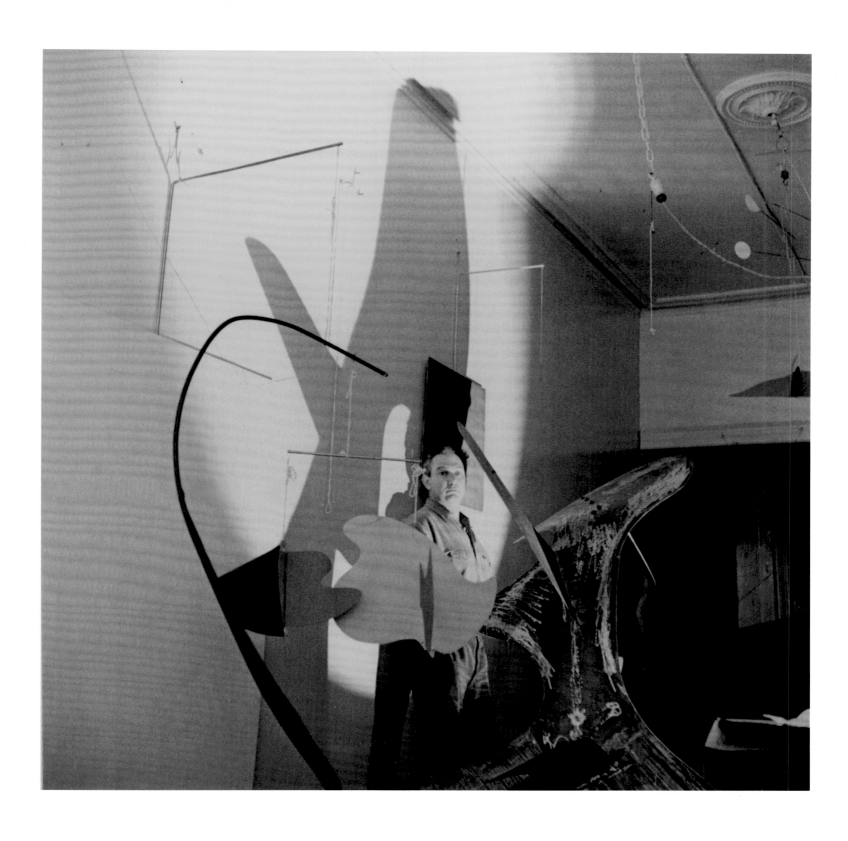

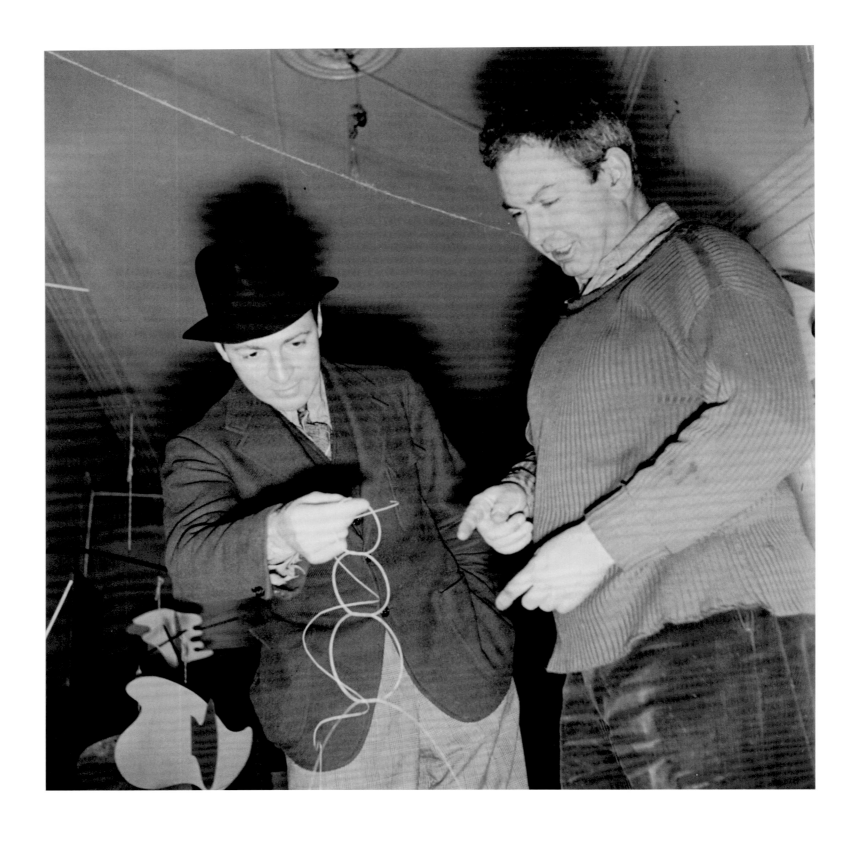

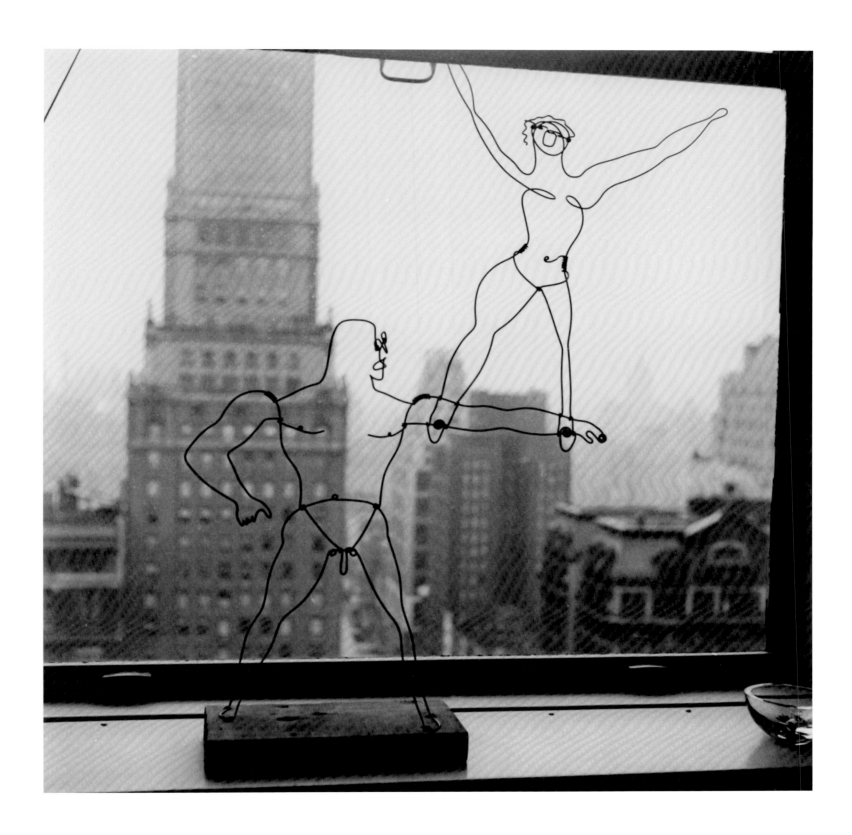

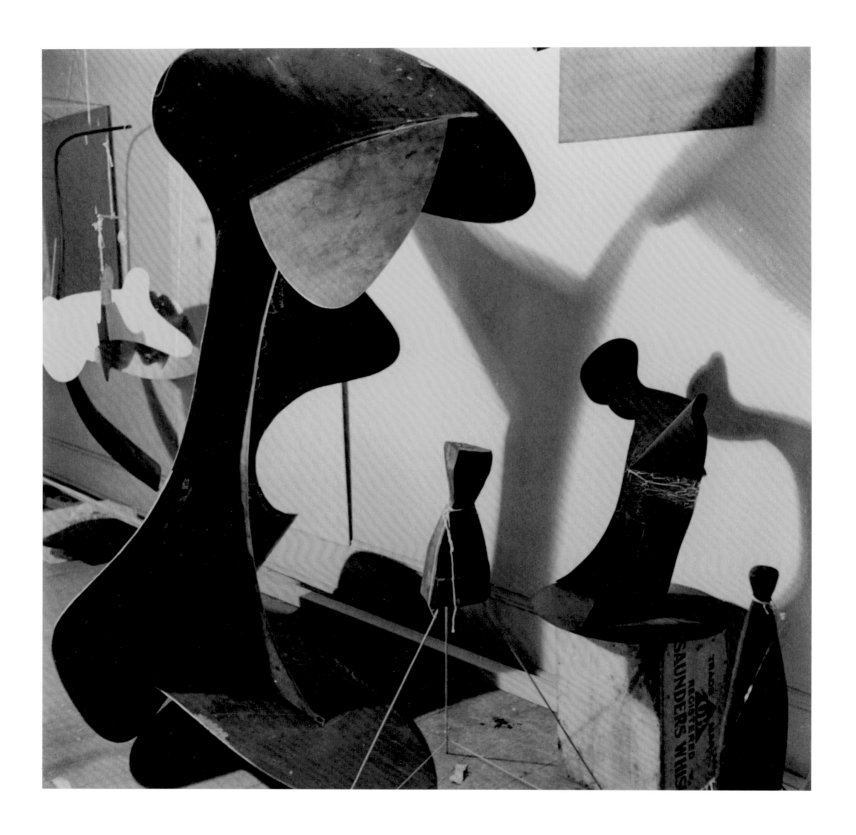

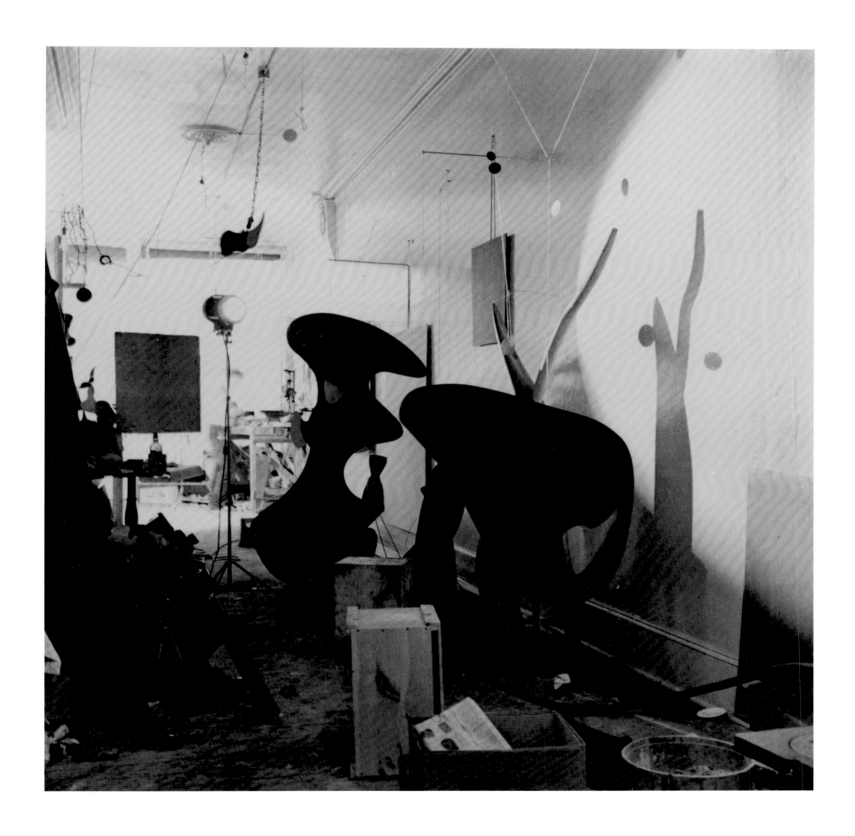

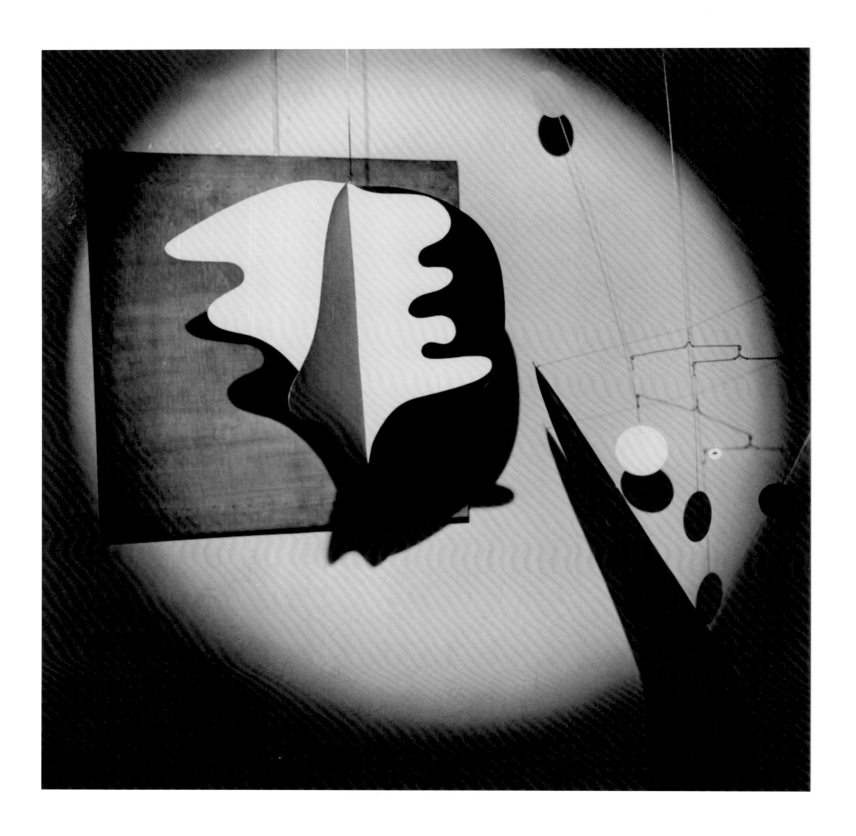

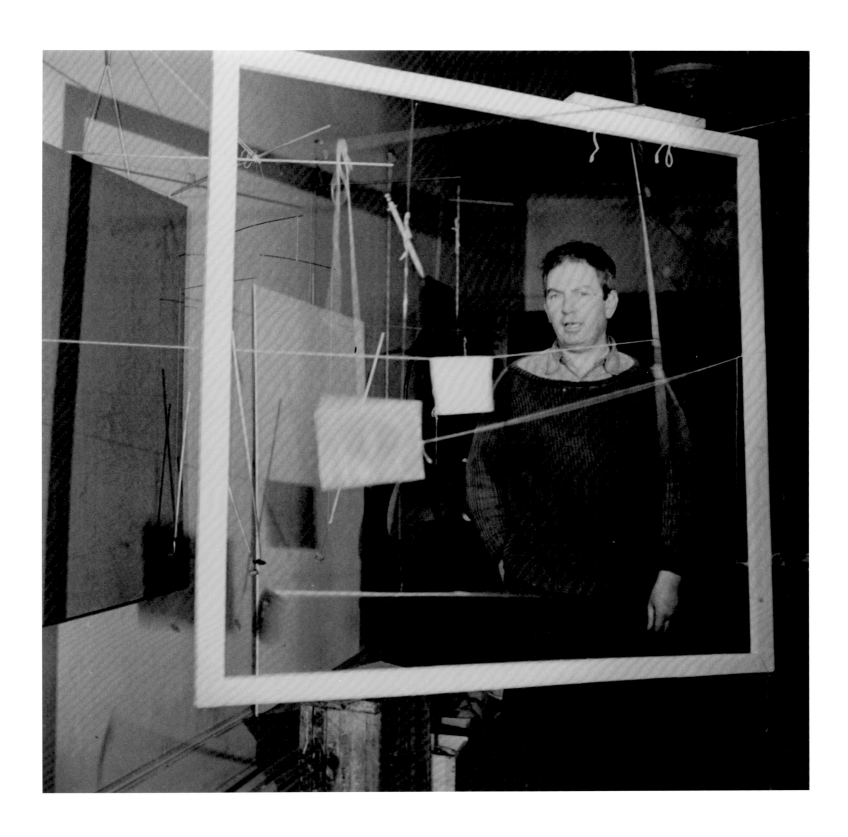

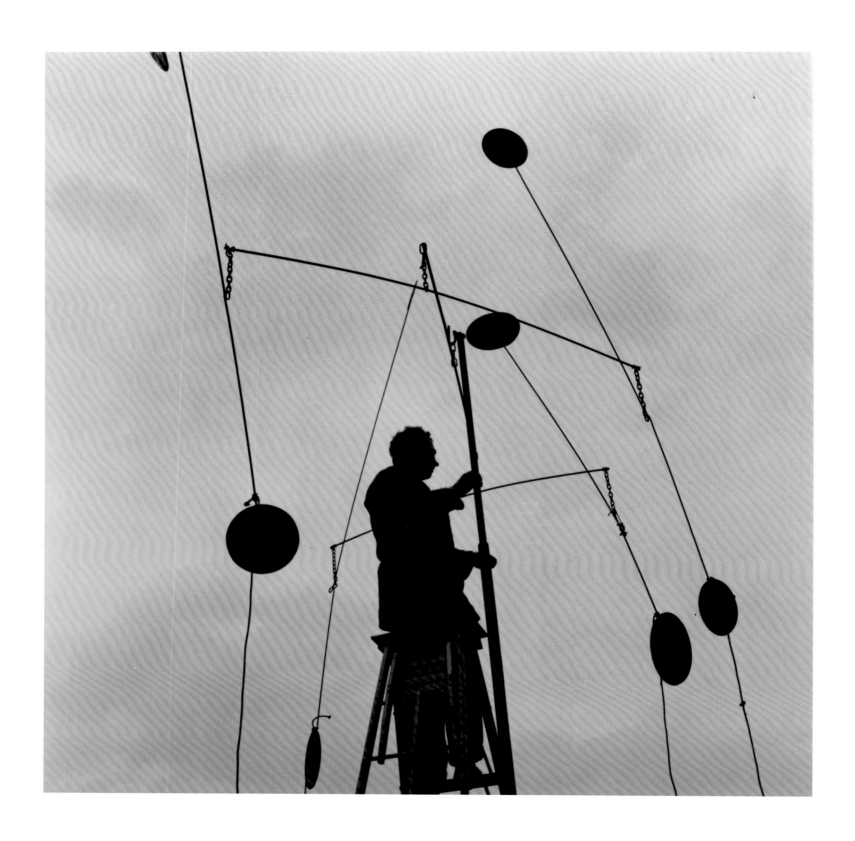

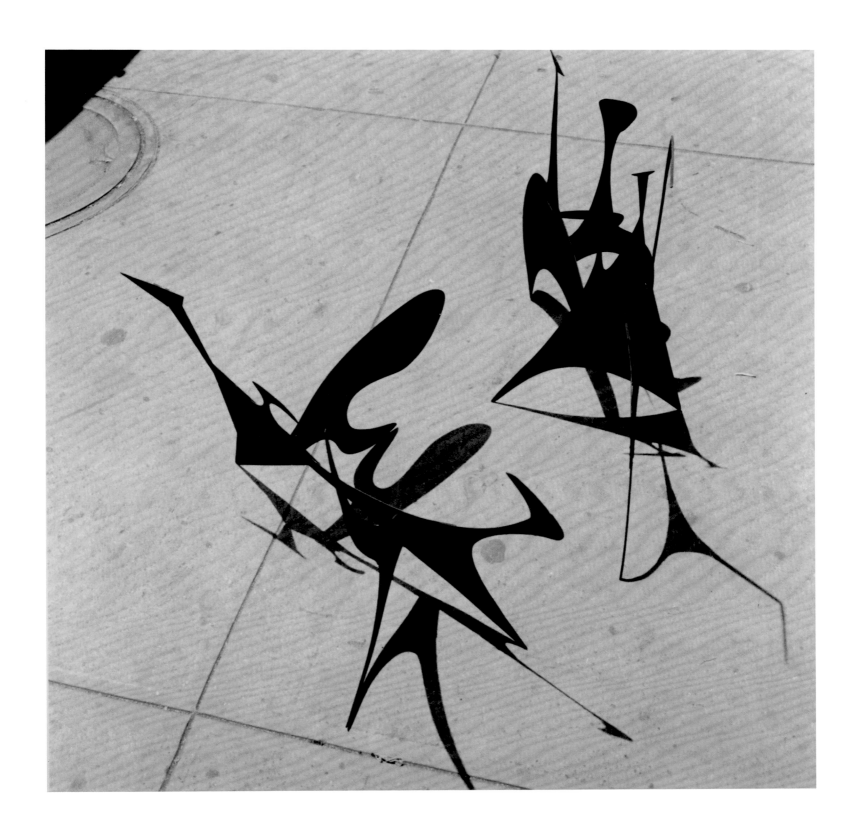

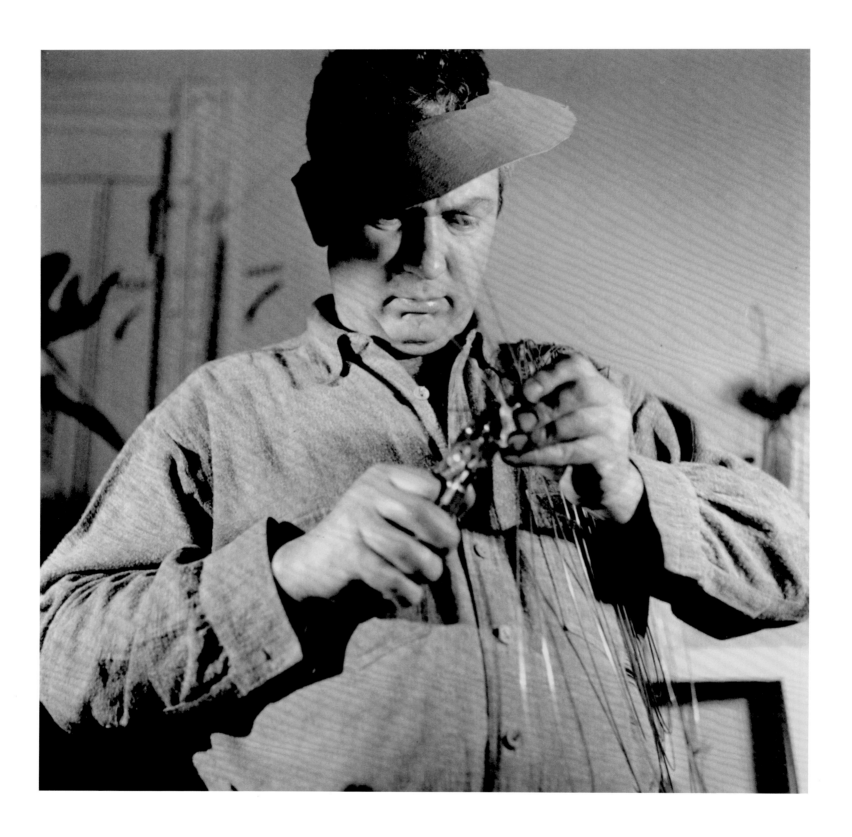

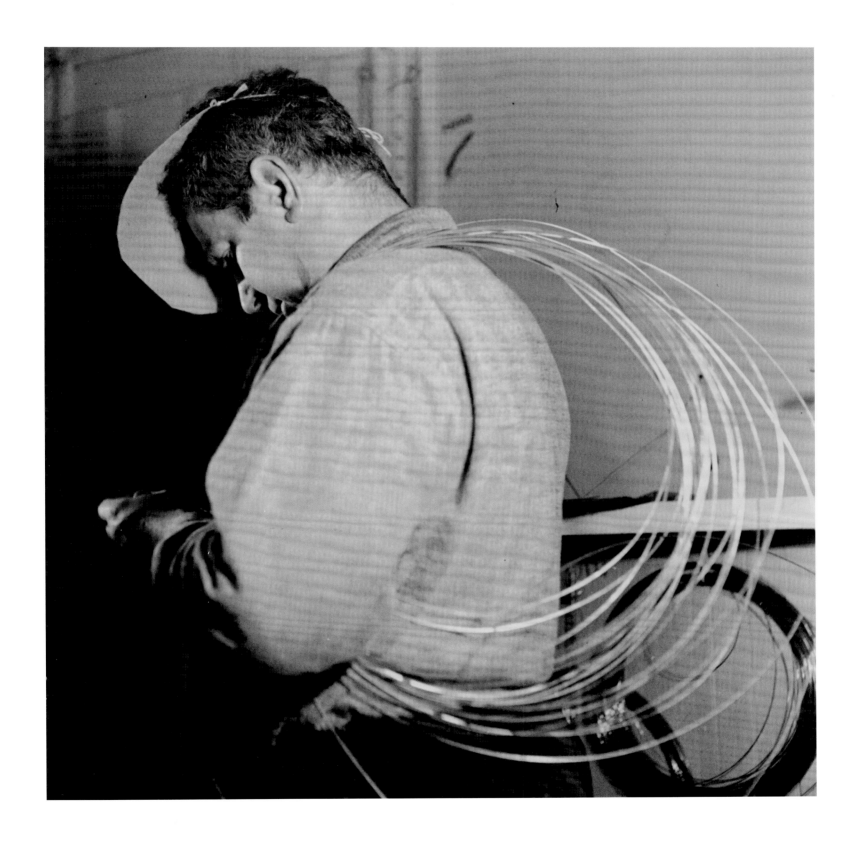

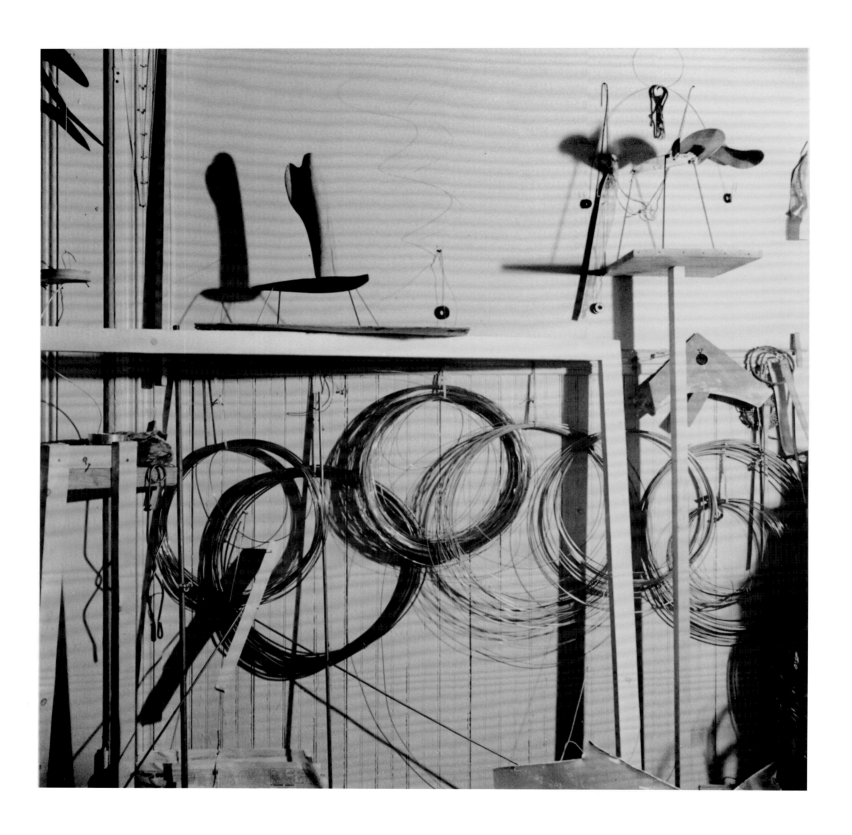

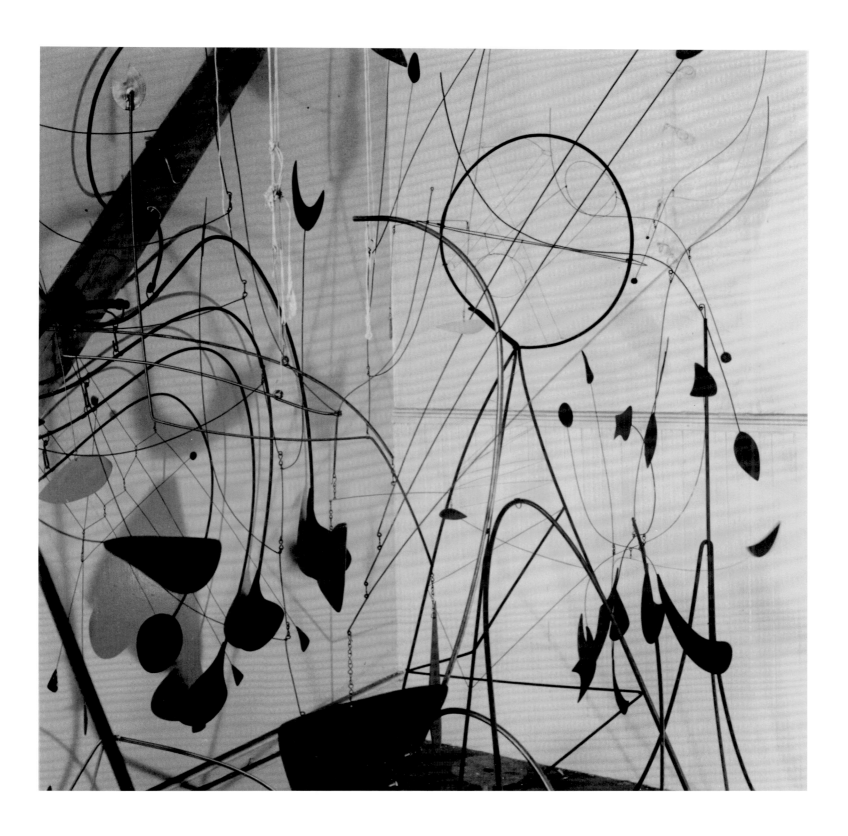

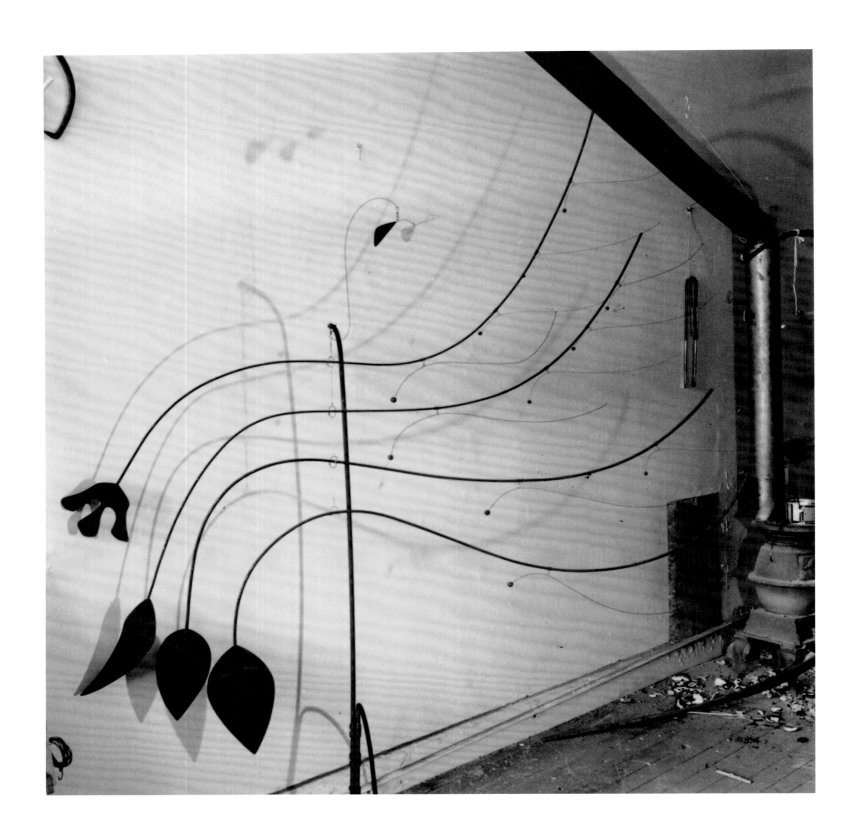

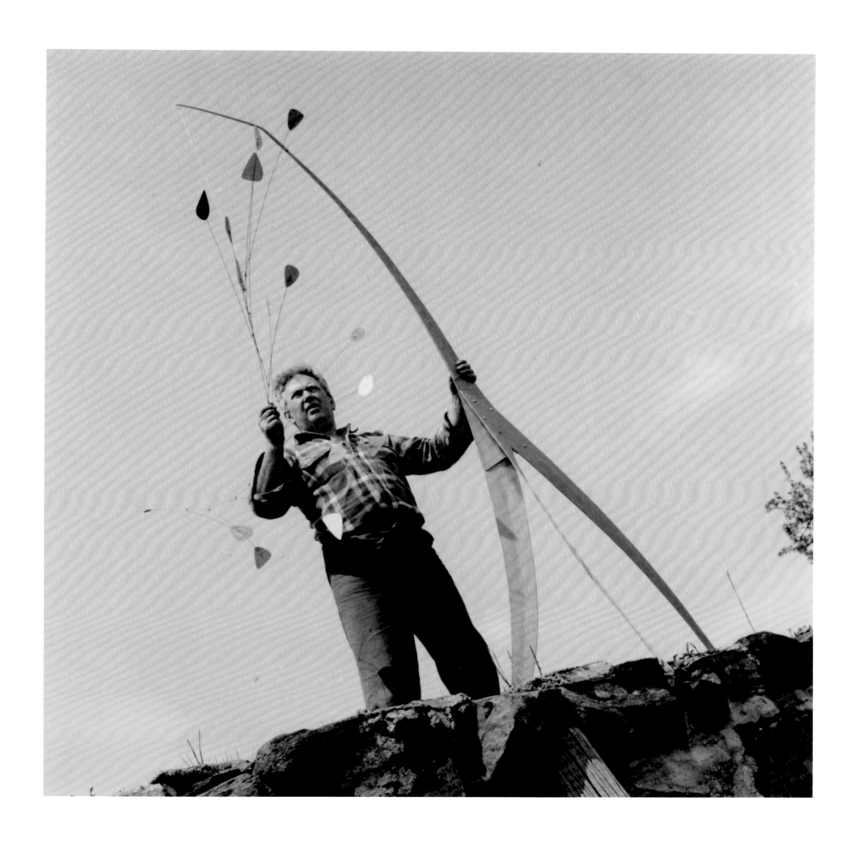

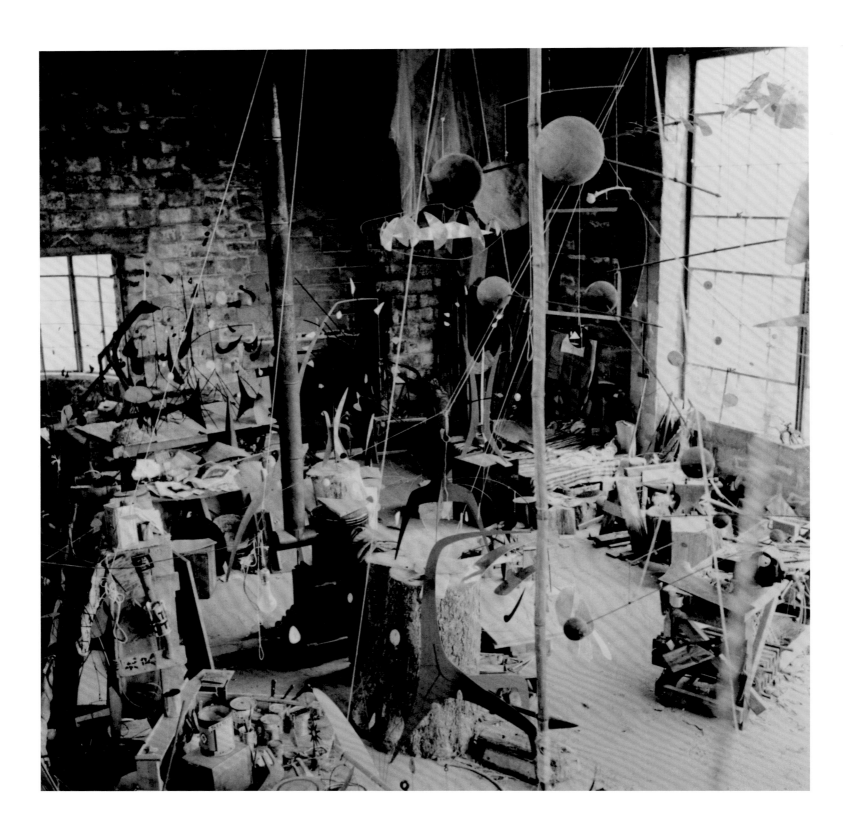

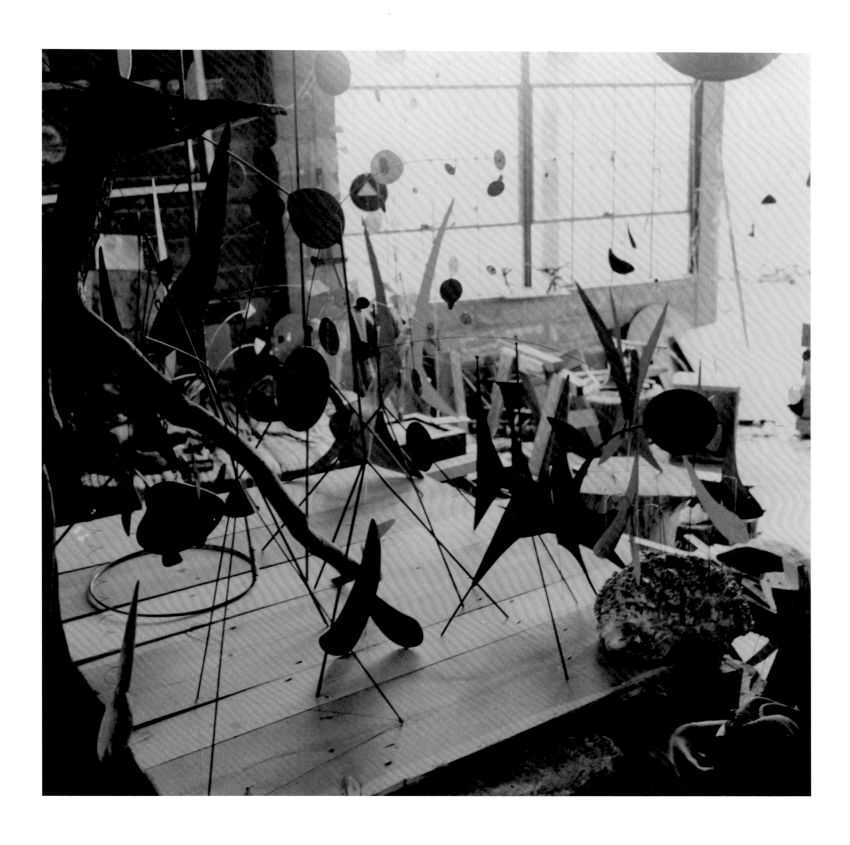

The Surrealist Years: 1926–1947

Alexander S. C. Rower

Portrait of Calder, ca. 1930. Photograph by Man Ray

Alexander Calder is born on July 22, 1898, in Lawnton, Pennsylvania, the second child of artist parents—his father is a sculptor and his mother a painter. Because his father Alexander Stirling Calder receives public commissions, the family traverses the country throughout Calder's childhood. Calder is encouraged to create, and from the age of eight he always has his own workshop wherever the family lives. For Christmas in 1909, Calder presents his parents with two of his first sculptures, a tiny dog and duck cut from a brass sheet and bent into formation. The duck is kinetic—it rocks back and forth when tapped. Even at age eleven, his facility in handling materials is apparent.

Despite his talents, Calder does not originally set out to become an artist. He instead enrolls at the Stevens Institute of Technology after high school and graduates in 1919 with an engineering degree. Calder works for several years after graduation at various jobs; he is a hydraulics engineer and automotive engineer, timekeeper in a logging camp, and fireman in a ship's boiler room. While serving in the latter occupation, on a ship from New York bound for San Francisco, Calder wakes up on deck to see both a brilliant sunrise and a scintillating full moon, each visible on opposite horizons (the ship then lay off the Guatemalan coast). The experience makes a lasting impression on Calder: he refers to it throughout his life.

Calder commits to becoming an artist shortly thereafter, and in 1923 he moves to New York and enrolls at the Art Students League. He also takes a job illustrating for the National Police Gazette, which sends him to the Ringling Brothers and Barnum & Bailey Circus to sketch circus scenes for two weeks in 1925, giving rise to his fascination with the circus as a subject for his art and providing fuel for his future presentation of his work of performance art, *Cirque Calder* (*Calder's Circus*).

Fig. 27 *Animal Sketching*, 1926

Fig. 28 Calder's passport, issued June 26, 1926

1926

January Artists Gallery, New York, includes Calder's oil paintings in a group exhibition. (CF, exhibition file)

February 27 American painter Walter Kuhn, who was instrumental in the installation of the 1913 Armory Show, organizes a stag dinner at the Union Square Volunteer Fire Brigade, Tip Toe Inn, New York, in honor of Romanian sculptor Constantin Brancusi's first visit to the United States. Calder paints *Firemen's Dinner for Brancusi* commemorating the event. (AAA, Louis Bouché Papers, dinner invitation)

March 5–28 Calder exhibits *The Stiff* at the "Tenth Annual Exhibition of the Society of Independent Artists," Waldorf Astoria, New York; the painting depicts a human dissection at Physicians and Surgeons Hospital. (CF, exhibition file)

Spring At a friend's house in Connecticut, Calder carves his first wood sculpture, *Flat Cat*, from an old oak fence post. (CF, Calder, unpub. MS. 1954–55, 174)

May *Animal Sketching* (fig. 27), a drawing manual written by Calder and filled with 141 of his drawings, is published. (CF, project file)

June 26 Calder receives his U.S. passport (fig. 28) in preparation for his first voyage to Europe. (CF, passport)

July 2 With the help of his art instructor, Clinton Balmer, Calder joins the crew of the *Galileo*, a British freighter sailing to England. Calder arrives in Hull on July 19, and on the following day takes the noon train to London, where he stays four nights with Bob Trube, a fraternity brother from his alma mater, Stevens Institute of Technology in New Jersey. (Calder 1966, 76–77; CF, Calder to mother, July 18; CF, Calder to parents, July 26)

July 24 Calder leaves England, taking the 10 A.M. train from Victoria Station to New Haven and a ferry to Ville de Dieppe in France. He arrives in Paris and checks into a room at the Hôtel de Versailles, 60 boulevard Montparnasse, where Trube's father is also staying.

Calder and José de Creeft, rue Broca, Paris, 1926

In Paris, I was received by Bob's father.... I had a mansard room and could look all the way across the roofs of Paris.... Mr. Trube and I walked along the sidewalks and passed by the Dôme. Though I did not understand much about the place, he sneered at "all the artists who don't do any work"—probably because he'd come up the hard way as an engineer. (CF, Calder to parents, July 26; Calder 1966, 77–78)

Summer At the Café du Dôme, at the time a meeting place for artists and art dealers, Calder recognizes American painter Arthur Frank, an acquaintance from New York, and meets British printmaker and proto-Surrealist Stanley William Hayter, whose wife he knew from the Art Students League. Around this time, he also enrolls in drawing classes at the Académie de la Grande Chaumière.

I don't think I wasted much time before I went to the Grande Chaumière to draw. Here there were no teachers, just a nude model, and everyone was drawing by himself; the atmosphere was much more subdued than at the Art Students League. (Calder 1966, 78)

August 3 Calder's French national identity card (fig. 29) is issued for 1926–27. (CF, *carte d'identité*)

August 26 Calder moves to 22 rue Daguerre, both his home and his studio.

I still considered myself a painter and was happy to be in my own workroom, in Paris.... I soon was making small animals in wood and wire and articulating them. (Calder 1966, 80; CF, Calder to parents, August 26)

Fall Hayter introduces Calder to José de Creeft, a Spanish sculptor living on rue Broca.

De Creeft suggests that Calder submit his works to the Salon des Humoristes. (Calder 1966, 80)

Fall Calder constructs his first completely wire sculptures, *Josephine Baker* and *Struttin' His Stuff* (figs. 30 and 31).

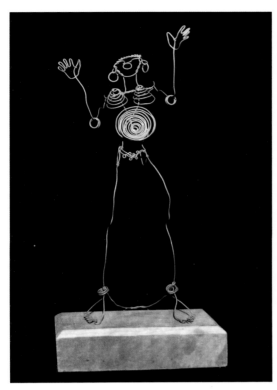

Fig. 30 *Josephine Baker*, 1926

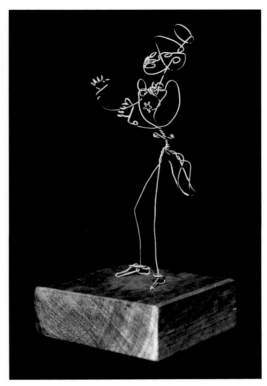

Fig. 31 *Struttin' His Stuff*, 1926

There was also a curious guy from California, a painter of sorts; he was curious because he'd order one course at a restaurant and would wait to see if he was still hungry before he ordered a second one. If he found the fried eggs too juicy, he'd admonish the waiter:

"Take these eggs back and blow their noses."

This was Clay Spohn . . . When he visited my studio and saw the objects I made out of wood and wire—I had a cow, a four-horse chariot which was quite wonderful but some damn fool lost it—he said, "Why don't you make them completely out of wire?"

I accepted this suggestion, out of which was born the first Josephine Baker and a boxing Negro in a top hat. (Calder 1966, 80)

Fall Calder begins creating *Cirque Calder* (*Calder's Circus*), a complex and unique body of art. Fashioned from leather, wire, cloth, and other found materials, *Cirque Calder* is designed to be manipulated manually by Calder. It develops into a multi-act articulated series of sculpture in miniature scale, a distillation of the natural circus. Every piece is small enough to be packed into a large trunk, enabling the artist to carry it with him and hold performances anywhere. Calder's renderings of his circus lasted about two hours and were quite elaborate. Over the next five years, Calder continues to develop and expand this work of performance art. (CF, project file)

September Advertising executive Lloyd Sloane introduces Calder to Marc Réal, artistic advisor of the magazine *Le Boulevardier*, to which he contributes drawings. (Calder 1966, 83)

September 8–18 Calder travels from France to New York on the SS *Volendam*.

I'd only been in Paris two months when I met a girl doing advertising for a travel agency working for the Holland-America Line. She got me a round-trip job to New York and back to Paris, making sketches of life on board from which an advertising brochure was compiled. I also got a couple of hundred dollars. (Calder 1966, 79; CF, Calder to parents, ca. August 26)

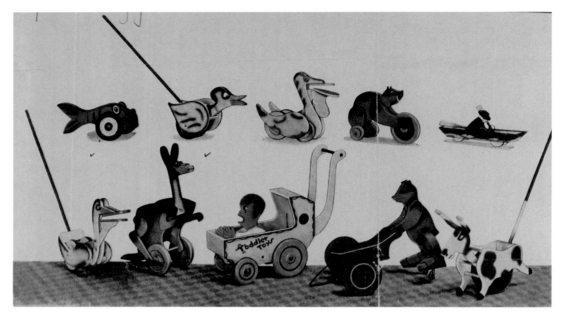

Fig. 33 Series of *Action Toys*, designed by Calder, fall 1927

October 1 Calder returns to France on the SS *Volendam*. (CF, Calder to parents, ca. September 1930, 26)

Fall Calder performs *Cirque Calder* for Frances C. L. Robbins, a patron of the Artists Gallery in New York. On her recommendation, English novelist Mary Butts brings writer Jean Cocteau to a performance. (CF, Calder unpub. MS. 1954–55, 68; Hawes, "Wiry Art")

1927

Paul Fratellini, of the clown troupe Les 3 Frères Fratellini, attends *Cirque Calder* at the invitation of Réal.

[Fratellini] took a fancy to the dog in my circus show. It was made of rubber tubing and he got me to enlarge it for his brother Albert, who always dragged a dog around with him. Before that he had a stuffed dog. Mine trotted and its tail wagged around. However, they just ignored the fact that I had made it and never announced it in their act— it remained a gift. (Calder 1966, 83)

May 1 Réal brings friends to see Calder perform *Cirque Calder*.

. . . among them Guy Selz and Legrand-Chabrier, who was a circus critic and who insisted I have a net under my trapeze act. I promptly devised one.

Legrand-Chabrier writes in his review:
Comme vous pourriez croire que c'est un personnage de conte, je vous révélerai son nom, vous pourrez vérifier, il s'appelle Alexandre Calder, et je crois, et j'espère, que vous entendrez parler de ses jouets (Calder 1966, 83; Legrand-Chabrier, "Un petit cirque")

June 17–21 Calder renews his identity card. (CF, *carte d'identité*)

Summer Calder meets a Serbian toy merchant who encourages him to make production toys.

The Serb said that if I made some articulated toys I could earn a living at it, so I was interested, because I did not have many nickels. The base of my subsistence was still seventy-five dollars a month provided by mother, and my ingenuity. . . . So I immediately set to work and made some articulated toys with wire, wood, tin, and leather. When I looked for my Serb, he had disappeared, but I continued making toys in this way. (Calder 1966, 80)

Fig. 32 Bird made of two loaves of French bread, August 1927

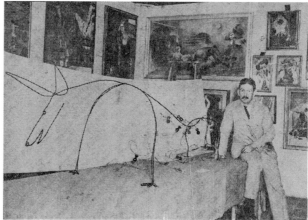

Fig. 34 Calder with *Romulus and Remus* at the "Twelfth Annual Exhibition of the Society of Independent Artists," Waldorf Astoria, 1928

August A selection of Calder's animated objects as well as a bird made from two loaves of French bread are exhibited at the galleries of Jacques Seligmann in Paris (fig. 32). (CF, exhibition file; Anon., "Jouets")

Fall Calder returns to the U.S., traveling to Oshkosh, Wisconsin, to contract with Gould Manufacturing Company. He makes prototypes for a series of animal "action toys" (fig. 33). (Calder 1966, 83–85)

Winter Calder returns to New York, where he stays with his parents at 9 East Eighth Street. He gives *Cirque Calder* performances in a rented room at 46 Charles Street. (Calder 1966, 86–87; CF, Calder unpub. MS. 1954–55, 46)

1928

February 20–March 3 "Wire Sculpture by Alexander Calder" is shown at the Weyhe Gallery, New York. (CF, exhibition file)

I showed wire animals and people to Carl Zigrosser of the Weyhe Gallery and bookshop and he decided forthwith to give me a show. My first show....

Among those sold was the first Josephine Baker which I had made in Paris. I think it is about then that some lady critic said: "Convoluting spirals and concentric entrails; the kid is clever, but what does papa think?" (Calder 1966, 86)

March 9–April 1 "Twelfth Annual Exhibition of the Society of Independent Artists," Waldorf Astoria, includes four Calder sculptures, among them *Romulus and Remus* (fig. 34) and *Spring*, a seven-foot-tall female figure holding a green flower. (CF, exhibition file)

Summer Calder spends the summer making wood and wire sculptures at the Peekskill, New York, farm of J. L. Murphy, the uncle of fraternity brother Bill Drew.

I worked outside on an upturned water trough and carved the wooden horse later bought by the Museum of Modern Art, a cow, a giraffe, a camel, an elephant, two elephants, another cat, several circus figures, a man with a hollow chest, and an ebony lady bending over dangerously, whom I daringly called Liquorice. (Calder 1966, 88–89; CF, Calder unpub. MS. 1954–55, 47)

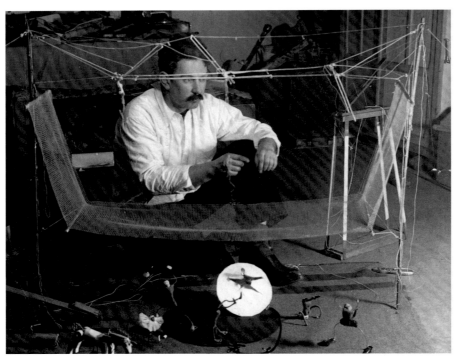

Fig. 36 Calder with his *Cirque Calder,* 1929. Photograph by Sacha Stone

February 4–23 "Wood Carvings by Alexander Calder" is on view at the Weyhe Gallery, New York (fig. 35). (CF, exhibition file)

Spring After attending a presentation of *Cirque Calder* at the rue Cels studio, German photographer Sacha Stone (fig. 36) suggests that Calder perform and exhibit in Berlin. (Calder 1966, 97)

March 15 The German consulate in Paris stamps Calder's passport. (AAA, passport)

April 1–15 "Alexander Calder. Skulpturen aus Holz und aus Draht" is presented at the Galerie Neumann-Nierendorf, Berlin (fig. 37). The opening attracts a notable crowd, including Charlie Chaplin and Yehudi Menuhin.

Chantal Quenneville Hallis, a French paintrix, was there and I made a wire fly dangling from a beam attached to a collar. That was about my first jewelry. (Calder 1966, 98–99; CF, Calder unpub. MS. 1954–55, 50)

April During Calder's Berlin stay, Dr. Hans Cürlis produces a short film in which Calder creates wire sculptures of a horse, the critic Paul Westheim, a woman, and a pair of acrobats. Calder also makes a wire portrait of Cürlis. (CF, Calder to parents, ca. April 1929)

May After Calder returns to Paris, Pathé Cinema produces a short film on him at work in his studio. He invites the celebrated model Kiki de Montparnasse to pose for a wire portrait (fig. 38).

Just before I left Paris in 1929, I could more or less be said to belong to quite a gang: Pascin, Foujita, Man Ray, Kiki, Desnos, and many others. I felt very much at home with them and they usually held forth at the Coupole Bar. I would have much preferred to stay in the open air on the terrace, but I was fond of this gang, so I ended up in the smoke of the Coupole Bar. (Calder 1966, 99; anon., *New York Herald*)

June 22 Calder embarks for New York on the *De Grasse.* During the voyage, he meets Edward Holton James and his daughter, Louisa. Calder later visits Louisa and her sister, Mary, at Eastham on Cape Cod. (AAA, passport; Calder 1966, 101)

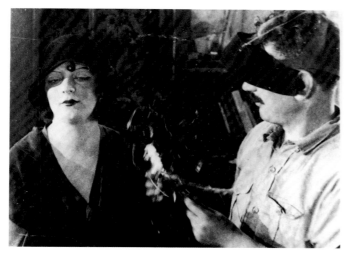

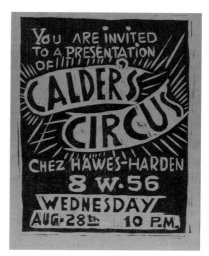

Fig. 38 Calder working on the wire portrait of Kiki de Montparnasse during the filming of a short film by Pathé Cinema, Paris, May 1929

Fig. 39 Invitation to a performance of *Circus* at the Hawes' apartment, August 28, 1929

August 28 Calder performs *Cirque Calder* at Hawes's apartment, 8 West Fifty-sixth Street, New York (fig. 39). (AAA, poster)

October 29 Calder presents *Cirque Calder* at 306 Lexington Avenue, New York, at the home of art patron Mildred Harbeck, whom he had met the previous spring in Paris.
I think we invited Frank Crowninshield, Vanity Fair *art editor, Edward Steichen, the photographer, and Mr. Erhard Weyhe, at whose gallery I had shown in New York. There were also many other guests.* (AAA, poster; Calder 1966, 103)

Fall At the invitation of his friend, the statesman Paul Nitze, Calder stages *Cirque Calder* in his apartment on East Fortieth Street, New York. (Calder 1966, 107)

November 30 *The New Yorker* magazine announces that performances of *Cirque Calder* can be arranged through the Junior League entertainment center at Saks Fifth Avenue. Calder is hired to perform in the Babylon, Long Island, home of Newbold Morris; Japanese-American sculptor Isamu Noguchi operates the phonograph that provides the music. (anon., "Sudden Brain Waves"; CF, Calder unpub. MS. 1954–55, 142)

December 2–14 "Alexander Calder: Paintings, Wood Sculptures, Toys, Wire Sculptures, Jewelry, Textiles" is held at Fifty-sixth Street Galleries, New York. Calder visits an exhibition at the adjacent Weyhe Gallery, where a collection of eighteenth-century mechanical birds inspires him to make a wire fish tank even more complex than the wire *Aquarium* in his own show. Featuring two articulated "swimming" fish, *Goldfish Bowl* (page 22) is his first crank-driven sculpture. He presents it to his mother as a Christmas gift. (Sweeney 1943, 25–26; Hayes 1977, 225–26)

December 25 Calder performs *Cirque Calder* in the home of Aline Bernstein on Park Avenue. Noguchi attends, as does Thomas Wolfe, who incorporates a wry fictionalized account into his 1934 novel *You Can't Go Home Again.* (Calder 1966, 106–7; Hayes 1977, 226)

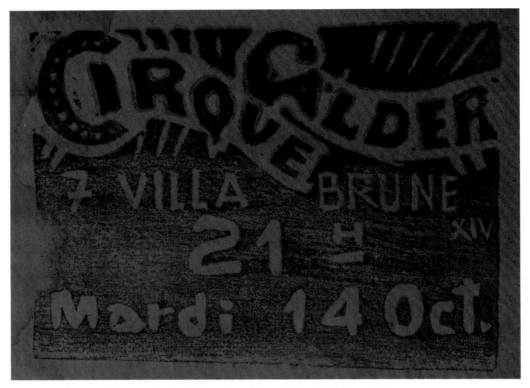

Fig. 40 Invitation to a performance of *Cirque Calder* at the artist's studio, Paris, October 14, 1930

December 31 Calder stages *Cirque Calder* on New Year's Eve at the home of Jack and Edith Straus located on West Fifty-seventh Street, New York. (CF, Calder unpub. MS. 1954–55, 142)

1930

January 27–February 4 The exhibition "Wire Sculpture by Alexander Calder" takes place at the Harvard Society for Contemporary Art, Cambridge, Massachusetts. Calder performs *Cirque Calder* for Harvard faculty and students on January 31. (CF, exhibition file)

Ca. March 10 Calder sails for Europe on the Spanish freighter *Motomar*. Though the ship docks only briefly in Málaga, the town's marketplace makes a strong impression on Calder.

I walked around . . . and discovered a vegetable and fruit store with stacks of fruit all green and purple. Two years later, on the same run, but in early September instead of March, the same shop was yellow and orange. (Calder 1966, 108–9)

Ca. March 12 Calder disembarks in Barcelona and checks into the Hotel Regina; he searches

the city for Miró, but is unable to find him. Calder eventually continues his journey by train to Paris, where he rents a studio at 7 Villa Brune. (Calder 1966, 109–10)

May 23–July 27 Calder is invited by his friend Rupert Fordham to sail to L'Île Rousse in Corsica. They travel to Antoni and Calvi on the west coast of the island. (Calder 1966, 110–12; CF, Calder to parents, May 23 and July 27)

After July 27 At the Fonderie Valsuani, Paris, Calder casts twelve sculptures in bronze, including *Cat*, *Cow* and *Weight Lifter*.

There is a very fine bronze foundry at the end of Villa Brune—so I am soon going to delve into cire perdue. I have been carving—and painting a bit, and am really getting under way. (CF, Calder to parents, May 23)

September 10 Calder stages *Cirque Calder* at his studio. He invites spectators to bring their own boxes for seating. (Bibliothèque littéraire Jacques Doucet, Bibliothèque Sainte Geneviève, Paris, Fonds Desnos, invitation)

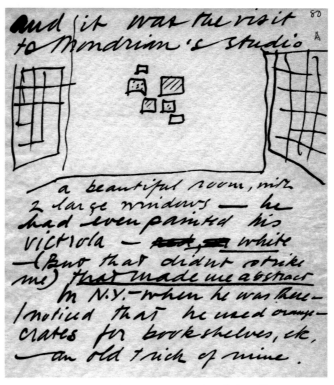

Fig. 41 Calder's drawing of his 1930 visit to Mondrian's Paris studio, 1952

Mid-September Louisa James visits Calder in Paris. (CF, Louisa to Mother, September 7)

October 14 On the advice of Frederick Kiesler, a Viennese architect and artist usually identified with Surrealism, Calder invites Le Corbusier, Karl Einstein, Fernand Léger, and Piet Mondrian to a presentation of *Cirque Calder* (fig. 40) at his studio. (Calder 1966, 112–13; AAA, poster)

October 15 Théo van Doesburg and his wife, Pétronella, attend *Cirque Calder*. "I got more of a reaction from Doesburg than I had from the whole gang the night before." (Calder 1966, 112–13)

October Accompanied by American artist William "Binks" Einstein, Calder visits Mondrian's studio at 26 rue de Départ, Paris. Already familiar with Mondrian's geometric abstractions, Calder is deeply impressed by the studio environment, documented in his drawing (fig. 41) and writings.

It was a very exciting room. Light came in from the left and from the right, and on the solid wall between the windows there were experimental stunts with colored rectangles of cardboard tacked on. . . . I suggested to Mondrian that perhaps it would be fun to make these rectangles oscillate. And he, with a very serious countenance, said: "No, it is not necessary, my painting is already very fast. . . . This one visit gave me a shock that started things."

For the next three weeks, Calder makes non-objective paintings. (Calder 1966, 113; Calder unpub. MS. 1953–54)

November Calder meets Surrealist filmmaker Luis Buñuel at the premiere of his *L'Âge d'or* at Studio 28, an event that launches their life-long friendship. The cinema entrance features works by Miró and Arp. (Marchesseau, *Intimate World*, 68)

Late Fall Kiesler introduces Calder to composer Edgard Varèse, and Calder eventually makes a wire portrait of him. Varèse, who feels that his own music resonates with Calder's new abstract sculpture, often visits Calder's studio. (Calder 1966, 125)

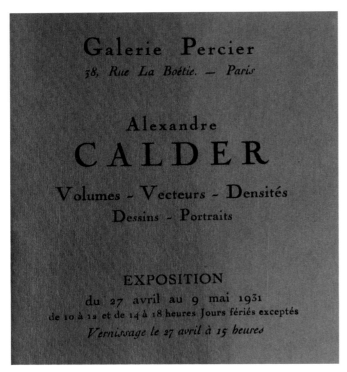

Fig. 42 Catalogue cover for "Alexander Calder: Volumes-Vecteurs-Densités. Dessins-Portraits" at Galerie Percier, Paris, April–May 1931

December 17–22 Calder returns to New York on the *Bremen* (Calder 1966, 114; AAA, postcard, Wiser to Calder)

1931

January 1–15 Calder orders printed postcards to announce performances of *Cirque Calder* at 903 Seventh Avenue, Store no. 3 (northeast corner of Fifty-seventh Street, New York). He gives five performances to audiences of about thirty each. (AAA, announcement; Powell, *World*)

January 17 Calder and Louisa James are married in Concord.

I took the circus to the James house in Concord, Massachusetts, and ran it the night before the wedding. The reverend who married us apologized for having missed the circus the night before. So I said: "But you are here for the circus, today." (Calder 1966, 115)

January 22 The Calders embark for Europe on the *American Farmer*. They return to Calder's

former studio at 7 Villa Brune. (Calder 1966, 116; CF, Calder to George Thomson)

April 27–May 9 Calder's abstract work is presented for the first time in the exhibition "Alexander Calder: Volumes-Vecteurs-Densités. Dessins-Portraits" at Galerie Percier, Paris (fig. 42). Léger writes in the introduction to the catalogue:

Eric Satie illustrated by Calder, why not? It's serious without seeming to be. Neoplastician from the start, he believed in the absolute of two colored rectangles. . . . His need for fantasy broke the connection; he started to "play" with his materials: wood, plaster, iron wire, especially iron wire . . . a time both picturesque and witty. . . . A reaction; the wire stretches, becomes rigid, geometrical-pure plastic— it is the present era—an anti-Romantic impulse dominated by a concern for balance.

Looking at these new works—transparent, objective, exact—I think of Satie, Mondrian, Marcel Duchamp, Brancusi, Arp—these unchallenged masters of unexpressed and silent beauty. Calder is in the same family. He is 100-percent American. Satie

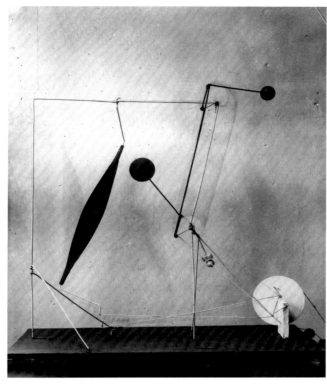

Fig. 43 Motorized sculpture that Duchamp first termed "mobile," 1931

and Duchamp are 100-percent French. How is that reconciled? (CF, exhibition file)

April 27 Pablo Picasso arrives early for the opening at the Galerie Percier and introduces himself to Calder. (CF, Calder unpub. MS. 1954–55, 95)

May 2 The Calders move into a three-story townhouse at 14 rue de la Colonie. (Calder 1966, 121; Hayes 1977, 252–53; AAA, taxi receipt)

End of May *Mary Reynolds is up from Villefranche for a few weeks, so we are seeing a bit of her and Marcel Duchamp.* (CF, Calder to parents, ca. June 5)

June Calder is invited to join Abstraction-Création. Members include Jean Arp, Robert Delaunay, Einstein, Jean Hélion, Mondrian, and Anton Pevsner.
I am now a member of a new group called Abstraction-Création—composed solely of people who do abstractions—and who will show in the fall (Nov.). They are also going to publish a journal. (CF, Calder to parents, July 1)

July 12 *I have been making a few new abstractions which have certain movements combined with their other features. I think there is something in it that may be good.* (CF, Calder to parents, July 12)

August-mid-September The Calders visit Palma de Mallorca, staying at the Hotel Mediterraneo. They call on the Juncosas, Pilar Miró's family. After a month, they return to Paris. (Calder 1966, 122–23)

August Harrison of Paris publishes *Fables of Aesop According to Sir Roger L'Estrange*, containing fifty illustrations by Calder. (CF, project file)

October 29–30 Calder performs *Cirque Calder* in his studio. (FJM, Calder to Miró, 1931)

Fall Using cranks and small electric motors, Calder concentrates on making mechanized abstract sculptures. (Calder 1966, 126)

Fall Duchamp visits Calder's studio.
There was one motor-driven thing with three elements (fig. 43). The thing had just been painted and

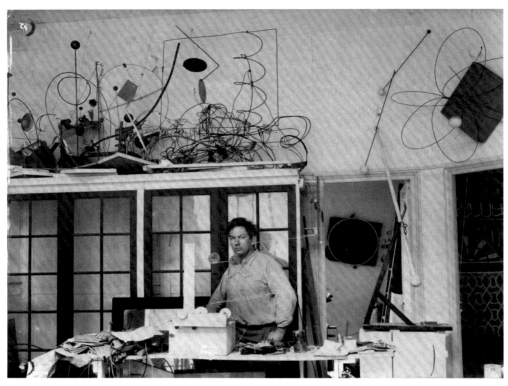
Calder in his Paris studio, 14 rue de la Colonie, fall 1931

was not quite dry yet. Marcel said: "Do you mind?"
When he put his hands on it, the object seemed to
please him, so he arranged for me to show in Marie
Cuttoli's Galerie Vignon, close to the Madeleine.
I asked him what sort of a name I could give these
things and he at once produced "Mobile." In addi-
tion to something that moves, in French it also
means motive. (Calder 1966, 127)

November Calder selects a sculpture from
among the works exhibited at Galerie Percier
and donates it to the recently founded Museum
Sztuki (Museum of New Art) in Lodz, Poland.
The work is later lost during World War II.

[The] object was an almost vertical rod, slightly
inclined, about a yard long with at the top a little
wire loop with a counterweight at its far end, and
another little piece, with another counterweight—
there were three elements. I rather liked it.

Six months or so later, a Polish poet—he said—
came and collected objects from the members of
Abstraction-Création for the museum of Lodz. I
wanted to keep the last object described, feeling it
was the most exciting, but it was the one he wanted,

for probably the same reason, so I gave it to him.
Later on, we heard he had been given some money
to buy these things—poetical omission. (Calder
1966, 118)

November Calder shows four sculptures
titled *Espaces vecteurs densités* at the Association
Artistique les Surindépendants, Porte de
Versailles, Paris. (CF, exhibition file)

Mid-November The Calders visit Port-Blanc
in the Côtes-du-Nord, Brittany. (Calder 1966,
125; CF, Louisa to Mother, November 30)

1932

Calder publishes "Comment réaliser l'art?" in
the first issue of *Abstraction-Création, Art Non
Figuratif*. Describing his mobiles, he writes:

How does art come into being?

Out of volumes, motion, spaces carved out within
the surrounding space, the universe.

Out of different masses, tight, heavy, middling—
achieved by variations of size or color.

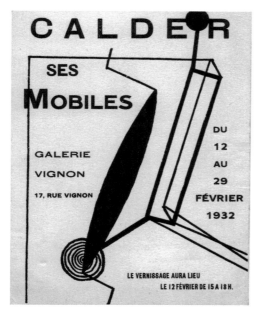

Fig. 44 Invitation to "Calder. Ses mobiles" at Galerie Vignon, Paris, February 1932

Fig. 45 Announcement for *Cirque Calder* performances at Calder's studio, Paris, February 1932

Out of directional line—vectors representing motion, velocity, acceleration, energy, etc.—lines which form significant angles and directions, making up one, or several, totalities.

Spaces and volumes, created by the slightest opposition to their mass, or penetrated by vectors, traversed by momentum.

None of this is fixed. Each element can move, shift, or sway back and forth in a changing relation to each of the other elements in this universe.

Thus they reveal not only isolated moments, but a physical law of variation among the events of life.

Not extractions, but abstractions:

Abstractions which resemble no living thing, except by their manner of reacting.

(Calder quoted in Arnason and Mulas 1971, 25)

January The exhibition "1940," which includes two sculptures by Calder, opens at Abstraction-Création, Porte de Versailles, Paris. Among the other participating artists are Arp, Mondrian, and van Doesburg.

February 12–20 "Calder. Ses mobiles" is held at Galerie Vignon, Paris. Duchamp suggests the exhibition title and invitation design (fig. 44). Gabrielle Buffet, art critic who later becomes the wife of artist Francis Picabia, reviews the exhibition:

Le mot "matière" est d'ailleurs très impropre ici: le souci de la qualité "matière" est totalement exclu de ses oeuvres, et leur élément véritable est le . . . mouvement. (CF, exhibition file; Calder 1966, 127; Buffet, "Alexander Calder")

February In response to Duchamp's term "mobile," Arp suggests the word "stabile" to describe the non-motorized constructions exhibited earlier at Galerie Percier.

Jean Arp said to me, 'Well, what were those things you did last year—stabiles?' Whereupon, I seized the term and applied it. (Calder 1966, 130)

February 20–22 Calder performs *Cirque Calder* at his studio (fig. 45). (AAA, poster)

May In preparation for their departure from Antwerp to New York on a Belgian freighter, the Calders rent their house to Buffet. (Calder 1966, 136–37)

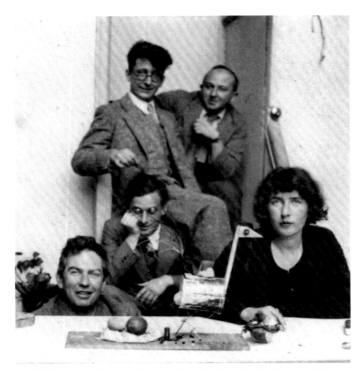

Jean Hélion's studio, Impasse Nansouty, Paris. Left to right, standing: Jean Hélion and Anatole Jakovsky; seated: Alexander Calder, William Einstein, and Louisa Calder, ca. 1933

May 9 Calder writes to James Johnson Sweeney, introducing himself and inviting the American critic to his exhibition at the Julien Levy Gallery, New York.

About 3 or 4 months [ago] M. Fernand Léger came to my house in Paris to see my "mobiles"—abstract sculptures which move—and said he would like to bring you to have a look at them too. You were then, I believe, in London. . . . I am now exposing a few of these "mobiles" at the Julien Levy Gallery 602 Madison Ave NYC and would be very pleased if you would come and see them. (JJS, Calder to Sweeney)

May 12–June 11 "Calder: Mobiles, Abstract Sculptures" is held at the Julien Levy Gallery. The exhibition announcement reprints Léger's introduction to Calder's 1931 Galerie Percier catalogue. Calder's father, Alexander Stirling Calder, attends the exhibition. (CF, exhibition file)

Summer The Calders visit Louisa's parents in Concord and Calder's parents in Richmond, Massachusetts. (CF, Calder unpub. MS. 1954–55, 146; anon., "International Artist")

By September 10 The Calders arrive in Barcelona after a fourteen-day passage on the *Cabo Tortosa*, Garcia and Díaz Spanish line. Following a stop in Málaga, they take a train from Barcelona to Tarragona. (Calder 1966, 138–40; FJM, Calder to Miró, July 19)

September 12 The Calders arrive at the Miró farm in Montroig for an eight-to-ten-day visit. The Calders and Mirós visit Cambrils and Tarragona together. (Calder 1966, 139–40; JM, 330)

After September 12 During their stay in Montroig, Calder performs *Cirque Calder* for the Mirós, their farmhands, and their neighbors. After the performance, Miró comments:
"I liked the bits of paper best."

These are little bits of white paper, with a hole and slight weight on each one, which flutter down several variously coiled thin steel wires, which I jiggle so that they flutter down like doves onto the shoulder of a bejeweled circus belle-dame. (Calder 1966, 139, 92)

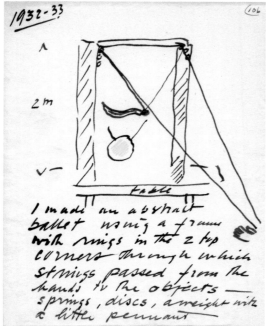
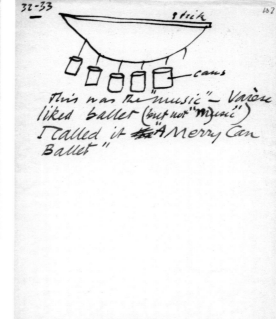

Fig. 46 Calder's drawings of his 1932-1933 *Ballet-Object*, 1952

Late September After a brief stop in Barcelona, the Calders return to Paris. (Calder 1966, 141)

1933

Calder constructs an interactive "performance" sculpture. (fig. 46)

I had a small ballet-object, built on a table with pulleys at the top of a frame. It was possible to move colored discs across the rectangle, or fluttering pennants, or cones; to make them dance, or even have battles between them. Some of them had large, simple, majestic movements; others were small and agitated. I tried it also in the open air, swung between trees on ropes, and later Martha Graham and I projected a ballet on these lines. (Quoted in Evans 1937, 62–67)

January 19–31 Calder sculptures are included in the group exhibition "Première série" at the Association Artistique Abstraction-Création, Paris (CF, exhibition file)

January 29–30 The Calders travel by train from Paris to Madrid, where they visit the Museo del Prado. (CF, Calder to Peggy, February 2)

February 1–2 Works by Calder are shown at the Sociedad de Cursos y Conferencias, Residencia de Estudiantes de la Universidad de Madrid. Calder also performs *Cirque Calder* for the students. (AAA, program; CF, Louisa to Mother, February 11; anon., "El Circ")

February 13 Miró arranges for an exhibition of drawings and sculpture by Calder at the Galeries Syra, Barcelona. (CF, Louisa to Mother, ca. December 1932; Louisa to Mother, February 11; anon, "El Circ")

After February 13 The Calders travel to Rome to visit Louisa's godmother, "Tanta" Bullard, returning to Paris on March 10. (CF, Louisa to Mother, ca. December 1932; FJM, Calder to Miró, March 15)

May Calder meets Gala and Salvador Dalí, the Surrealist master.

As he lived not far away from the rue de la Colonie, I decided to call on him. He was busy sorting dirty

Calder in his Roxbury icehouse studio with *Money Bags*, 1934

postcards, but took time out to give me a little green book, Babauo, *which was a scenario for a movie. He had written it and had it printed.*

A few days later, I returned it with a remark that there were in it "too many restless inner tubes, pumping up and down." He immediately took offense, and this coolness has existed between us ever since. (Calder 1966, 142)

May 16–18　"Présentation des oeuvres récentes de Calder" takes place at Galerie Pierre Colle, Paris.

Spring　Louisa has a miscarriage. (Calder 1966, 142; JJS, Calder to Sweeney, September 20, 1934)

June 9–24　"Arp, Calder, Miró, Pevsner, Hélion, and Seligmann" is presented at Galerie Pierre, Paris; Anatole Jakovski writes the text for the catalogue. At Galerie Pierre, Calder meets Sweeney for perhaps the first time. Sweeney becomes an avid proponent of Calder's work. (Calder 1966, 148; Lipman 1976, 331)

By 22 June　Miró stays with the Calders at 14 rue de la Colonie while he arranges an exhibition of his recent paintings. On June 24, Miró

presents the couple with a painting as a going-away present. (JM, 330–31)

End of June　Calder and Louisa give up their house in Paris and return to New York in the company of Hélion.

July　The Calders visit Louisa's parents in Concord and Calder's parents in Richmond, Massachusetts. They search for a new house along the Housatonic River in Massachusetts, while also considering real estate in Tarrytown, New York; New City, New York; Yaphank, New York; Westport, Connecticut; and Sandy Hook, Connecticut. (Calder 1966, 143–44)

August 12–27　Among the fifteen Calder sculptures on display in "Modern Painting and Sculpture" at The Berkshire Museum, Pittsfield, Massachusetts, are *Dancing Torpedo Shape*, *Nymph*, and one of the wire *Josephine Bakers*. Calder writes a statement for the catalogue.

Why not plastic forms in motion? Not a simple translatory or rotary motion, but several motions of different types, speeds and amplitudes composing

Calder in Roxbury, ca. 1934

to make a resultant whole. Just as one can compose colors, or forms, so one can compose motions. (CF, exhibition file)

August The Calders visit a real-estate agency in Danbury, Connecticut. After viewing several properties, they discover a dilapidated eighteenth-century farmhouse in Roxbury, Connecticut; both Louisa and Calder claim to have been the first to exclaim, "That's it!" They purchase it, and Calder converts the adjoining icehouse into a modest dirt-floored studio. (Calder 1966, 143–45; CF, mortgage records)

1934

January 30 Calder performs *Cirque Calder* at the Park Avenue home of Mr. and Mrs. Huntington Sheldon. (JJS, Calder to Sweeney, ca. January 1934)

February 7 The Calders attend the premiere of Gertrude Stein's *Four Saints in Three Acts,* which is set to music by Virgil Thomson and performed at the Wadsworth Atheneum, Hartford, Connecticut. Afterward, they attend dinner at the home of A. Everett "Chick" Austin, Jr., director of the Atheneum, where they meet with old friends, including Thomson and Julien Levy, and new acquaintances such as James Thrall Soby and Austin. (Calder 1966, 146)

March "The First Municipal Art Exhibition," Radio City Music Hall, Rockefeller Center, New York, includes two works by Calder, a gouache titled *Abstraction*, and the motorized mobile *A Universe*. Alfred H. Barr, Jr., founding director of The Museum of Modern Art, New York, purchases *A Universe* for his institution. (CF, exhibition file; Calder 1966, 148)

April 6–28 "Mobiles by Alexander Calder" is presented at Pierre Matisse Gallery. James Johnson Sweeney writes in the preface for the catalogue:

The evolution of Calder's work epitomizes the evolution of plastic art in the present century. Out of a tradition of naturalistic representation, it has worked by a simplification of expressional means to a plastic concept which leans on the shapes of

the natural world only as a source from which to abstract the elements of form. (CF, exhibition file)

Summer In Roxbury, Calder works prolifically on "panels" and "frames"; these sculptures consist of moving abstract forms set in front of colored plywood panels or within boxlike frames. The works relate to the idea of three-dimensional paintings in motion that Calder proposed to Mondrian during his 1930 visit. (CF, object files)

Summer Calder produces his first outdoor works, *Red and Yellow Vane* and *Untitled*, from sheet metal and wire. Discovering that these two objects are easily damaged by the weather, he uses heavier welded steel for the standing mobile *Steel Fish*. (CF, object files)

Before September 20 Calder takes Louisa to have a quiet stay with her parents in Concord during her pregnancy. (Calder 1966, 150; JJS, Calder to Sweeney, September 20)

Winter The Calders spend the winter in an apartment on Eighty-sixth Street and Second Avenue, New York. Calder rents a small store nearby where he whites out the window and converts it into a studio. (Calder 1966, 156)

1935

January 14–31 "Mobiles by Alexander Calder" is held at The Renaissance Society of the University of Chicago; Sweeney writes the preface for the catalogue. On January 16 and 19, Calder gives performances of *Cirque Calder* in the University of Chicago's Weiboldt Hall for the Renaissance Society. He also performs at the home of Walter S. Brewster, a trustee of the Art Institute of Chicago, on January 20. (Calder 1966, 153; Cass, "Dinner Party," January 10)

February 1–26 The Arts Club of Chicago presents "Mobiles by Alexander Calder." (CF, exhibition file)

After February Calder offers Sweeney a sculpture from his first show at the Pierre Matisse Gallery, for which Sweeney had writ-

Fig. 49 Paper costumes for *A Nightmare Side Show*, February 1936

ten an introduction to the catalogue. Sweeney chooses *Object with Red Discs*; on principle, he insists that Calder accept a small sum in return for the sculpture. (Author's interview with Seán Sweeney, July 22, 1997)

Spring While traveling home from Chicago, Calder stops in Rochester, New York, to see Charlotte Whitney Allen. She commissions a standing mobile for her garden, which had been designed by landscape architect Fletcher Steele. (Calder 1966, 153–54)

April 20 The Calders' first daughter, Sandra, is born, on Miró's birthday.

Summer Calder constructs mobile sets for Martha Graham's dance *Panorama*. On August 5–6, Calder and Louisa visit Graham in Bennington, Vermont, to preview *Panorama* before its premiere at the Vermont State Armory, Bennington, on August 14–15. (CF, project file)

Winter Calder again collaborates with Graham, making a group of six mobiles for her dance *Horizons*. (CF, project file)

1936

Levy's *Surrealism* is published in New York; it is the first English text on the subject. Levy writes:

It is impossible accurately to estimate the relative importance of the younger surrealists, until aided by the perspective of time. Outstanding among the newcomers seem to be Gisèle PRASSINOS, Richard OELZE, Hans BELLMER, Leonor FINI, Alexander CALDER, and Joseph CORNELL.... Alexander Calder is sometimes surrealist and sometimes abstractionist. It is to be hoped that he may soon choose in which direction he will throw the weight of his talents.

February First Hartford Music Festival, Wadsworth Atheneum, presents Erik Satie's cantata *Socrate*, conducted by Virgil Thomson. As a stage setting for the production, Calder creates an elaborate performance enacted only by geometric forms (fig. 48). (CF, project file)

Fig. 50 Announcement for "Mobiles and Objects by Alexander Calder," Pierre Matisse Gallery, New York, February 1936

Fig. 48 **Drawing of a set constructed of mobiles for Erik Satie's** *Socrate*, **1936**

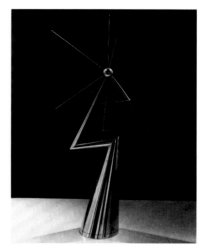

Fig. 51 *William S. Paley Trophy* for Amateur Radio, designed by Calder, 1937

February 15 Calder makes paper costumes for *A Nightmare Side Show* (fig. 49), one of thirteen group processions in *Paper Ball: Le Cirque des Chiffonniers*, also taking place as a part of the First Hartford Music Festival. (CF, project file)

February 10–29 "Mobiles and Objects by Alexander Calder" is held at the Pierre Matisse Gallery, New York (fig. 50). (CF, exhibition file)

February 23 Graham premieres *Horizons* at the Guild Theatre, New York City. The program note reads:

The "Mobiles," designed by Alexander Calder, are a new conscious use of space. They are employed in Horizons as visual preludes to the dances in this suite. The dances do not interpret the "Mobiles," nor do the "Mobiles" interpret the dances. They are employed to enlarge the sense of horizon. (CF, project file; quoted in Anon., "Graham Dance Group")

April 2 Calder performs *Cirque Calder* in New York at the Pierre Matisse Gallery. (AAA, Calder to Bunce, March 26)

April 24–25 *Socrate* is performed at the Colorado Springs Fine Arts Center. (CF, project file)

May 5–June 8 Vassar College, Poughkeepsie, New York, presents "Sculpture by Alexander Calder." (CF, exhibition file)

May 22–29 Galerie Charles Ratton, Paris, presents "Exposition surréaliste d'objets." Calder contributes a standing mobile. This is the first time the artist's work is formally exhibited with that of the Surrealist group.

June 11–July 4 Roland Penrose includes Calder's *Shark and Whale* (page 35) in "International Exhibition of Surrealism" at his New Burlington Galleries, London.

July The Calders vacation at Eastham on Cape Cod. (AAA, Calder to Bunce, July 13)

Winter Calder is commissioned by architect Paul Nelson to design a trophy for CBS's Annual Amateur Radio Award (fig. 51). (CF, project file; Calder 1966, 155)

Fig. 52 Set designs for Charles Tracy's playlet, *OO to AH*, 1937

Calder and Pablo Picasso with *Mercury Fountain* in the Spanish Pavilion at the Paris World's Fair, 1937

Calder with Dolores, Pilar, and Joan Miró, Varengeville-sur-Mer, summer 1937

December 7–January 17, 1937 Calder's *Praying Mantis* and *Object With Yellow Background* are included in the exhibition "Fantastic Art, Dada and Surrealism" organized by the Museum of Modern Art, New York. The show travels from New York to Pennsylvania Museum of Art, Philadelphia; Institute of Modern Art, Boston; Museum of Fine Arts, Springfield, Massachusetts; Milwaukee Art Institute; University Gallery, University of Minnesota, Minneapolis; and San Francisco Museum of Art. (CF, exhibition file)

December 15 Calder performs *Cirque Calder* in his apartment at 244 East Eighty-sixth Street. (AAA, Calder to Bunce, December 9)

1937

Calder designs staging and costumes (fig. 52) for *OO to AH*, a playlet in two scenes written by Charles Tracy but never performed. (CF, project file; Tracy, "OO to AH")

February 23–March 13 Calder's first large-scale bolted stabiles, *Devil Fish* (fig. 53, pages 50–

51), and *Big Bird* (fig. 54) are on view in "Stabiles and Mobiles" at the Pierre Matisse Gallery, New York. (CF, exhibition file)

April 15 The Calders sail for Europe, ultimately landing at Le Havre, France. (CF, passport; Calder 1966, 156)

Late April Nelson and his wife, Francine, invite the Calders to stay with them in Varengeville, on the Normandy coast. Léger, Pierre Matisse, and his wife, Teeny, also visit. (Calder 1966, 156–57)

Late April or early May The Calders return to Paris, where they move to 80 boulevard Arago, to a house designed by Nelson and owned by Calder's friend Alden Brooks. Visitors include Finnish architect Alvar Aalto and his wife, Aino. Calder uses the garage, outfitted with an automotive turntable, as a studio. (Calder 1966, 157–58)

May Calder and Miró visit the Spanish Pavilion under construction at the 1937 World's Fair site in Paris. Calder meets the pavilion's

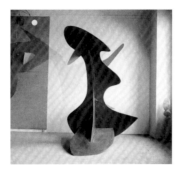

Fig. 53 *Devil Fish,* Pierre Matisse Gallery, New York, 1937

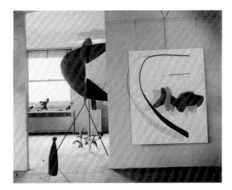

Fig. 54 *Big Bird,* Pierre Matisse Gallery, New York, 1937

Fig. 55 Calder with his *Mercury Fountain* in the Spanish Pavilion at the Paris World's Fair, July 1937

architects, José Luis Sert and Luis Lacasa. Sert eventually commissions Calder to make *Mercury Fountain* for the Spanish Pavilion. Mined from Almadén in Spain, the mercury symbolizes Republican resistance to fascism. (Calder 1966, 158; Freedberg 1986, 504–5)

Summer The Calders rent a house in Varengeville, where Calder uses the garage as his studio. Among the visitors to the house are French painters Georges Braque and Pierre Loeb; art journalist and critic Myfanwy Evans; British sculptor Barbara Hepworth; Miró; the Nelsons; British painters Ben Nicholson and John Piper; and cultural theorist Herbert Read. (Calder 1966, 162–63)

June 3 Calder performs *Cirque Calder* at 80 boulevard Arago in Paris. (Bruguière Collection, Paris, invitation)

July 12 The Spanish Pavilion, featuring Pablo Picasso's *Guernica,* Miró's *Reaper,* and Calder's *Mercury Fountain,* opens at the Paris World's Fair (fig. 55). (CF, exhibition file)

October 21 The Calders arrive in Folkstone, England, later renting an apartment in Belsize Park, London. Calder establishes a studio in Camden Town and gives *Cirque Calder* performances. (CF, passport; Calder 1966, 164–65)

December 1–24 Mayor Gallery, London, presents "Calder: Mobiles and Stabiles." (CF, exhibition file)

1938

March 1 The Calders return to New York. They rent a different apartment in the building on Eighty-sixth Street and Second Avenue in which they had previously lived. (Calder 1966, 167)

After March 1 Calder is commissioned by Wallace Harrison and André Fouilhoux, architects of Consolidated Edison's pavilion at the u
a "water ballet" for the building's fountain. Although water jets are installed around the pavilion, the water ballet is never executed. (Calder 1966, 176)

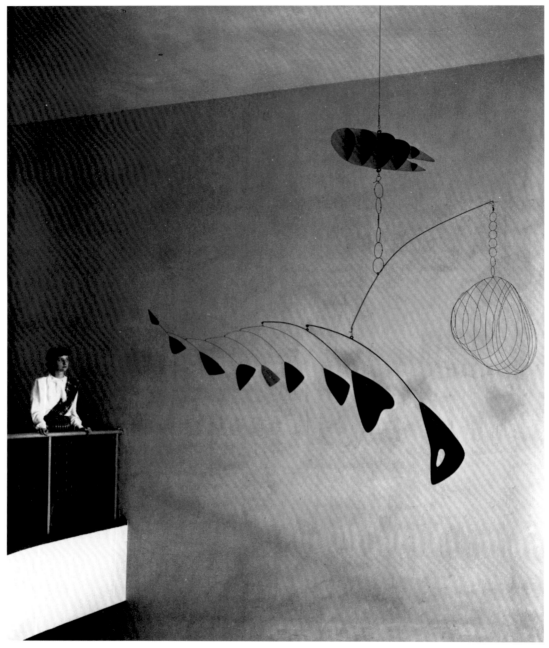

Fig. 56 *Lobster Trap and Fish Tail*, 1939, The Museum of Modern Art, New York

Fig. 57 *Stabile*, Plexiglas sculpture awarded prize in The Museum of Modern Art competition in 1939

Fig. 58 Catalogue for "Calder Mobiles-Stabiles," Pierre Matisse Gallery, New York, May 1939

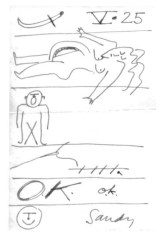

Fig. 59 Birth announcement for Mary Calder, May 25, 1939

October Calder begins construction of a large studio on the old dairy barn foundations in Roxbury. (Calder 1966, 169–70)

November 8–27 Calder's first retrospective, "Calder Mobiles," is presented by the George Walter Vincent Smith Gallery, Springfield, Massachusetts. Sweeney writes a foreword to the catalogue. Aalto, Léger, architectural historian Siegfried Giedion, and art patron Katherine S. Dreier attend the opening. (CF, exhibition file)

December Artek Gallery; Helsinki, presents "Alexander Calder: Jewelry." (CF, exhibition file)

1939

Calder is commissioned to make *Lobster Trap and Fish Tail* (fig. 56); the mobile is installed in the principal stairwell of the Museum of Modern Art's new building on West Fifty-third Street, New York.

Calder is invited to make sculptures for an African Habitat designed by Oscar Nitzschke

for the Bronx Zoo. Calder conceives of treelike sculptures to be made in steel so they can withstand the abuse of the wild animals. Although the African Habitat is never realized, Calder creates four models for the project: *Sphere Pierced by Cylinders* (page 81), *Four Leaves and Three Petals* (pages 68-69), *Leaves and Tripod*, and *The Hairpins*. (Canaday, "Lift")

April 30 Calder submits a Plexiglas stabile (fig. 57) to a competition sponsored by Röhm and Haas at the Museum of Modern Art, New York. The work is exhibited at the Hall of Industrial Science during the New York World's Fair.

A plexiglass manufacturer wanted to get some publicity, cheaply. So he put up a modest prize and published a lot of rules about what you could do with plexiglass and how to work it. I entered this competition, but I did not like their suggestions on how to work it. I just used a hacksaw and a file. Anyway, they finally took my object and reproduced it—they thought—nice and smooth. Also, it turned out they did not have any black plexiglass, and where I was to have varicolored lights playing at the end of a two-inch stalk, they abandoned that as

André Breton, Jacqueline Breton, Louisa Calder, Rose Masson, Charlie Prescott, André Masson, Beatrice Prescott, Alexander Calder, Mary Calder, and Teeny Matisse, Roxbury, 1941

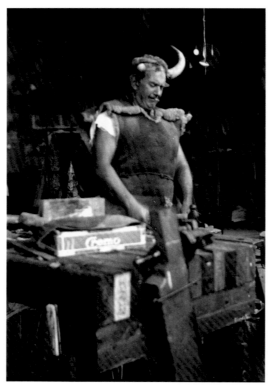

Calder in his studio in Roxbury, 1941

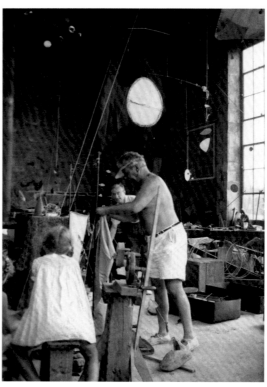

Calder setting up *Cirque Calder* in his studio, with Yves Tanguy and Sandra Calder, Roxbury, 1941

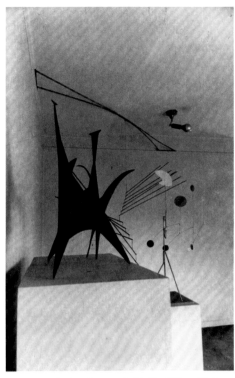

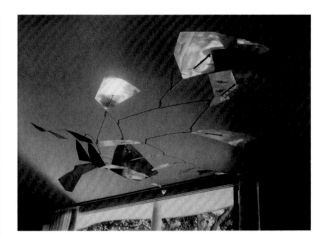

Fig. 61 *Mobile*, Hotel Avila Ballroom, Caracas, Venezuela, 1941

Fig. 60 Installation photograph, "Calder," Pierre Matisse Gallery, New York, May 1940

being too complicated, and made a horrible base for the thing, too. In spite of this, I was awarded the prize, because I knew the jury—or rather, the jury knew me. (CF, exhibition file; Calder 1966, 175; Anon., "Forum")

May 9–27 "Calder Mobiles-Stabiles" is on view at the Pierre Matisse Gallery, New York (fig. 58). (CF, exhibition file)

May 25 The Calders' second daughter, Mary, is born (fig. 59).

Summer Sert and his wife, Moncha, pay an extended visit to the Calders in Roxbury. (Calder 1966, 174)

1940

May 14–June 1 "Calder" is shown at the Pierre Matisse Gallery, New York (fig. 60). (CF, exhibition file)

October 11–14 A private exhibition of Calder's sculptures takes place inside and outside the home of Harrison and his wife, Ellen,

in Huntington, Long Island. (MoMA, invitation; CF, Myra Martin to Ellen Harrison, October 24)

December 3–25 "Calder Jewelry" is shown at Willard Gallery, New York. (CF, exhibition file)

1941

André Breton—progenitor of Surrealism—Duchamp, and Ernst organize "127 Objects, Drawings, Photographs, Paintings, Sculptures, and Collages from 1910 to 1942." Breton's "Artistic Genesis and Perspective of Surrealism" is included in the catalogue introduction. This essay marks the first time Breton formally associates Calder with the Surrealist group:

From its original exteriority, the object in sculpture became increasingly self-denying in appearance as it traversed the two great crises of cubism and futurism . . . it [then] found itself pitting its resource, in constructivism, . . . from that moment it had no alternative but to arise, phoenix-like, from its own ashes, achieving this renascence by . . . the pure joys of equilibrium (Calder). . . . With every anecdotal element excluded, Calder's object is reduced to a

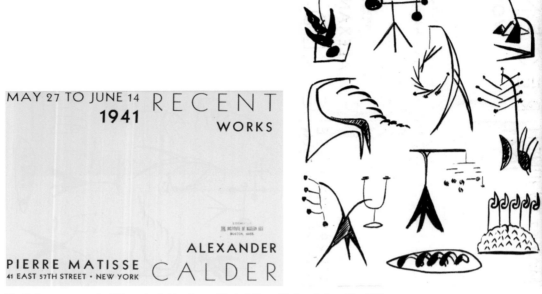

Fig. 62 Announcement for "Alexander Calder: Recent Works," Pierre Matisse Gallery, May 1941

few simple lines put into sharp relief by elementary colours, but by sole virtue of movement—not represented movement, any longer, but real movement—it is miraculously restored to life in its most concrete form and conveys to us with equal felicity the evolutions of the celestial bodies, the trembling of leaves on their branches, the memory of caresses. (Breton 1972, 72–73)

Harrison commissions Calder to make a mobile (fig. 61) for the ballroom of the Hotel Avila, Caracas. (CF, project file)

March 28–April 11 "Alexander Calder: Mobiles, Jewelry" and "Fernand Léger: Gouaches, Drawings" are presented at The Arts and Crafts Club of New Orleans, Louisiana. (CF, exhibition file).

May 27–June 14 "Alexander Calder: Recent Works" is held at the Pierre Matisse Gallery, New York (fig. 62). (CF, exhibition file)

July 16 Hoping to immigrate to the United States, Buñuel appeals to Calder:

Nous avons besoin de deux lettres d'affidavit moral. *Voila ce qui dit mon avocat: "The letter of your friend should specify that he is a citizen of U.S.A.; also the length of his acquaintance with you and your wife, and any commendatory statements as he may be willing to make." Nous nous connaissons personellement il y a très peu de temps mais il y a longtemps de nom. Voudriez vous faire cette lettre pour Jane et une autre pour moi?* (CF, Buñuel to Calder, July 16).

September 27–October 27 "Alexander Calder, Mobiles, Stabiles, Jewelry" and "A Few Paintings by Paul Klee" are on view at The Design Project, Los Angeles. (CF, exhibition file)

1942

October Peggy Guggenheim inaugurates her Art of This Century gallery with "Exhibition of the Collection," which includes, along with Calder's 1941 sculpture *Mobile*, works by Breton, Cornell, Dalí, de Chirico, Delaunay, Duchamp, Ernst, Giacometti, and Miró, among many others. (Lader 1981, 363–67)

Fig. 63 *Red Petals*, The Arts Club of Chicago, 1942

José Lluis Sert, Fernand Léger, and André Masson, Roxbury, ca. 1942

Before November 12 The Calders move to 255 East Seventy-second Street. (CF, André Masson to Calder, November 12)

March 3 Calder is commissioned to make *Red Petals* (fig. 63) for the Arts Club of Chicago: Red Petals . . . *was made during the war for a little octagonal room lined with rosewood. As I become professionally enraged when I see dinky surroundings, I did my best to make this object big and bold—to dwarf these surroundings.* (Calder 1966, 185–86; CF, Rue Shaw to Calder, March 3)

March 7–28 Sculptures by Calder and paintings by Miró are exhibited at Vassar College, Poughkeepsie, New York. (CF, exhibition file)

May 19–June 12 "Calder: Recent Work" is held at the Pierre Matisse Gallery, New York. (CF, exhibition file)

May 20 Calder performs *Cirque Calder* at Herbert and Mercedes Matter's apartment, 328 East Forty-second Street, New York. (CF, Calder to de Creeft, May 18)

June The first issue of *VVV*, a Surrealist journal founded and edited by David Hare with editorial advice from André Breton and Max Ernst, is released; it features a Matter photograph of Calder's Roxbury studio and of Calder and Louisa together eating outside. Written below the photographs is:

In our days the aviary of all
Light and the nocturnal refuge
Of all tinkling.
The Studio of Alexander Calder, Roxbury, Conn.
The time of enchantment and the art of living.

July–November Calder is classified 1-A (top eligibility) by the army, though he is never drafted. He studies industrial camouflage at New York University and applies for a commission in camouflage work with the Marine Corps.

Although the army says that the painter is of little or no use in modern camouflage, I feel that this is not so, and that the camoufleur is still a painter, but on an immense *scale (using color, materials, forms, plant life, etc. as his media), and in a negative sense*

Fig. 64 Installation view of "First Papers of Surrealism," New York, 1942
Philadelphia Museum of Art, Marcel Duchamp Archive, Gift of Jacqueline, Peter, and Paul Matisse in memory of their mother,
Alexina Duchamp

(for instead of creating, he demolishes a picture and reduces it to nil, to the best of his ability). (Calder 1966, 183; Lipman 1976, 333; CF, application to the Marine Corps, September 21, 1942)

October 14 France Forever (The Fighting French Committee in the United States), Washington, D.C., presents "Calder." (CF, exihibition file)

October 14–November 7 The Coordinating Council of French Relief Societies sponsors the exhibition "First Papers of Surrealism" at the Whitelaw Reid Mansion, New York, organized by Breton and Duchamp. Duchamp creates *Mile of String* on which he invites Calder to hang his works (fig. 64). Calder proceeds to construct small paper sculptures intended as a pun on the exhibition's title. However, Breton vetoes the collaboration, and the large standing mobile *The Spider* (page 55) is installed instead. (CF, exibition file)

November 6–27 "Calder Drawings" is now on view at The Arts Club of Chicago.

Winter Calder works on a new series of sculptures made of carved wood objects interconnected by wire.

They had a suggestion of some kind of cosmic nuclear gases—which I won't try to explain. I was interested in the extremely delicate, open composition.

Sweeney and Duchamp propose the name "constellations" for these sculptures. (Calder 1966, 179; Arnason and Mulas 1971, 202)

December 1–24 Willard Gallery, New York, presents "Calder Drawings." (CF, exhibition file)

December 7–February 22, 1943 "Artists for Victory: An Exhibition of Contemporary American Art" is presented at the Metropolitan Museum of Art, New York; Calder wins fourth prize. Prizewinners Calder, de Creeft, and Philip Evergood are interviewed at the Museum for a WABC Radio program titled *Living Art*, broadcast December 8. (CF, exhibition file; AAA, oral history collection)

Fig. 65 Letter from Calder to James Johnson Sweeney containing the phrase "Sewer-realist," 1943

1943

Yves Tanguy and Kay Sage, the Surrealist painters, buy a house in nearby Woodbury, Connecticut, and become close friends of the Calders. Rose and André Masson, another expatriate Surrealist, live in nearby New Preston.

I remember one day when we lived in New York and I had to go to Roxbury. I drove up and first called on the Massons, André and Rose, in New Preston, north of us, and I told them he should put more red in his painting. Then I went to our house in Roxbury and got whatever it was—and finally I went to the Tanguys' and told Yves he should put more red in his painting. (Calder 1966, 180)

April 16–May 15 Art of This Century hosts "Exhibition of Collage," comprising works that date between 1911 and 1943, including examples by Arp, Braque, Calder, Cornell, Duchamp, Ernst, Robert Motherwell, and Picasso. (Lader 1981, 375)

May Calder writes to Sweeney (fig. 65) suggesting that *Cello on a Spindle* (fig. 1, page 12) be included in his upcoming retrospective at the Museum of Modern Art, New York:

There is an object thus about 1936(?) Rather Sewer-realist. Somebody lost the discs, but I can make new ones. (JJS, Calder to Sweeney)

May 15–June 15 "Calder: Constellationes" is shown at the Pierre Matisse Gallery, New York. (CF, exhibition file)

May 28–July 6 "17 Mobiles by Alexander Calder" is held at the Addison Gallery of American Art in Andover, Massachusetts. The catalogue contains a statement by Calder.

At first [my] objects were static, seeking to give a sense of cosmic relationship. Then . . . I introduced flexibility, so that the relationships would be more general. From that I went to the use of motion for its contrapuntal value, as in good choreography. (Addison Gallery 1943, 6)

September 29–January 16, 1944 The Museum of Modern Art, New York, presents "Alexander Calder: Sculptures and Constructions," curated by Sweeney and Duchamp. Calder writes:

Simplicity of equipment and an adventurous spirit in attacking the unfamiliar or unknown are apt to

141

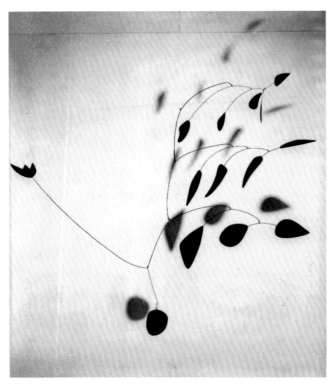

Fig. 66 *Black Lily*, 1944

result in a primitive and vigorous art. Somehow the primitive is usually much stronger than art in which technique and flourish abound. (CF, exhibition file)

Calder gives a number of *Cirque Calder* performances in the museum, also offering a private performance at Sweeney's apartment in October. Originally scheduled to close on November 28, it is extended to January 16 due to public demand. (CF, exhibition file, unpub. MS. 1943; AAA, Sweeney to Jean Lipman, July 1971)

October Following a dispute about the pricing of his sculptures, Calder withdraws from representation by Pierre Matisse Gallery. (CF, Calder to Matisse, October 22)

November 30–December 31 Guggenheim presents "Natural, Insane, Surrealist Art" at Art of This Century. Organized with Ladislas Segy, the exhibition features Calder's *Cobble* and *Hairy Object*, as well as works by Ernst, Klee, Masson, Matta, Miró, and Tanguy, among others. (Lader 1981, 385)

December 1–7 Calder travels to Chicago to organize an exhibition of his jewelry at the Arts Club, which runs from December 3 to 27.

December 4 Both the old icehouse studio and part of the Roxbury farmhouse are destroyed by an electrical fire. At the time, Louisa and the two girls are staying with the Serts in New York. Louisa tells Calder about the fire when he joins them on December 7.

The one thing I was really worried about, should there be a fire, was a gift of Miró, a 1933 painting he had given me in Paris, a canvas five feet by four. I had placed this in the front hall, which was very small, with a special unhooking device of wire loops on nailheads–in case of an emergency . . .

When Miró came to Roxbury in 1947, he was very much interested in this picture, because he could see himself as an old master. (CF, exhibition file; NL, Calder to Shaw, November 13; Calder 1966, 185–87; NL, Calder to Shaw, December 14)

1944

Agnes Rindge Claflin writes and narrates *Alexander Calder: Sculpture and Constructions*, a film based on the retrospective at the Museum

From left to right: Luis Masson, Diego Masson, Calder, and André Masson, with Mrs. Mario Pedrosa, Roxbury, 1944

Opening for "Alexander Calder: Sculptures and Constructions," The Museum of Modern Art, New York. From left to right: Yves Tanguy, James Johnson Sweeney, Alexander Calder, and Peter Blume, 1943

Opening for "Alexander Calder: Sculptures and Constructions," The Museum of Modern Art, New York. Inside the museum, from left to right: Marcel Duchamp, James Johnson Sweeney, and Herbert Matter; outside: Calder, 1943

of Modern Art, New York. Cinematography is by Matter. (CF, project file)

Calder gives *Black Lily* (fig. 66) to the Museum of Western Art in Moscow. (Calder 1966, 185)

Before May In New York, Calder meets Brazilian architect Henrique Mindlin.

He had been intrigued by a small mobile he had seen somewhere, and wanted one for himself. It was sort of a little chair, made out of a bent piece of metal, with three legs and a feather sitting in a notch on the top. I made him a similar one which could be taken to pieces—legs taken off, metal feather removed—so he could fly it to Rio without any trouble. I often regret not having made him a cloth vest with pockets, each the color of the part contained. (Calder 1966, 198)

February 3 Calder attends Mondrian's memorial service at the Universal Chapel at Lexington Avenue and Fifty-second Street, New York. (PM, 85)

March Calder contributes the cover illustration to *View*, a Surrealist magazine edited by

Charles Henri Ford and published in New York. (*View*, March)

March 27–April 9 Calder's *Black Lily* is loaned by the Russian Embassy in Washington, D.C., to "Calder: Paintings, Mobiles, Stabiles and Jewelry," held at the local gallery France Forever. Calder performs *Cirque Calder* twice during the exhibition. (CF, exhibition file; Calder 1966, 184–85; AAA, Calder to Warner, April 3)

Summer The Calders live in the Tanguy-Sage household while the burned house is repaired. Calder does not rebuild the icehouse studio, which had burned to its foundations, but he and Louisa decide to take permanent residence at their home in Roxbury. (Calder 1966, 187; author's interview with Mary Calder Rower, November 16, 1997)

Fall Curt Valentin publishes *Three Young Rats and Other Rhymes*, with eighty-five drawings by Calder and edited by Sweeney. (CF, project file)

I had left Pierre Matisse at the time of my show at the Museum of Modern Art. . . .

Fig. 67 *Man-Eater with Pennants*, The Museum of Modern Art, New York, 1945

Her beams bemocked the sultry main,
Like April hoar-frost spread;
But where the ship's huge shadow lay,
The charméd water burnt alway
A still and awful red.

Beyond the shadow of the ship,
I watched the water-snakes:
They moved in tracks of shining white,
And when they reared, the elfish light
Fell off in hoary flakes.

By the light of the Moon he be-
holdeth God's creatures of the
great calm.

31

Fig.69 *The Rime of the Ancient Mariner* by Samuel Taylor Coleridge, illustrated by Calder, 1946

Curt Valentin inquired about me several times, through André Masson, and I finally joined his stable . . . he used to purchase things in Europe— Moore, Piper, Beckmann, Picasso, Miró, Juan Gris, and so forth—and he sold these things in the United States. (Calder 1966, 194)

September 6–24 Calder is represented by a work on paper in the exhibition "Abstract and Surrealist Art in the United States" at the San Francisco Museum of Art. (CF, exhibition file)

November 28–December 23 The exhibition "Recent Work by Alexander Calder" at the Buchholz Gallery/Curt Valentin, New York, includes plaster and bronze sculptures and the drawings for *Three Young Rats and Other Rhymes*. (CF, exhibition file)

December 12–January 31, 1945 Julien Levy hosts the "Imagery of Chess" exhibition, comprising paintings, sculptures, and newly designed chessmen by vanguards such as Breton, Calder, Ernst, Tanguy, and Dorothea Tanning. In the course of the exhibition, George Koltanowski, world champion of blind-fold chess, plays five simultaneous games against Alfred Barr, Jr., Ernst, Frederick Kiesler, Levy, and others. Duchamp acts as the referee. (CF, exhibition file)

December 28–January 16, 1945 San Francisco Museum of Art presents "Alexander Calder: Watercolors." (CF, exhibition file)

1945

January 6 Calder's father dies in Brooklyn. Calder and Louisa leave their daughters in the care of the Massons and bury Stirling in Philadelphia. (Author's interview with Mary Calder Rower, November 16, 1997)

March Calder works on costumes and scenery for the dance project *Billy Sunday*, composed by Remi Gassman. The project, intended for the University of Chicago, is never produced. (AAA, Calder to Keith Warner, March 6; AAA, Calder to Warner, April 2)

June 1 Commissioned by the Museum of Modern Art, New York, to make a work for

Fig. 68 Calder with Marcel Duchamp, review of "Alexander Calder. Mobiles, Stabiles, Constellations," Galerie Louis Carré, Paris, 1946

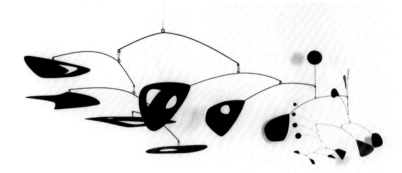

Fig. 70 *Twenty Leaves and an Apple,* 1946

the sculpture garden, Calder creates *Man-Eater with Pennants* (fig. 67).

I am down here to put up a new monster in the museum garden—however it seems to be of such dimensions that everyone is getting cold feet. (AAA, Calder to Warner)

Fall Calder produces a series of small-scale works, many from scraps trimmed during the making fabrication of other objects. Duchamp arranges for Calder to exhibit these pieces at Galerie Louis Carré in Paris. Intrigued by the limitations on parcel size imposed by the U.S. Postal Service, Calder creates larger, collapsible works to be reassembled on arrival in Paris (fig. 68). (Calder 1966, 188; CF, exhibition file)

Fall Masson brings French author and philosopher Jean-Paul Sartre to visit Calder in Roxbury. When Sartre visits Calder again at his studio in New York, the artist gives him *Peacock*, a mobile whose elements are cut from flattened Connecticut license plates. (Calder 1966, 188–89)

September–October 6 "Calder Gouaches" is on view at Samuel M. Kootz Gallery, New York. (CF, exhibition file)

November 13–December 1 Buchholz Gallery/ Curt Valentin, New York, presents "Recent Works by Alexander Calder."

After November 13 Calder works on *Ballet* and *Cirque Calder,* two of the seven dream sequences included in Hans Richter's *Dreams That Money Can Buy;* the film also features sequences by Ernst, Léger, Man Ray, and Duchamp. *Ballet* is described in the film brochure:

Calder constructions yield quite unsuspected effects on the screen—effects produced by the incorporation of their shadows, artful closeups, surprising color schemes, and not least by Paul Bowles' score. Sparkling, dangling and jingling in a universe composed of nothing but light and hue, these mobiles which we thought we knew now seethe with strange revelations.

Richter writes of Calder's second sequence, *Cirque Calder:*

Fig. 71 Catalogue for "Alexander Calder. Mobiles, Stabiles, Constellations," Galerie Louis Carré, 1946

Calder's circus figures, witty productions of an atavistic imagination, parade to a score by David Diamond which enhances their eerie non-existence. (CF, Calder to Richter, November 2; CF, project file)

1946

The Rime of the Ancient Mariner by Samuel Taylor Coleridge, with 29 illustrations by Calder (fig. 69) and an essay by Robert Penn Warren, is published in New York by Reynal and Hitchcock. (CF, project file)

Thomas Emery's Sons, Inc., commissions Calder to construct a mobile, *Twenty Leaves and an Apple* (fig. 70), for the Terrace Plaza Hotel, Cincinnati, designed by Gordon Bunshaft of Skidmore, Owings & Merrill. (CF, project file)

June 5–6 Calder takes his first transatlantic flight from New York to Paris to prepare for an exhibition at Galerie Louis Carré. (CF, passport)

July 23 The exhibition at Galerie Louis Carré is delayed and Calder returns to New York. He and Carré ask Sartre to write an essay for the catalogue. (Calder 1966, 189; MoMA, Calder to Valentin, August 6)

August 12 Calder and Louisa attend the premiere of Padraic Colum's play, *Balloons*, with mobile sets by Calder, performed at the Ogunquit Playhouse, Maine. (AAA, Calder to Warner, July)

September 7 Calder holds a performance of *Cirque Calder* in the family's Roxbury home studio.

Wish you were to be here Sat., Sept. 7—as I have decided to do the CIRCUS. I have to show the children how to run it so that they can carry on. (AAA, Calder to Warner, August 30)

September 23 Calder returns to Paris. (CF, passport)

October 25–November 16 "Alexander Calder: Mobiles, Stabiles, Constellations" is on view at Galerie Louis Carré, Paris. Henri Matisse attends the exhibition. Along with photographs by Matter, the catalogue (fig. 71) includes two

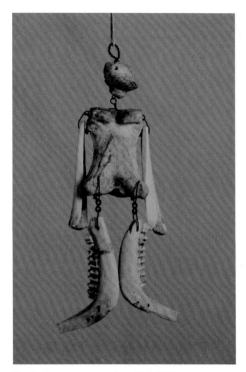

Fig. 72 *Personnage pour Joan Miró*, 1947

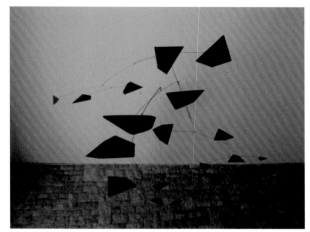

Fig. 73 *Polygones Noirs*, 1947

essays—Sartre's "Les Mobiles de Calder" and Sweeney's "Alexander Calder." Sartre writes:

Most of Calder's constructions are not imitative of nature; I know no less deceptive art than his. Sculpture suggests movement, painting suggests depth or light. A "mobile" does not "suggest" anything: it captures genuine living movements and shapes them. "Mobiles" have no meaning, make you think of nothing but themselves. They are, *that is all; they are absolutes.* (CF, exhibition file)

November 19–30 Calder sails from Le Havre to New York on the *John Ericsson*. (Calder 1966, 194; CF, passport)

1947

January 7–29 Calder exhibits gouaches, bronzes, and mobiles at the Portland Art Museum, Oregon. (CF, exhibition files)

February 12 The Mirós and their daughter, Dolores, arrive in the United States. Calder meets them at LaGuardia Airport.

I have spent a good deal of this week waiting for the arrival of Joan Miró, and his family, by plane from Lisbon. I went to New York on the train 8 days ago (Fri.) as he was due on Sunday. He did [not] come, nor did he send word explaining. So I came home Tuesday A.M. on train. Then there was another cable saying he would arrive Wed. eve.—so I drove the La Salle (open, top down) straight to La Guardia, and got there just in time. So we installed them in a little apartment on 1st ave. (very nice), and then had a bite at Matisse's. (AAA, Calder to Warner, February 15)

February 17–March 16 San Francisco Museum of Art opens a Calder exhibition that includes mobiles, bronzes, and works on paper. (CF, exhibition file)

Before March 7 The Mirós arrive at the Calders' home in Roxbury for a visit. (SM, Miró to Willem Sandberg, March 7)

March Calder performs *Cirque Calder* in Roxbury for the Mirós, Mindlin and his wife Helena, and Henri Seyrig, director of the Institut français d'archéologie. (CF, Calder unpub. MS. 1954–55, 155)

Fig. 74 Calder lithograph for "Le Surréalisme en 1947," organized by Breton and Duchamp, 1947

March 10–28 Mattatuck Historical Society, Waterburg, Connecticut, exhibits "Alexander Calder." (CF, exhibition file)

April 20 Miró celebrates his and Sandra Calder's birthday with the Calders at their apartment on East Seventy-second Street, New York; he gives Sandra a drawing, and she gives him a collage gouache of a butterfly. Calder presents Miró with a mobile personage made of animal bones (fig. 72). (Author's interview with Mary Calder Rower, November 16, 1997)

After May 5 Calder trades the mobile *Polygones noirs* (fig. 73) for Miró's *Femmes et oiseaux dans la nuit*, 1947, a painting related to Miró's mural for the Terrace Plaza Hotel, Cincinnati. (CF, object file)

May 26 The Stable, New Haven, Connecticut, presents "Alexander Calder." (CF, exhibition file)

July 7 "Le Surréalisme en 1947" is organized by Breton and Duchamp for Galerie Maeght, Paris. Calder produces a lithograph (fig. 74) for the catalogue. (Breton and Duchamp, 1947)

December Calder rebuilds the burned ice-house studio in Roxbury, converting it into a large living room. (AAA, Calder to Warner, December 13)

December 9–27 "Alexander Calder" is on view at the Buchholz Gallery/Curt Valentin, New York. (CF, exhibition file)

In 1947 Breton and Duchamp organize their last Surrealist exhibition and Peggy Guggenheim's Art of This Century closes, but Calder's affiliation with the Surrealists continues for the next two decades. Hans Richter's film *Dreams That Money Can Buy* is released in 1948, and Calder participates in two later Richter films: *8x8* (1957), with Arp, Paul Bowles, Cocteau, Duchamp, Sert, and Tanguy; and *Alexander Calder: From the Circus to the Moon* (1963).

As the range and breadth of his various projects and commissions expand, Calder's artistic talents become renowned worldwide. In 1949, he wins first prize for his largest mobile to date, *International Mobile*, at the Philadelphia Museum of Art's Third International Exhibition of Sculpture. He designs sets for *Happy as Larry* (1949), a play directed by Burgess Meredith, and for *Nuclea* (1952), a performance directed by Jean Vilar.

In his later years, Calder concentrates his efforts primarily on large-scale commissioned works. Some of these major monumental sculptures include: *.125*, a mobile for John F. Kennedy Airport (1957); *La Spirale*, for UNESCO, in Paris (1958); *Man*, for the Expo in Montreal (1967); *El sol rojo* (the tallest of Calder's works), installed for the Olympic Games in Mexico City (1968); and *La Grande Vitesse*, commissioned by the city of Grand Rapids, Michigan, the first public work of art to be funded by the National Endowment for the Arts (NEA) (1969).

From 1948 to the end of his life, Calder has two-hundred-and-sixty-five monographic exhibitions and eight additional museum retrospectives. In 1976, the Whitney Museum of American Art in New York presents his tenth major retrospective, "Calder's Universe." Calder dies in New York on November 11, 1976, at the age of seventy-eight.

Catalogue Checklist

Checklist of the Exhibition

Alexander Calder

Goldfish Bowl, 1929
Wire
16 × 15 × 6 inches
(40.6 × 38.1 × 15.2 cm)
Courtesy Calder Foundation,
New York
Page 22

Hercules and Lion, 1929
Wire
60 × 48 × 24 inches
(152.4 × 121.9 × 61 cm)
Courtesy Calder Foundation,
New York
Page 19

Two Acrobats, 1929
Painted wire and wooden base
34 9/16 × 21 5/8 × 6½ inches
(87.8 × 55 × 16.5 cm)
The Menil Collection, Houston
Page 23

Untitled, 1930
Oil on canvas
28¾ × 23¾ inches (73 × 60.3 cm)
Courtesy Calder Foundation,
New York
Page 72

Croisière, 1931
Wire, wood, and paint
37 × 23 × 23 inches
(94 × 58.4 × 58.4 cm)
Courtesy Calder Foundation,
New York
Page 73

Movement in Space, 1932
Gouache and ink on paper
22¾ × 30¾ inches (57.8 × 78.1 cm)
National Gallery of Art,
Washington, D. C.
Gift of Mr. and Mrs. Klaus G. Perls
Houston only
Page 75

Space Tunnel, 1932
Watercolor and ink on paper
22¾ × 30½ inches (57.8 × 77.5 cm)
Courtesy Calder Foundation,
New York
Page 79

Untitled, 1932
Ink on paper
30 × 22 inches (76.2 × 55.9 cm)
Courtesy Calder Foundation,
New York
Page 45

Untitled, 1932
Ink on paper
30 × 22 inches (76.2 × 55.9 cm)
Courtesy Calder Foundation,
New York
Page 46

Untitled, 1932
Watercolor and ink on paper
30¾ × 23 inches (78.1 × 58.4 cm)
Courtesy Calder Foundation,
New York
Page 61

Untitled, 1932
Ink on paper
23 × 30¼ inches (58.4 × 78.1 cm)
Courtesy Calder Foundation,
New York
Page 74

Untitled, 1932
Ink on paper
22 15/16 × 30 7/8 inches
(58.3 × 78.4 cm)
Courtesy Calder Foundation,
New York
Page 76

Cône d'ébène, 1933
Ebony, rod, wire, and paint
106 × 55 × 24 inches
(269.2 × 139.7 × 61 cm)
Courtesy Calder Foundation,
New York
Page 27

Shark and Whale, ca. 1933
Wood, rod, and paint
34 × 40 1/8 × 6¼ inches
(86.5 × 102 × 16 cm)
Centre Pompidou, Musée national
d'art moderne, Paris
Houston only
Page 35

The Planet, 1933
Ink on paper
21 5/8 × 29½ inches (54.9 × 74.9 cm)
Courtesy Calder Foundation,
New York
Page 77

Untitled, 1933
Colored inks and graphite on paper
30¾ × 22¾ inches (78.1 × 57.8 cm)
Courtesy O'Hara Gallery,
New York
Page 47

Untitled, 1933
Gouache and ink on paper
21 7/8 × 29 7/8 inches (55.6 × 75.9 cm)
Courtesy Calder Foundation,
New York
Page 44

Black Frame, 1934
Wood, sheet metal, wire, and paint,
with motor
37 × 37 × 24 inches
(94 × 94 × 61 cm)
Courtesy Calder Foundation,
New York
Page 78

Money Bags, 1934
Wood
13 7/8 × 15½ × 11 5/8 inches
(35.2 × 39.4 × 29.5 cm)
Courtesy Calder Foundation,
New York
Page 30

Gibraltar, 1936
Lignum vitae, walnut, steel rods,
and painted wood
51 7/8 × 24¼ × 11 3/8 inches
(131.7 × 61.3 × 28.7 cm)
The Museum of Modern Art,
New York,
Gift of the artist, 1966. 847.1966.a–b
Page 32

Ruby-Eyed, 1936
Painted sheet metal and glass
15 × 6¼ × 13 inches
(38.1 × 15.9 × 33 cm)
National Gallery of Art,
Washington, D.C.
Gift of Mr. and Mrs. Klaus G. Perls
Page 33

Tightrope, 1936
Ebony, wire, rod, lead, and paint
45½ × 27½ × 138½ inches
(115.6 × 69.9 × 351.8 cm)
Courtesy Calder Foundation,
New York
Page 26

White Panel, 1936
Sheet metal, wire, plywood, string,
and paint
84½ × 47 × 51 inches
(214.6 × 119.4 × 129.5 cm)
Courtesy Calder Foundation,
New York
Page 34

Devil Fish, 1937
Sheet metal, bolts, and paint
68 × 64 × 47 inches
(172.7 × 162.6 × 119.4 cm)
Courtesy Calder Foundation,
New York
Pages 50-51

Apple Monster, 1938
Wood (apple branch), wire, and
paint
66 × 55½ × 32½ inches
(167.6 × 141 × 82.6 cm)
Courtesy Calder Foundation,
New York
Pages 48-49

Untitled, 1938
Wood, wire, and paint
70¼ × 37 × 23½ inches
(178.4 × 94 × 59.6 cm)
Courtesy Calder Foundation,
New York
Page 38

Four Leaves and Three Petals,
ca. 1939
Sheet metal, wire, and paint
80¹¹⁄₁₆ × 68½ × 53½ inches
(205 × 174 × 135 cm)
Musée national d'art moderne/
Centre de Creation Industrielle,
Centre Pompidou, Paris, 1983
Pages 68–69

Sphere Pierced by Cylinders, 1939
Wire and paint
83 × 34 × 43 inches
(210.8 × 86.4 × 109.2 cm)
Courtesy Calder Foundation,
New York
Page 81

Black Beast, 1940
Sheet metal, bolts, and paint
103 × 163 × 78½ inches
(261.6 × 414 × 199.4 cm)
Courtesy Calder Foundation,
New York
San Francisco and Minneapolis only
Pages 52-53

Calderoulette, ca. 1940
Brass, nylon thread
20¾ × 28 × 17 inches (52.7 × 71 × 43 cm)
Private collection
Page 24

Eucalyptus, 1940
Sheet metal, wire, and paint
95¼ × 61 inches (241.9 × 154.9 cm)
Ivan and Genevieve Reitman
Houston and San Francisco only
Page 64 and back cover

The Spider, 1940
Sheet metal, wire, and paint
95 × 99 × 73 inches
(241.3 × 251.5 × 185.4 cm)
Nasher Sculpture Center, Dallas
Page 55 and front cover

Giraffe, ca. 1941
Sheet metal, wire, and paint
102 × 38 × 56 inches
(259 × 96.5 × 22 cm)
Collection of Mr. and Mrs. Gund
Houston only
Page 54

Un effet du japonais, 1941
Sheet metal, rod, wire, and paint
80 × 80 × 48 inches
(203.2 × 203.2 × 121.9 cm)
Courtesy Calder Foundation,
New York
Page 63

Untitled, 1941
Wood, sheet metal, wire, and paint
24½ × 20 × 16 inches
(62.2 × 50.8 × 40.6 cm)
Courtesy Calder Foundation,
New York
Page 36

Constellation, ca. 1942
Wood, wire, and paint
22½ × 28½ × 20 inches
(57.2 × 72.4 × 50.8 cm)
Courtesy Calder Foundation,
New York
Pages 84–85

Constellation, 1943
Wood, wire, and paint
33 × 36 × 14 inches
(83.8 × 91.4 × 35.6 cm)
Courtesy Calder Foundation,
New York
Page 82

Constellation, 1943
Wood, wire, and paint
51 × 45 × 8 inches
(129.5 × 114.3 × 20.3 cm)
Private Collection, San Francisco
Page 86

Constellation Mobile, 1943
Wood, string, wire, and paint
53 × 48 × 35 inches
(134.6 × 121.9 × 88.9 cm)
Courtesy Calder Foundation,
New York
Page 83

Wooden Bottle with Hairs, 1943
Wood and wire
22⅜ × 13 × 12 inches
(56.8 × 33 × 30.5 cm)
Whitney Museum of American Art,
New York, 50th anniversary gift of
the Howard and Jean Lipman
Foundation, Inc.
Page 31

Double Helix, 1944
Bronze
31½ × 31¼ × 24 inches
(80 × 79.4 × 61 cm)
Courtesy Calder Foundation,
New York
Page 80

The Snag, 1944
Bronze
39 × 33 × 21 inches
(99.1 × 83.8 × 53.3 cm)
Courtesy Calder Foundation,
New York
San Francisco and Minneapolis only
Page 60

Untitled, 1945
Wood, sheet metal, wire, and paint
81 × 73 × 45 inches
(205.7 × 185.4 × 114.3 cm)
Courtesy Calder Foundation,
New York
San Francisco and Minneapolis only
Page 65

Untitled *(23 Feuilles à l'écart)*, 1945
Aluminum, steel, painted metal
and wire
60⅞ × 126 inches
(154.6 × 320 cm)
Private Collection, San Francisco
San Francisco only
Pages 66–67

Bougainvillier, 1947
Sheet metal, wire, lead,
and paint
78½ × 86 inches
(199.4 × 218.4 cm)
Jon and Mary Shirley
Page 62

Parasite, 1947
Sheet metal, rod, wire, and paint
41 × 68 × 28 inches
(104.1 × 173 × 71.1 cm)
Courtesy Calder Foundation,
New York
San Francisco and Minneapolis only
Pages 56–57

Ashtray Mobile, ca. 1951
Tin cans and metal
28 inches (71.1 cm) high
Saul Steinberg estate
Page 37

Max Ernst
Forêt (Forest), 1927
Oil on paper mounted on canvas
27⅛ × 19⅝ inches (69 × 50 cm)
The Menil Collection, Houston
Page 58, fig. 18

Painting for Young People, 1943
Oil on canvas
24⅛ × 30⅛ inches
(61.4 × 76.6 cm)
The Menil Collection, Houston
Page 59, fig. 19

The King Playing with the Queen,
1944; cast 1954
Bronze
37¾ × 33 × 21¼ inches
(96 × 84 × 54 cm)
Edition 2/9
The Menil Collection, Houston
Page 39 (bottom left), fig. 16

Moonmad, 1944; cast 1956
Bronze
37¼ × 12¾ × 11⅜ inches
(94.6 × 32.4 × 28.9 cm)
The Menil Collection, Houston
Page 39 (bottom right), fig. 17

René Magritte
*Ceci est un morceau de fromage (This Is
a Piece of Cheese)*, 1936 or 1937
Oil on canvas mounted on paperboard
in freestanding painted wood frame,
set in covered glass cheese dish
Glass dish: 12 × 10 × 10 inches
(30.5 × 25.3 × 25.3 cm)
Framed painting: 4¹⁵⁄₁₆ × 7¼ inches
(12.4 × 18.4 cm)
The Menil Collection, Houston
Page 21, fig. 10

Golconde (Golconda), 1953
Oil on canvas
31½ × 39½ inches (80 × 100.3 cm)
The Menil Collection, Houston
Page 20 (bottom), fig. 9

Joan Miró
Peinture (La Magie de la couleur)
(Painting [The Magic of Color]), 1930
Oil on canvas
59⅛ × 88⅝ inches (150.5 × 225 cm)
The Menil Collection, Houston
Page 71 (top), fig. 21

Pablo Picasso
*Femme au fauteuil rouge (Woman in a
Red Armchair)*, 1929
Oil on canvas
25⅝ × 21¼ inches (65 × 54 cm)
The Menil Collection, Houston
Page 39 (top right), fig. 15

Yves Tanguy
Et Voilà! (La Veille au soir)
(There! [The Evening Before]), 1927
Oil on canvas
25¾ × 21⅜ inches (65.3 × 54.3 cm)
The Menil Collection, Houston
Page 70, fig. 20

"Cabinet of Curiosities"
Gathered by the artist's grandson,
Alexander S. C. Rower, from
Calder's Roxbury studio, these 30
objects recall the Surrealists'
fascination with mysterious objects,
as well as provide an intimate
experience of Calder's surroundings
and interests.
Pages 40–43

Comparative Illustrations

"The Surreal Calder: A Natural"
See Checklist of the Exhibition for figs.
9–10, 15–21

Fig. 1 *Cello on a Spindle*, 1937
Sheet metal, wood, and paint
62¼ × 46½ × 35½ inches
(158.1 × 118.1 × 90.2 cm)
Kunsthaus Zürich

Fig. 2 *Cirque Calder (Calder's*
Circus), 1926–31
Mixed media: wire, wood, metal,
cloth, yarn, paper, cardboard,
leather, string, rubber tubing, corks,
buttons, rhinestones, pipe cleaners,
bottle caps
Overall: 54 × 94¼ × 94¼ inches
(137.2 × 239.4 × 239.4 cm)
Whitney Museum of American Art,
New York; Purchase, with funds
from a public fund-raising campaign
in May 1982. One half the funds were
contributed by the Robert Wood
Johnson Jr. Charitable Trust.
Additional major donations were
given by The Lauder Foundation;
the Robert Lehman Foundation,
Inc.; the Howard and Jean Lipman
Foundation, Inc.; An anonymous
donor; The T. M. Evans Foundation,
Inc.; MacAndrews & Forbes Group,
Incorporated; the DeWitt Wallace
Fund, Inc.; Martin and Agneta
Gruss; Anne Phillips; Mr. and Mrs.
Laurance S. Rockefeller; the Simon
Foundation, Inc.; Marylou Whitney;
Bankers Trust Company; Mr. and
Mrs. Kenneth N. Dayton; Joel and
Anne Ehrenkranz; Irvin and
Kenneth Feld; Flora Whitney
Miller. More than 500 individuals
from 26 states and abroad also
contributed to the campaign.

Fig. 3 *Calder Toys*, 1902–45
Mixed media
Dimensions variable
University of California, Berkeley
Art Museum
Gift of Margaret Calder Hayes,
Class of 1917

Fig. 4 Jean Arp
Configuration with Two Dangerous
Points, ca. 1930
Wood
27½ × 33½ inches (69.8 × 85.1 cm)
Philadelphia Museum of Art,
A. E. Gallatin Collection

Fig. 5 André Masson
Automatic Drawing, 1925–26
Ink on paper
12 × 9½ inches (30.4 × 24.1 cm)
Centre Pompidou, Musée national
d'art moderne, Paris

Fig. 6 Joan Miró
The Hermitage, 1924
Oil and/or aqueous medium, crayon,
and pencil
45 × 57⅞ inches (114.3 × 147 cm)
Philadelphia Museum of Art,
Louise and Walter Arensberg
Collection

Fig. 7 René Magritte
Le Monde invisible (*The Invisible
World*), 1954
Oil on canvas
77 × 51⅝ inches (195.6 × 131.1 cm)
The Menil Collection, Houston

Fig. 8 Marcel Duchamp
Fountain, 1917/1964
Third version, replicated under the
direction of the artist in 1964 by the
Galerie Schwarz, Milan
24 inches (61 cm) high
Centre Pompidou, Musée national
d'art moderne, Paris

Fig. 11 Paul Klee
Seiltänzer (*Tightrope Walker*), 1923
Color lithograph on Japanese
wove paper
Comp: 17⅜ × 10½ inches (44.1 × 26.7
cm); sheet: 19 × 12⅝ inches (48.3 ×
32.1 cm)
Norton Simon Museum, The Blue
Four Galka Scheyer Collection

Fig. 12 Joan Miró
Object, 1936
Assemblage: stuffed parrot on wood
perch, stuffed silk stocking with
velvet garter and doll's paper show
suspended in a hollow wood frame,
derby hat, hanging cork ball,
celluloid fish and engraved map
31⅞ × 11⅞ × 10¼ inches
(78.7 × 54.6 cm)
The Museum of Modern Art,
New York
Gift of Mr. and Mrs. Pierre Matisse

Fig. 13 Alberto Giacometti
Table surréaliste (*The Surrealist
Table*), 1933/1969
Bronze
56¼ × 40½ × 17 inches
(143 × 103 × 43 cm)
Centre Pompidou, Musée national
d'art moderne, Paris

Fig. 14 Salvador Dalí
Téléphone-Homard (*Lobster
Telephone*), 1936
Plastic, painted plaster, and mixed
media
¾ × 13 × ¾ inches (1.8 × 33 × 1.8 cm)
Tate

Fig. 22 Joan Miró
*Constellation: Awakening in the Early
Morning*, 1941
Gouache and oil wash on paper
18⅛ × 15 inches (46 × 38 cm)
Kimbell Art Museum, Fort Worth
Acquired with the generous
assistance of a grant from Mr. and
Mrs. Perry R. Bass

Fig. 23 Pablo Picasso
Le Verre d'absinthe (*Glass of Absinthe*),
1914
Painted bronze
8¾ inches (22.2 cm) high
Philadelphia Museum of Art,
A. E. Gallatin Collection

Fig. 24 Max Ernst
Les Asperges de la lune (*Lunar
Asparagus*), 1935
Plaster
65¼ × 15¾ × 9⅛ inches
(165.7 × 40 × 23.2 cm)
The Museum of Modern Art, New
York

Fig. 25 Jean Arp
Trousse d'un Da (*Case for a Da*),
1920–21
Driftwood nailed onto wood
15¼ × 10½ × 2 inches
(38.7 × 27 × 4.5 cm)
Centre Pompidou, Musée national
d'art moderne, Paris

Fig. 26 Herbert Matter
Untitled (*set in motion*), 1936

Calder by Matter

Page 91
Calder with *White Panel* and *Devil
Fish*, before completion, New York
City storefront studio, winter 1936

Page 92
Calder with Pierre Matisse with
wire figure from *Tightrope*, and
White Panel, New York studio, 1936

Page 93
Two Acrobats, Pierre Matisse
Gallery, New York, 1940

Page 94
Devil Fish, *Tightrope*, and *White
Panel*, New York studio, winter 1936

Page 95
Calder (background) showing *Devil
Fish*, *Tightrope*, and *White Panel*, to
an unidentified visitor (foreground,
left), New York studio, winter 1936

Page 96
New York studio, winter 1936

Page 97
Frame for *Snake and Cross* in an early
configuration, New York studio,
winter 1936

Page 98
Calder assembling *Nine Discs*,
Roxbury, Connecticut, summer 1938

Page 99
Untitled and *Spiny*, both 1939

Pages 100–101
Calder at work on *Tightrope*, New
York studio, winter 1936

Page 102
New York studio, winter 1936

Page 103
The Spider and *Sphere Pierced by
Cylinders*, New York studio, 1940

Page 104
Four Leaves and Three Petals, New
York studio, 1936

Page 105
Calder with *Giraffe*, Roxbury,
ca. 1941

Pages 106–107
Interior of studio showing *Apple
Monster*, *Black Beast* (maquette),
Untitled, and *Un effet du japonais*,
Roxbury, 1941

Selected Bibliography

Alexander Calder: Sculptures of the Nineteen Thirties. Exhibition catalogue. New York: Whitney Museum of American Art, 1987.

Alexander Calder. Volumes-Vecteurs-Densités. Dessins-Portraits. Exhibition catalogue. Paris: Galerie Percier, 1931.

André Breton. Exhibition catalogue. Paris: Centre Pompidou, Musée national d'art moderne, 1991.

Arnason, H. Harvard, and Pedro E. Guerrero. *Calder*. New York: Van Nostrand, 1966.

Arnason, H. Harvard, and Ugo Mulas. *Calder*. New York: Viking, 1971.

Arp, Calder, Miró, Pevsner, Hélion, and Seligmann. Exhibition catalogue. Paris: Galerie Pierre, 1933.

Balakian, Anna. *André Breton: Magus of Surrealism*. New York: Oxford University Press, 1971.

Barr, Alfred H., Jr., ed. *Cubism and Abstract Art*. Exhibition catalogue. New York: Museum of Modern Art, 1936.

Barr, Alfred H., Jr., and Georges Hugnet. *Fantastic Art, Dada and Surrealism*. Edited by Barr. Exhibition catalogue. New York: Museum of Modern Art, 1936.

Breton, André, and Marcel Duchamp. *Le Surréalisme en 1947. Exposition internationale du surréalisme*. Exhibition catalogue. Paris: Éditions Maeght, 1947.

Breton, André, and Paul Éluard. *Dictionnaire abrégé du surréalisme*. Paris: Galerie des Beaux-Arts, 1938.

Breton, André. *Surrealism and Painting*. Translated by Simon Watson Taylor. New York: Harper & Row, 1972.

Bruzeau, Maurice. *Calder à Saché*. Paris: Éditions Cercle d'Art, 1975.

Buffet-Picabia, Gabrielle. *Rencontres avec Picabia, Apollinaire, Craven, Duchamp, Arp, Calder*. Paris: C. Belfond, 1977.

Calder, Alexander. *Calder: An Autobiography with Pictures*. New York: Pantheon Books, 1966.

Calder, Alexander. "Mobiles." In *The Painter's Object*, edited by Myfanwy Evans. London: Gerold Howe, 1937, 62–67.

Carandente, Giovanni. *Calder: Mobiles and Stabiles*. Exhibition catalogue. London: Collins, 1968.

Derriere la miroir. La Fondation Maeght. Paris: Éditions Maeght, 1974.

Duchamp, Marcel. "Thirty-three Critical Notes." In *Collection of the Société Anonyme: Museum of Modern Art 1920*, edited by George Heard Hamilton. New Haven: Yale University Art Gallery, for the Associates in Fine Arts, 1950.

Durozoi, Gérard. *History of the Surrealist Movement*. Translated by Alison Anderson. Chicago and London: University of Chicago Press, 2002.

Edwards, Hugh. *Surrealism & Its Affinities: The Mary Reynolds Collection*. Introduction by Marcel Duchamp. Chicago: The Art Institute of Chicago, 1956.

Exposition surréaliste d'objets. Exhibition catalogue. Paris: Galerie Charles Ratton, 1936.

The Fantastic in Modern Art Presented by View. Exhibition catalogue. New York: Hugo Gallery, 1945.

First Papers of Surrealism. Exhibition catalogue. New York: Coordinating Council of French Relief Societies, 1942.

Freedberg, Catherine Blanton. *The Spanish Pavilion at the Paris World's Fair of 1937*. New York: Garland Publishing, 1986.

Giménez, Carmen, and Alexander S. C. Rower. *Calder: Gravity and Grace*. Exhibition catalogue. Bilbao: Museo Guggenheim, 2003.

Guggenheim, Peggy, ed. *Art of This Century: Objects–Drawings–Photographs–Paintings–Sculpture–Collages 1910 to 1942*. Exhibition catalogue. New York: Art of This Century, 1942.

Hayes, Margaret Calder. *Three Alexander Calders: A Family Memoir*. Middlebury, Vermont: Paul S. Eriksson, 1977.

Lader, Melvin P. *Art of This Century: The Surrealist Milieu and the American Avant-Garde, 1942–1947*. Ann Arbor, Michigan: University Microfilms International, 1981.

Levy, Julien. *Surrealism*. New York: Black Sun Press, 1936.

Lipman, Jean. *Calder's Universe*. Exhibition catalogue. New York: Whitney Museum of American Art, 1976.

Marchesseau, Daniel, and Eleanor Levieux. *The Intimate World of Alexander Calder*. Translated by Barbara Shuey. Exhibition catalogue. New York: Harry N. Abrams, 1989.

Marshall, Richard D. *Alexander Calder: Poetry in Motion*. Exhibition catalogue. Seoul: Kukje Gallery, 2003.

———. *Alexander Calder. Stabilen, mobilen*. Exhibition catalogue. Amsterdam: Stedelijk Museum, 1959.

Nadeau, Maurice. *The History of Surrealism*. Translated by Richard Howard. New York: Macmillan, 1965.

Paris–New York. Exhibition catalogue. Paris: Centre Pompidou, Musée national d'art moderne, 1977.

Prather, Marla, with Alexander S. C. Rowler, et al. *Alexander Calder: 1898–1976*. Exhibition catalogue. Washington, DC: National Gallery of Art, 1998.

Recent Work by Alexander Calder. Exhibition catalogue. New York: Buchholz Gallery / Curt Valentin, 1944.

Rubin, William S. *Dada and Surrealist Art*. New York: Harry N. Abrams, 1968.

———. *Dada, Surrealism, and Their Heritage*. Exhibition catalogue. New York: Museum of Modern Art, 1968.

Russell, John. *Max Ernst: Life and Work*. New York: Harry N. Abrams, 1967.

Seaver, Richard. *André Breton, Manifestoes of Surrealism*. Translated by Helen R. Lane. Ann Arbor: University of Michigan Press, 1969.

17 Mobiles by Alexander Calder. Exhibition catalogue. Andover, Mass.: Addison Gallery of American Art, 1943.

Spies, Werner. *La Révolution surréaliste.* Exhibition catalogue. Paris: Centre Pompidou, Musée national d'art moderne, 2002.

Spiller, Jürg, ed. *The Thinking Eye.* Vol. 1 of *The Notebooks of Paul Klee.* Translated by Ralph Manheim. New York: George Wittenborn, 1961.

Stevens, Mark, and Annalyn Swan. *De Kooning: An American Master.* New York: Alfred A. Knopf, 2004.

Sweeney, James Johnson. *Alexander Calder.* Exhibition catalogue. New York: Museum of Modern Art, 1943.

———. *Alexander Calder: Sculptures and Constructions.* Exhibition catalogue. New York: Museum of Modern Art, 1943.

Turner, Elizabeth Hutton, and Oliver Wick, eds. *Calder, Miró.* Exhibition catalogue. Riehen/Basel and Washington, D.C.: Fondation Beyeler and Phillips Collection, 2004.

Zafran, Eric M., with Arthur Miller et al. *Calder in Connecticut.* Exhibition catalogue. Hartford, Connecticut: Rizzoli International, 2000.

Articles

Breton, André. "Le Merveilleux contre le mystère. À propos du symbolisme." *Minotaure,* no. 9 (Oct. 1936), 25–31.

Buffet-Picabia, Gabrielle. "Alexander Calder, ou le roi du fil de fer." *Vertigral* 1, no. 1 (July 15, 1932), 1.

———. "Sandy Calder, forgeron lunaire." *Cahiers d'art* 20–21 (1945–46), 324.

Canaday, John. "Art: Calder Provides a Lift as Always." *New York Times,* Oct. 24, 1970.

Cass, Judith. "Calder to Give His Circus at Dinner Party: Sculptor to Perform at Brewster Home." *Chicago Tribune,* Jan. 10, 1935.

"El 'Circ més petit del món,' de l'escultor Alexandre Calder, a Barcelona." *La Publicitat,* Feb. 9, 1933.

"Forum of Events: Abstract Sculpture in Plexiglass." *The Architectural Forum* 7, no. 6 (June 1939), 26.

Frejaville, Gustave. "Les Attractions de la Quinzaine. Les Poupées acrobats du cirque Calder." *Comoedia,* Apr. 24, 1929.

Hawes, Elizabeth. "More than Modern—Wiry Art." *Charm,* Apr. 1928, 47, 68.

"International Artist Pays Visit to Concord." *Concord Herald,* June 16, 1932.

Legrand-Chabrier. "Alexandre Calder et son cirque automatique." *La Volonté,* May 19, 1929.

———. "Un Petit Cirque à domicile." *Candide,* no. 171, June 23, 1927, 7.

"Jouets et objets de poésie." *Comoedia,* Aug. 1927.

"Les jouets de Calder." *Les Échos des industries d'art,* no. 25 (Aug. 1927), 23.

"Martha Graham and Dance Group." *Dance Observer* (Apr. 1936), 40.

"Mobile Sculpture." *Architectural Review* 83, no. 494 (Jan. 1938), 52, 56.

New York Herald, May 21, 1929, Paris edition.

Pemberton, Murdock. "Calder's Circus." *New Yorker* (Dec. 7, 1929).

———. "The Art Galleries: Pigment and Tea Leaves." *New Yorker* (Feb. 23, 1929).

Powell, Hickman. "His Elephants Don't Drink." *The World,* Jan. 18, 1931.

Sweeney, James Johnson. "Alexander Calder." *Axis* 1, no. 3 (July 1935), 19–21.

"Sculpture by Wire is New Achievement of Alexander Calder at Galerie Billiet." *Chicago Tribune,* Jan. 1929, Paris edition.

Soby, James Thrall. "Calder, Matisse, Miró, Matta." *Arts and Architecture* 66, no. 4 (Apr. 1949), 26–28.

Tracy, Charles. "OH to AA, a Stage Playlet in Two Scenes." *Transition* 26 (Winter 1937), 134–40.

View 4, no. 1 (Mar. 1944), cover.

"View Magazine's Group Show at Hugo Gallery." *Art News* 44 (Dec. 1, 1945), 26.

"Vital." *New York Times,* Jan. 20, 1952.

VVV, no. 1 (June 1942), 9.

Archival Sources

AAA (Archives of American Art, Smithsonian Institution, Washington, D.C., Alexander Calder Papers) includes artist-donated letters, photographs, press clippings, exhibition announcements, and a scrapbook containing hundreds of clippings and memorabilia from 1926 to 1932.

CF (Calder Foundation, New York) maintains an archive of over 120,000 documents, including correspondence and unpublished manuscripts, 26,000 photographs, and thousands of press clippings, articles, books, and films. In addition, the Foundation's catalogue raisonné project maintains a database of over 22,000 works of art by Calder with photography, physical data, provenance, and publication and exhibition history for each piece.

MoMA (The Museum of Modern Art, New York, Alexander Calder files) includes exhibition catalogues, the Curt Valentin Gallery records, an album of catalogues, invitations, announcements, and clippings; publicity scrapbooks (public affairs department); and museum exhibition documents, event photographs, and the exhibition guest books (archives department).

FJM (Fundació Joan Miró, Barcelona)

FPJM (Fundació Pilar i Joan Miró, Majorca)

JJS (James Johnson Sweeney Archive [private collection])

ML (Morgan Library, New York; Pierre Matisse Gallery Archive)

NL (Newberry Library, Chicago; Special Collections)

SM (Stedelijk Museum Amsterdam)